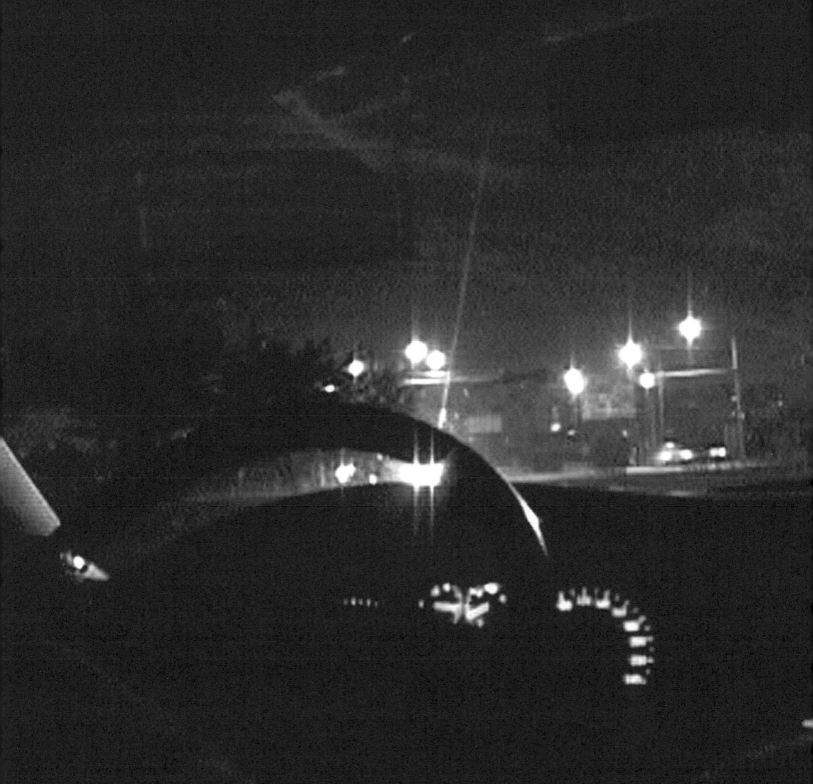

YOUR BRIGHT FUTURE

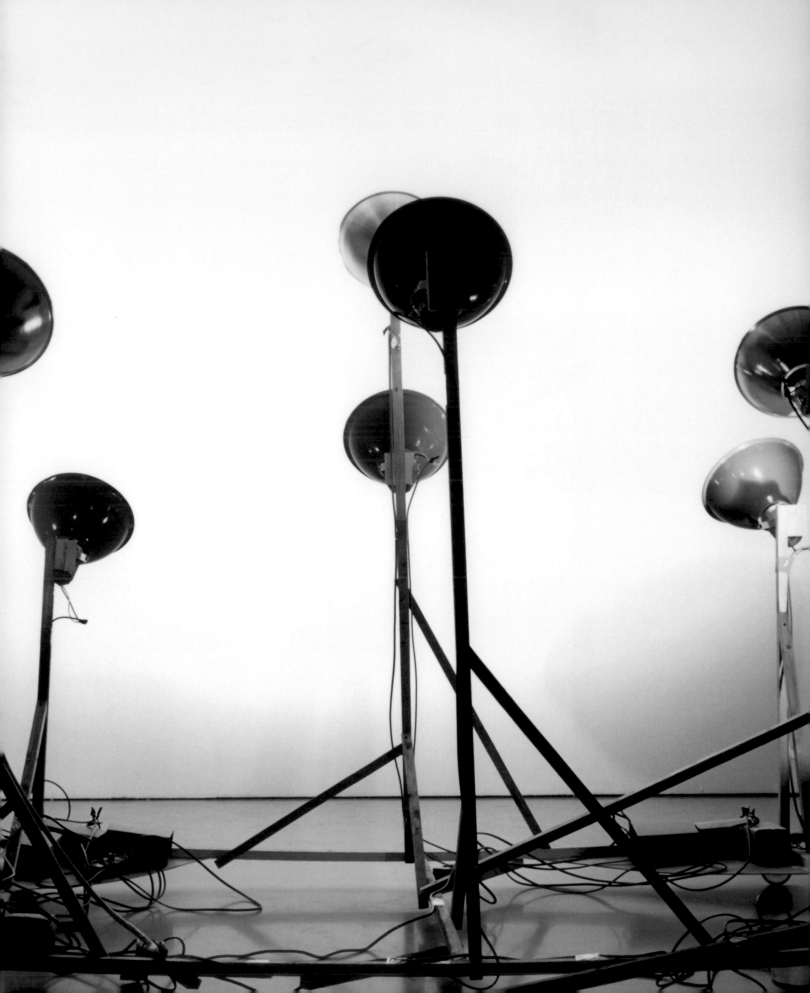

YOUR BRIGHT FUTURE
12 CONTEMPORARY ARTISTS FROM KOREA

CHRISTINE STARKMAN AND LYNN ZELEVANSKY
WITH CONTRIBUTIONS BY JOAN KEE AND SUNJUNG KIM

The Museum of Fine Arts, Houston / Los Angeles County Museum of Art / Distributed by Yale University Press, New Haven and London

This catalogue was published to coincide with the exhibition *Your Bright Future: 12 Contemporary Artists from Korea,* co-organized by the Museum of Fine Arts, Houston, and the Los Angeles County Museum of Art, in association with SAMUSO: Space for Contemporary Art, Seoul.

Exhibition dates:
Los Angeles County Museum of Art
June 28–September 20, 2009

The Museum of Fine Arts, Houston
November 22, 2009–February 14, 2010

Presented by:

Ⓗ **HANJIN SHIPPING**

Publications Director: Diane Lovejoy
Editorial Manager: Heather Brand

Translator (for interviews): Doryun Chong
Translator (for chronology): Hyeyoung Cho

Designed by Jeff Wincapaw
Proofread by Sharon Rose Vonasch
Indexed by Kay Banning
Typeset by Maggie Lee
Produced by Marquand Books, Inc., Seattle
 www.marquand.com
Color management by iocolor, Seattle
Printed and bound by CS Graphics Pte., Ltd., Singapore

Cover illustration: Do Hu Suh, *Fallen Star 1/5* (detail), 2008–9.
Endpapers illustration: Minouk Lim, *Wrong Question,* 2006, 3-channel video installation, 9:38 min.
Page 2: Bahc Yiso, *Your Bright Future* (detail), 2002/2006.
Pages 6–7: Haegue Yang, *Series of Vulnerable Arrangements —Blind Room* (detail), 2006.
Page 9 (left to right, top to bottom): Bahc Yiso, *Your Bright Future* (detail), 2002/2006; Choi Jeong-Hwa, *SUGARSUGAR* (detail), 2006; Gimhongsok, *The Bremen Town Musicians* (detail), 2006–7; Jeon Joonho, *In God We Trust* (detail), 2004; Kim Beom, *Untitled (News)* (detail), 2002; Kimsooja, *A Needle Woman* (detail), 1999–2001, Delhi; Koo Jeong-A, *R* (detail), 2005; Minouk Lim, *New Town Ghost* (detail), 2005; Jooyeon Park, *Untitled* (detail), 2002–4; Do Ho Suh, *Reflection* (detail), 2004; Haegue Yang, *Storage Piece* (detail), 2003/2009; Young-hae Chang Heavy Industries, *CUNNILINGUS IN NORTH KOREA* (detail), 2003.

Distributed by Yale University Press, New Haven and London
www.yalebooks.com

Library of Congress Cataloging-in-Publication Data

Your bright future : 12 contemporary artists from Korea.
 p. cm.
Published to coincide with an exhibition held at the Los Angeles County Museum of Art, June 28–Sept. 20, 2009, and at the Museum of Fine Arts, Houston, Nov. 22, 2009–Feb. 14, 2010.
Includes bibliographical references and index.
Summary: "Offers an unprecedented look at the work of twelve of Korea's most significant contemporary artists through three essays, artists' biographies and interviews, and a chronology"—Provided by publisher.
ISBN 978-0-300-14689-9 (hardcover: alk. paper)
1. Art, Korean—21st century—Exhibitions. I. Museum of Fine Arts, Houston. II. Los Angeles County Museum of Art. III. Title: 12 contemporary artists from Korea. IV. Title: Twelve contemporary artists from Korea.
N7365.6.Y55 2009
709.519'0747641411—dc22 2008033967

Curators' Statement

From the outset, the title *Your Bright Future: 12 Contemporary Artists from Korea* raises questions. In today's increasingly globalized world, is it relevant to identify an artist or a group of artists solely by nationality? Some of the artists represented in this exhibition left Korea and then returned; one came to Korea from the United States and has stayed for an extended period; and many others left Korea to live primarily in Europe or the United States. Yet, wherever they are at any given moment, these artists all have an intimate relationship to Korea that informs the artwork they produce. The purpose of our endeavor is not to locate these artists physically, but rather to locate Korea in the contemporary international art world. We submit the title of this book, the exhibition bearing the same name, and its related programs as just the beginning of a much longer conversation.

Christine Starkman, curator of Asian art, The Museum of Fine Arts, Houston

Lynn Zelevansky, Terri and Michael Smooke Curator and Department Head, Contemporary Art, Los Angeles County Museum of Art

Translation Note: In Korea, family names precede given names; however, some individuals reverse the name order in international contexts. In this publication, the names are arranged according to the artist's or individual's preference. The Romanization of these names, as well as the Romanization of titles of artworks and the names of companies and organizations, also conforms to the individual's or organization's designated preference. Where no preference was determined, the names are spelled according to the Korean Revised Romanization system.

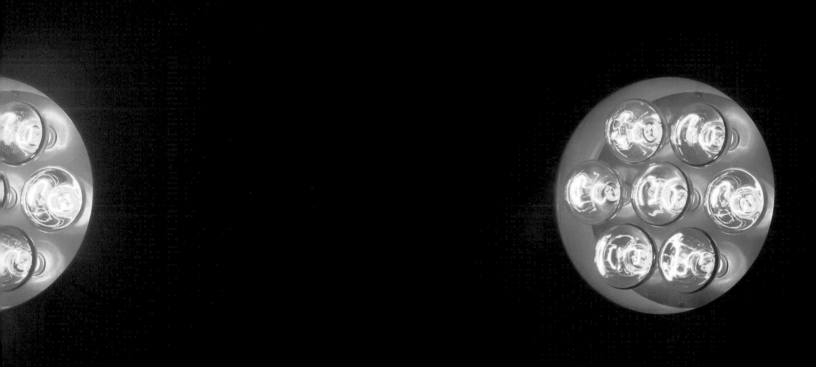

CONTENTS

Foreword

The Los Angeles County Museum of Art and the Museum of Fine Arts, Houston, are proud to present *Your Bright Future: 12 Contemporary Artists from Korea*. Given the vibrancy of the Korean and Korean American communities in Los Angeles, Houston, and other North American cities, and the fascination of the contemporary art world with East Asia, it is surprising that major museum exhibitions focusing exclusively on contemporary art from Korea have been exceedingly rare in the United States. Despite the presence on the international scene of renowned figures such as Do Ho Suh and Kimsooja, South Korea's accomplished—indeed, often fascinating—contingent of artists is too little recognized. With in-depth presentations of works by twelve artists born between 1957 and 1972, *Your Bright Future* is an effort to bring the consideration of contemporary Korean art to the fore.

All but one of the artists represented in *Your Bright Future* have studied and/or lived abroad—some still do. They all employ the visual forms associated with contemporary art worldwide. Not all of them identify themselves, first and foremost, as Korean, and they have strikingly different attitudes about participating in an exhibition based on nationality. They all, however, share the generative experience of a divided country with a rich history and a tumultuous recent past, and this cannot help but be reflected in their art. Their work is often revelatory in its investigation of language, translation, ephemerality, and the possibilities for communication across national and cultural boundaries.

In Los Angeles, the presentation of *Your Bright Future: 12 Contemporary Artists from Korea* is made possible in part by Hanjin Shipping. We are extremely grateful for their support.

Lynn Zelevansky, the Terri and Michael Smooke Curator and Department Head, Contemporary Art at LACMA; and Christine Starkman, curator of Asian art at the MFAH; were joined in the organization of the this exhibition by Sunjung Kim of SAMUSO: Space for Contemporary Art, Seoul. Hyonjeong Kim Han, of LACMA's Chinese and Korean Art Department, served as consulting curator on this project. Their hard work and discernment brought this project to fruition.

Michael Govan, Wallis Annenberg Director and CEO, Los Angeles County Museum of Art

Peter C. Marzio, Director, The Museum of Fine Arts, Houston

Hanjin Shipping is honored to serve as the presenting sponsor of *Your Bright Future: 12 Contemporary Artists from Korea* at the Los Angeles County Museum of Art. The exhibition presents major pieces by twelve South Korean artists, born between 1957 and 1972, who work with installation, video, and performance art, as well as unconventional forms of sculpture and drawing. Coming of age amid political turmoil and increased freedoms, the artists included in this show are keenly aware of their position as citizens of a relatively small, increasingly prosperous but divided country in a rapidly globalizing world. Their work, vanguard in form, reflects this consciousness.

As a global shipping company transporting over a hundred million tons of cargo annually, we at Hanjin are focused on connecting people from all over the world. With our support of *Your Bright Future,* we are proud to bring a taste of our country's rich contemporary culture to LACMA audiences through the art and artists of South Korea. Los Angeles County boasts the highest concentration of Koreans and Korean-Americans in the nation, and with this presentation of *Your Bright Future,* we are bringing a piece of the modern-day Korea to them, and to the entire Los Angeles community, in the form of an extraordinary contemporary art exhibition.

We at Hanjin hope that this exhibition will bring well-deserved attention to Korea and its contemporary culture, piquing people's curiosity about our country and its artists. Our desire is that visitors come away with a sense of the depth and sophistication of contemporary Korean art. It is with great pleasure that we assist in bringing these works of art to Los Angeles.

Eunyoung Choi
Chairwoman
Hanjin Shipping

Acknowledgments

In 2004, Peter C. Marzio, director of the Museum of Fine Arts, Houston (MFAH), visited Korea for the first time on the invitation of the Korea Foundation. He was struck by the beauty, elegance, and verve of Korean art and culture, from ancient times to the present, and realized the lack of awareness of it in the United States. Upon his return, he initiated plans to open a gallery at the MFAH devoted to the arts of Korea, and resolved to implement further programming on Korean art at the museum.

Later that year, the MFAH hosted a forum of Korean scholars and specialists to brainstorm strategies for accomplishing Marzio's aim. After consideration and debate, the experts at the conference recommended an exhibition on contemporary Korean art. J. Keith Wilson, then the chief curator of Asian art at the Los Angeles County Museum of Art (LACMA), who attended the conference, enthusiastically supported LACMA's involvement in the exhibition and sought the support of LACMA's director at that time, Andrea Rich, and the museum's Department of Contemporary Art. Keith remained involved in the organization of the exhibition for a time after he moved to Washington, D.C., to become the associate director and curator of ancient Chinese art at the Smithsonian's Arthur M. Sackler and Freer Gallery of Art, and we owe him a debt of gratitude for his careful consideration of the project in its early stages, and for his useful advice.

Shortly after we began working on the show, Sunjung Kim joined the curatorial team as a specialist in contemporary Korean art. Then chief curator of the Artsonje Center in Seoul, Kim is now the director of SAMUSO: Space for Contemporary Art in Seoul, where she organizes many national and international contemporary art projects. She acquainted us with a wide variety of Korean artists working at home and abroad, and her counsel has been invaluable. Hyonjeong Kim Han, LACMA's associate curator of Korean art, generously agreed to consult with us on the project. She has supported this endeavor throughout, and we very much appreciate her help.

Between 2004 and 2007, we traveled to Korea frequently to see contemporary art and learn as much as we could about the context in which it is made, often making repeat visits to artists whom we thought might be right for the exhibition. This activity resulted in a final group of twelve artists working in a variety of media, all of whom focus, to greater or lesser extents, on the nature of language and communication across national and cultural boundaries. In 2007–8, we invited these artists to visit Los Angeles and Houston in order to understand more fully the cultural and physical environments in which their work would be shown, and to plan for their representation in the exhibition.

Your Bright Future would not have been possible without the generous efforts of many people. We would like to thank our directors, Peter C. Marzio of the MFAH and Michael Govan of LACMA, for their vision and support in bringing the importance of these artists, and contemporary Korean art in general, to the public's attention. Sunjung Kim's staff at SAMUSO labored on this project with dedication and energy. In particular, Seungmin Yoo, who organized our trips to Korea, painstakingly researched and wrote this book's important chronology. Sunyoung Oh and Nari Jang, also of SAMUSO, never tired of our numerous requests for information about the artists and images of their work.

We would like to thank Ra Young Hong, deputy director of Leeum, Samsung Museum of Art, and Soyeon Ahn, chief curator of Leeum, Samsung Museum of Art, who graciously met with us and offered valuable counsel. Kim Hong-hee, director of the Gyeonggido Museum of Art, did the same. Kim Youngna, professor in the Department of Archaeology and Art History at Seoul National University, and Yi Song-mi, emeritus professor in the Academy of Korean Studies, helped to give us a broader picture of the Korean scene, and recommended artists for our consideration.

Kumja Paik Kim, emeritus curator of Korean art at the Asian Art Museum in San Francisco, lent her experienced insight to this project from the very beginning. Joan Kee, assistant professor in the History of Art Department at the University of Michigan in Ann Arbor, wrote the introductory essay to this volume and provided scholarly advice on modern and contemporary Korean art. Iris Moon, PhD student in the Department of Architecture at the Massachusetts Institute of Technology, helped with researching and finalizing the chronology, and Hyeyoung Cho, lecturer in the Department of Ceramic Art at Ewha Womans' University, diligently translated it. Doryun Chong, assistant curator

Choi Jeong-Hwa, *Site of Desire*, 2005, ephemeral installation of red plastic take-out containers, height: 215⅜ inches (547 cm), installation view at the Korean Pavilion, Venice Biennale, Venice, Italy, no longer extant.

of visual art at the Walker Art Center, translated the catalogue's many artist interviews. We are grateful to Ed Marquand of Marquand Books, Seattle, as well as to Jeff Wincapaw, for providing a sensitive and intelligent design for this book.

Many colleagues at the MFAH helped to make *Your Bright Future: 12 Contemporary Artists from Korea* and its related materials and programs a reality. We thank Vivian Li, former curatorial assistant for the Asian Art Department, for contributing the artist biographies, and for her insight and tireless dedication in the management of the various details of this challenging project, from coordinating the texts and obtaining images for the catalogue to serving as the liaison with the numerous departments, artists, galleries, and institutions with extraordinary tact and professionalism. Petrine Knight, former administrative assistant to the Asian Art Department, handled the clerical and administrative matters related with the exhibition with her usual care. Diane Lovejoy, publications director, and Heather Brand, editorial manager, exercised exceptional insight into the content, layout, design, and production of the final impressive catalogue. In the Freed Image Library, Marcia K. Stein deftly oversaw the cataloging of all of the photography for the project.

Several other staff members at the MFAH also contributed an enormous amount of time and energy to the organization and presentation of this exhibition, most notably Jack Eby, exhibit design director, and William T. Cochrane, exhibition designer; Victoria Ramirez, the W. T. and Louise J. Moran Education Director, and Margaret Mims, associate director of education; Kathleen B. Crain and John M. Obsta, exhibitions registrars, and Julie Bakke, chief registrar; Karen Bremer Vetter, chief administrator of exhibitions and curatorial; Richard Hinson and Michael Kennaugh, preparations managers, and their installations staff; and Phenon Finley-Smiley, manager of graphics, and Chick Bianchi, graphics production specialist. Yasufumi Nakamori, assistant curator, photography, was instrumental in conceptualizing for the opening a significant platform for public and scholarly discussion about contemporary Korean art and culture in relation to the exhibition. Amy Purvis, director of development, and Kathleen Jameson, assistant director, programming and grants coordinator for capital projects, led the efforts to secure the funding for this large-scale show. Mary Haus, director of marketing and communications, and her staff vigorously promoted this exhibition to the public. Jonathan W. Evans and Margaret Culbertson of the Hirsch Library helped in obtaining research materials and resources. MFAH curatorial colleagues James Clifton, curator of Renaissance and Baroque painting and director of the Sarah Campbell Blaffer Foundation, and Barry Walker, curator, modern and contemporary art and prints and drawings, offered crucial and timely advice, response, and critique.

At LACMA, the support team was headed by Michele Urton, assistant curator in the Department of Contemporary Art. Michele worked closely with a number of the artists to ensure the realization of complex projects and, in her inimitable fashion, made certain that all of LACMA's departments worked together expediently. Justin Cavin, curatorial administrator in the department, oversaw everyone's travel arrangements, created the publication's checklist, gathered publicity photos, and always made certain that the artists' needs were met. Soo Kyung Cho, intern in the Department of Contemporary Art, painstakingly checked the Romanization of Korean words throughout the catalogue and provided necessary research and support for the show. Contemporary art intern Flora Kao also provided research and support. We are grateful for the help of curatorial assistant Michelle Bailey in the Department of Chinese and Korean Art, curatorial administrator Vanessa May Holterman, and postdoctoral fellow Kyungja Hwang.

Irene Martin, assistant director; Sarah Minnaert, exhibition programs coordinator; and Marciana Broiles, financial analyst of LACMA's Exhibitions Department, worked with their usual dedication and expertise in overseeing the budgets and other administrative aspects of the show. Melissa Bomes, associate vice president, corporate partnerships and marketing; Tracy Mizrahi, major gifts officer; Stephanie Dyas, director, government and foundation grants of the Development Department; and VanAn Tranchi, grants manager, brought crucial funding to fruition.

Victoria Behner, senior exhibition designer, created and re-created the exhibition design as the artists' projects evolved, cheerfully coping with the complexities of working

in a new building. Daniel Forrest, staff architect, and Donald Battjes, chief of operations, gave important advice on the plan. Alexandra Moran, senior assistant registrar, exhibitions, oversaw the shipping of works for the exhibition with the assistance of Maria Aimerito, contract registrar for exhibitions and data management support. Jeff Haskin, manager of art preparation and installation, helped budget for the needs of different works; he and his staff installed the exhibition with their accustomed professionalism. John Bowsher, director of special art installations, provided important assistance with outdoor works. William Stahl, construction manager, and his staff dealt expertly with the challenges of reconfiguring walls in the Broad Contemporary Art Museum at LACMA.

Acting as consultants at all venues, Peter Kirby interfaced with LACMA's Audio-Visual Department, expertly overseeing the implementation of the artists' video, film, and sound requirements, while Christian Johnson worked closely with Choi Jeong-Hwa to realize his complex outdoor installations.

Without the artists, there would be no exhibition, so our final thanks must go to Choi Jeong-Hwa, Gimhongsok, Jeon Joonho, Kim Beom, Kimsooja, Koo Jeong-A, Minouk Lim, Jooyeon Park, Do Ho Suh, Haegue Yang, and Young-hae Chang and Marc Voge of Young-hae Chang Heavy Industries for their wonderful work, and for the time, energy, and attention they gave to this project. We unfortunately did not have the honor of meeting the late Bahc Yiso, among the most influential of South Korea's contemporary artists. Our gratitude goes to Hawon Ku, Bahc's niece, who took time out of her busy schedule as a postdoctoral fellow at Seoul National University to supply us with material and information that helped illuminate our understanding of the artist, his philosophy, and his work. Equally important, Ms. Ku worked with Sunjung Kim to make possible the reconstruction of two works that the artist produced first at the Artsonje Center. It has been a privilege to engage with the work of these very gifted artists.

Christine Starkman, curator of Asian art, The Museum of Fine Arts, Houston

Lynn Zelevansky, Terri and Michael Smooke Curator and Department Head, Contemporary Art, Los Angeles County Museum of Art

Joan Kee

LONGEVITY STUDIES
The Contemporary Korean Art Exhibition at Fifty

Few subjects offer a more useful point of entry into the field of contemporary Korean art than the question of longevity. Specifically at issue is the longevity of the contemporary Korean art show, the group exhibition that revolves around the idea of a discrete contemporary Korean art. Taking place in 2009, a little more than fifty years after the first contemporary Korean art shows took place, the exhibition *Your Bright Future: 12 Contemporary Artists from Korea* is as much an opportunity to explore this question as it is an introduction to the field of contemporary Korean art now. On the face of it, the secret of the contemporary Korean art show's longevity seems obvious enough. Exhibitions need money, institutional support, logistical know-how, and most important, a surfeit of ambition. But probe a little further and one soon uncovers a contentious struggle over authority. Questions of relevance are often those belonging to matters of property: who has authority; who wants it; and in what ways is authority claimed, possessed, and transferred? To explore the reasons behind the contemporary Korean art show's half-century of existence is to get a clearer sense of the tensions sustaining contemporary art in Korea.

The first exhibitions took place not long after the nominal end of the Korean War in 1953, when Cold War tensions neared their peak and South Korea ranked among the poorest countries in the world. Organized by U.S. curators and institutions, these exhibitions more directly reflected the views of their U.S. organizers than those of their Korean counterparts. At least one of these shows was part of the U.S. State Department's efforts to contain the threat of Communism by way of cultural exchange. A show of contemporary Korean art held at the University of Minnesota in 1957, for example, was directly facilitated by the State Department's International Cooperation Administration, which regarded South Korea as a crucial zone in which to resist Communist aggression.[1] The U.S. state would continue to exercise influence in the next few decades, albeit less directly, through the medium of the South Korean state. As part of its drive to consolidate its power through the promotion of cultural solidarity, the U.S.-backed authoritarian government of ex-military general Park Chung-hee funded shows of Korean art at home and abroad. Contemporary Korean art shows would flourish after the late 1970s, when a critical mass of private funders entered the Korean art world. Newspaper companies sponsored art competitions that awarded substantial cash prizes, while a number of galleries did a brisk trade in the buying and selling of paintings.[2] Though heavily dependent on state support, the conglomerates, or *jaebeol,* became another force in the art world in the decade bookended by the 1988 Seoul Olympics and the global economic crisis of 1997. Generally intended for venues located outside Korea, shows of contemporary Korean art demonstrated the wealth and status of these new private funders as they did the nationalism long promoted by the South Korean state.

As contemporary Korean art shows proliferated after the Korean economy recovered its bearings in the late 1990s, some artists developed ennui toward the essentialism and excessive grandstanding commonly associated with this form of display. Still, the visibility offered by these kinds of large-scale shows such as *Peppermint Candy,* the first extended survey of Contemporary Korean art in South America (fig. 1), was enough to ensure the participation of many other artists. Asked why he chose to participate in *Elastic Taboos,* a 2007 survey of contemporary Korean art at the Kunsthalle Wien in Vienna, photographer Oh Hein-kuhn answered, "If not art, then money or fame."[3] Indeed, if quantity and geographical scope are anything to go by, the contemporary Korean art show seems even more robust now than it did when the mere promise of showing overseas was both cause for celebration and competition.

But what explains its continuing appeal? No amount of pragmatic incentive can adequately describe the persistence of a type of show based on themes of nation, culture, and ethnicity, especially in the last several years when even the critique of identity politics became so dated as to feel perversely relevant. Here we turn to ambition. Shows that took place in the 1960s and 1970s often followed the lead of the South Korean state, which urgently sought to carve out a place for itself among the international order of nations. Organizers of and participants in several exhibitions genuinely believed in the ideals of cultural unity and autonomy, often summed up as "Koreanness." Later shows took a different tack when organizers emphasized art's capacity to reflect upon what its producers saw as society's irrevocably fragmented nature; themes of inequity, instability, and uncertainty became as important to shows in the 1980s and after as Koreanness was to earlier exhibitions. In nearly all of these exhibitions, however, was a tacit will to redefine the idea of a contemporary Korean art, to play author, so to speak. The exhibition offers a tempting chance for testing one's powers and asserting

Fig. 1. Oh Inhwan, *Where a Man Meets Man,* 2007, powdered incense, dimensions vary, collection of the artist, installation view from the exhibition *Peppermint Candy: Contemporary Art from Korea,* Museo de Arte Contemporáneo, Santiago, Chile, 2007.

one's cultural authority. What follows is a look at four exhibitions in which this chance was seized, challenged, and exchanged for yet other ways of "authoring" contemporary Korean art.

Drawing the Lines of Battle: *Contemporary Korean Painting*, 1968

It is a truism of exhibition planning that each show is necessarily the work of numerous "authors": curators, artists, critics, and so forth. For sheer variety of authorial viewpoints, few shows can match *Contemporary Korean Painting* (*Kankoku gendai kaiga ten*), the first significant group show of contemporary Korean art in Japan. Cosponsored by the newly established Korean embassy in Japan, the Korea Information Service, and the National Museum of Modern Art in Tokyo, the show marked the first real artistic exchange between the two countries since Korea's liberation from Japanese colonial rule at the end of World War II (fig. 2). Indeed, politics rather than aesthetics lay at the heart of the show, an intention tellingly reflected in the choice of cover image for the catalogue: the yin-yang symbol of the South Korean flag.[4] The idea for the show was first proposed to the museum by artist Lee Se-duk, a frequent art adviser to the South Korean state and one of the most enthusiastic supporters of internationalizing Korean art through exhibitions. Together with Honma Masayoshi, the curator of the National Museum of Modern Art, Lee sought to present the "face of today's Korean art" in Japan, "the country that was at once so near, yet so far."[5]

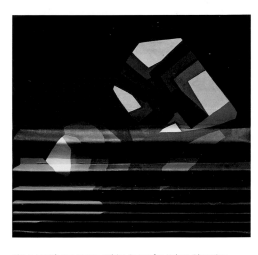

Fig. 3. Ha Chong Hyun, *White Paper for Urban Planning*, 1967, oil on canvas, 41¾ × 41¾ inches (105 × 105 cm), collection of the artist.

Fig. 4. Lee Ufan, installation view of *Landscape I–III*, 1968, oil on canvas, each: 85¾ × 74¾ inches (218 × 190 cm), no longer extant.

Save for two artists based in Tokyo, all the participants were selected by a jury consisting of historian, and the National Museum's curatorial head, Choi Su-nu, and critics Yi Kyungsung, Lim Young-bang, Yoo June-sang, and Lee Yil.[6] Yi, who had studied in Tokyo, and the last three, who had spent some time in Paris in the 1950s and 1960s, were among the most cosmopolitan members of the South Korean art world.

Contemporary Korean Painting attracted wide, if brief, coverage in the mainstream press. Some commentators applauded what they saw as examples of "a unique Korean sensibility."[7] Others registered disappointment at what they saw as the show's failure to deliver anything new to the proverbial table. The critic Ishiko Junzō insinuated that many of the works shown had failed to convince the viewer due to overly simplistic definitions of contemporary art. Instead of focusing on the task of "how to express the imagined world," the show was content to define contemporary art as either art that happened to be made in the recent present, or as art that absorbed the most up-to-date trends.[8] Especially prevalent were geometric abstractions that hovered somewhere between illusion and materiality (fig. 3). The popular weekly *Asahi Journal* saw the show as a lost opportunity. Korean art, like that of Japan, was far too invested in the trends of New York and Paris. Foreshadowing the promotion of a

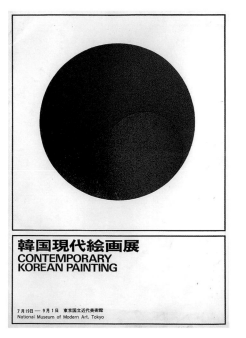

Fig. 2. Exhibition catalogue cover, *Contemporary Korean Painting*, 1968.

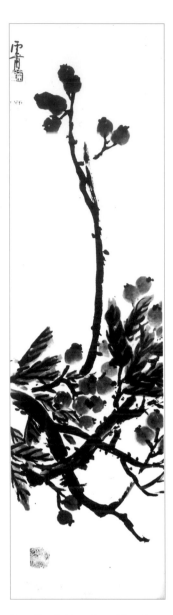

Fig. 5. Kim Ki-ch'ang, *Loquat Branch,*
undated.

discrete contemporary Asian art undertaken by institutions like the Japan Foundation and the Fukuoka Art Museum beginning in the late 1970s, the article inquired about the possibility of an "Asian conception" of art and internationalism.[9]

Among those involved with the show's organization, responses ranged from pessimistic contempt to subdued optimism. Noting the sparseness of serious critical response, exhibition participant Kim Chong-hak scoffed at his Korean peers for thinking that the show was a major international undertaking when it failed to attract the attention of the Japanese art world.[10] Perhaps in defense of his own position as one of the show's jurors, Lee Yil saw the exhibition as a success insofar as it helped introduce contemporary Korean art to a Japanese audience.[11] Nevertheless he chafed at what he described as the favoritism shown to established artists at the expense of fresher, more "experimental" works made by younger artists.[12]

The real sparks would fly in the exhibition's accompanying roundtable discussion, in which generational difference emerged as the touchstone of conflict. Representing the established artists was abstract painter Yoo Young-kuk. Like most of his oil-painting contemporaries, he had received considerable training in Japan in the 1930s. On the other side of the ring was Lee Ufan, who had initially studied ink painting at Seoul National University before leaving for Japan in 1956. Still in his early thirties, Lee would soon attract attention in the Tokyo art world for his writings that would help catalyze the formation of the Mono-ha, the loose affiliation of artists that would come to occupy a central place in the history of contemporary art in Japan. In the roundtable, Lee brashly suggested that cultural difference was an insufficient premise upon which to make one's case in the international art world. Like his enormous fluorescent pink monochromes, which insisted upon physical immediacy as central to the viewing experience, Lee too argued for the centrality of interpretation and theory in artistic practice (fig. 4).[13] Affronted at the "very idea of a young person directly putting forth his ideas on art," Yoo loftily stated that any privileging of logical explanation was but a compensatory gesture trying to make up for a weak painting.[14]

Fraught as it was, the disagreement might have ended there without further provocation. But Lee complicated the generation gap by tacitly connecting the established generation to the willful myopia of misplaced nationalism. He suggested that Korean culture is problematic, a position that was intimately linked to his

experiences as a Korean resident in Japan. In the late 1960s, Koreans who lived in Japan faced double alienation. They lacked full citizenship rights in Japan, an absence that curiously resonated with the lack of critical attention paid to *Contemporary Korean Painting*. At the same time, their loyalties were questioned by a violently anti-Communist South Korea, deeply suspicious of the pro-North Korean sympathies of the Chongryon, the largest organization for resident Koreans in Japan. Lee described his sense of being torn between his Korean nationality and his professional identity as an artist and critic ("a Korean versus an artist").[15] Lee also acknowledged the chilling effect that past convention, especially nationalism, had on cultural production. Seoul, he implied, was a place where cultures or cultural trends brought in from elsewhere could not survive.[16]

Interface as Face-off: *Secondes Rencontres Internationales d'Art Contemporain*, 1978

Lee's maverick attitudes exercised a keen fascination for younger artists, particularly following his artistic and critical successes in the Japanese art world. His critical views of nationalism, however, failed to make much of an impact on undermining the ideal of a unified ethnic identity. In the mid-1970s, this ideal turned into a virtual system of belief through the ascent of what became known as *dansaekhwa,* or Korean monochrome painting.

The idea of a distinctly "Korean" monochrome painting was first deployed in a group show of primarily white monochromatic paintings held at the cutting-edge Tokyo Gallery in 1975. It quickly attracted a following among critics in Japan as well as Korea, including Nakahara Yusuke, the commissioner of the 1970 Tokyo Biennale, which, through its conspicuous foregrounding of Minimalist and post-Minimalist works by Japanese and non-Japanese artists, had tried to affirm the presence of an international visual idiom. Possibly drawn by what he may have sensed as another potentially comprehensive idiom, Nakahara decided to emphasize Korean monochrome painting in the show *Korea: A Facet of Contemporary Art* at Tokyo's Central Museum of Art. In the show's catalogue, he championed the difference he saw in the works vis-à-vis their counterparts in Europe, the United States, and Japan.[17] Artists in Korea were drawn to the idea of Korean monochrome painting on similar grounds. A young painter named Kim Chang-sup wrote, "I believe that we react quickly enough on our own so as not to have to be pathologically

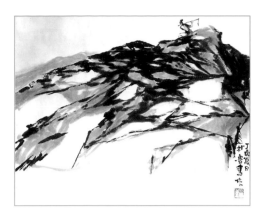

Fig. 6. Pak Nae-hyon, *Rock and Flutist,* undated, oil on canvas, 8 × 10 inches (20 × 25 cm).

Fig. 7. Installation view of *Contemporary Korean Paintings,* 1958, World House Galleries, New York, Lee Se-duk Collection, Archives of Korean Art, Leeum.

sensitive to the contexts or movements of the West."[18] If the Japanese and Korean art worlds readily accepted the idea of Korean monochrome painting, it was partly contingent on efforts to reconfigure the world—the belief in a unique Koreanness, incommensurable to anything that could be found in the West, fed into a larger desire to level the field of encounter between Asia and the West.

Many viewers had long accepted incommensurability as a measure of quality. In the catalogue for the 1958 show *Contemporary Korean Paintings* in New York, the exhibition's organizer, Ellen Conant, celebrated the idea of "synthesis" that might enable Korean art to reach a condition of singularity that would neither be Western nor Asian (figs. 5, 6, and 7).[19] Similarly, a reviewer of the show praised one work for its ability to fuse "Korean motives and modern abstraction" while criticizing most of the oil paintings for reminding him too much of the School of Paris.[20] These views were also shared by Lee Yil when Korean monochrome painting made its European debut as part of the South Korean delegation to the exhibition *Secondes Rencontres Internationales d'Art Contemporain*

at the Grand Palais in Paris.[21] Perhaps mindful of the criticisms directed against the works shown in the 1968 show at the National Museum of Modern Art in Tokyo, Lee argued that Korean art no longer tried to follow the international pack but was its own phenomenon, impervious to comparison.[22]

Rhetoric had its limits. The Parisian audiences were not altogether convinced by what they saw. *Le Figaro* described the monochromes as an outcome of the exhibition's arbitrary choice.[23] Other reviewers reportedly condemned what they saw as a lack of originality even as they praised some works for their "Asianness and creativity."[24] Even less convinced were critics writing for the Korean press. Excepting the "face-saving" works of artists like Kwon Yong-woo, Kim, and Lee, as well as Ha Chong Hyun (fig. 8), who pressed paint through the canvas from behind in a denial of painting's claims to frontality, the Paris correspondent for the influential newspaper *Chosun Ilbo* was especially withering in his assessment: "The works did not seem as if they hailed from a country with

Fig. 8. Ha Chong Hyun, *Conjunction,* 1977, oil on hempen cloth, 50 × 65 inches (127 × 165 cm), collection of the artist.

over five thousand years of tradition, but rather those from a cultural colony of some Western nation."[25] In a time when the Korean art world was in the midst of confronting the legacies of Japanese colonialism, accusations like these had the effect of gasoline poured onto an already raging bonfire. Park Seobo, one of the exhibition participants and an important promoter of Korean monochrome painting, wrote not one, but two angry rebuttals defending the merits of his work and others like it.[26]

Much of the no-holds-barred atmosphere mirrored the vitriolic battles for authority then taking place within the Korean art world. Korean monochrome painting played no small role in fostering the atmosphere of polarization. Many of the artists associated with the idea enjoyed a level of critical visibility that their counterparts

could only imagine. Although the idea of a Korean monochrome painting began life in a privately run gallery in Tokyo, it soon bore the imprimatur of South Korean state approval, a highly visible example of which was its prominence in *Secondes Rencontres Internationales d'Art Contemporain.* Not only was the show facilitated by the Association Française d'Action Artistique, the quasi-governmental agency charged with exporting French art shows abroad, but the South Korean delegation was sponsored by its government through the Ministry of Culture and Information. The fact that several examples of Korean monochrome painting were chosen over other available modes of art-making suggests a marked preference on the part of the state. Those excluded from such public endorsement quickly denounced this state of affairs on grounds of principle; critics like Won Dong-suk castigated "monochromatic art" for its disconnection from "the realities and the sensibilities of the people."[27] The lines of battle were duly drawn between the state as the oppressor and "the people" as the oppressed.

There was another, though relatively unnoticed binary that distinguished the plural mass from the unique individual. Echoing Lee Ufan's lament from a decade prior, in which Lee found himself grappling with an artificial wedge separating national origin from professional identity, Paris-based sculptor Chung Bo-won criticized *Secondes Rencontres Internationales d'Art Contemporain* as a victim of scale: Why frame the show, basically a gathering of individual outlooks and tastes, in terms of grand tropes of "race" or "tradition"?[28] Moreover, why was it that engagement with Euro-America had to continue on terms of nationalist refusal or abject assimilation?[29]

The Yesterday and Today of Contemporary Korean Art, c. 1986

Chung's questions regarding the terms of engagement were temporarily overpowered by another form of authority, the strident ideological wars affecting both the Korean art world and Korean society as a whole. After South Korean president Park Chung-hee was assassinated in 1979, there was a period of respite that was quickly put to an end by a military coup led by yet another military strongman, Chun Doo-hwan. Advocates of democratization, whose numbers swelled after Park Chung-hee effectively transformed his rule into outright dictatorship in 1972, could little stomach the idea of yet another long winter of authoritarian rule. Criticisms against Chun's government rapidly escalated in both quantity and vigor,

Fig. 9. Interior view of the National Museum of Contemporary Art, Gwacheon, 1988.

Fig. 10. Double-page spread on the National Museum of Contemporary Art opening in *Gyegan Misul,* 1986; an installation view of *The Yesterday and Today of Contemporary Korean Art* is seen in the upper right-hand corner.

especially after its bloody suppression of student, and later, citizen protests in the city of Gwangju in 1980.

In the art world, the loudest cries of dissent came from artists and commentators affiliated with the Minjung movement. As its name suggests, the Minjung (roughly translated as "the common people") took direct aim at the premises upon which the state sought to affirm its power. Sung Wan kyung openly quibbled with the state's promotion of a unified national culture, which he disputed as being nothing more than an illusion.[30] For "authentic" communication to occur, he argued, one must look to small groups and communities, including those belonging to the Korean diaspora.[31]

Sung's argument was published just after the new building of the state-run National Museum of Contemporary Art opened its doors to the public in August 1986 (fig. 9). Commissioned not long after Seoul was tapped to host the 1988 Olympics, the new museum was part of a state-led frenzy of preparations. Designed to resemble a traditional Korean palace, the building was a testament to the resources of the state. An estimated twenty billion *won* was lavished on the museum, a far cry from the state of twenty years ago when Yi Kyungsung—now the director of the grand new building—bemoaned the unacceptable display conditions of what had been the museum.[32] The museum's exhibition program was no less ambitious. Four shows greeted the visitor, including what was, and still is, by far the largest survey of twentieth-

century Korean art ever to take place (fig. 10). *The Yesterday and Today of Contemporary Korean Art (Hanguk hyeondae misului eojewa oneul)* covered nearly eight decades of art from the advent of Japanese colonization in 1910 to the present, with almost seven hundred works on display. In the preface to the show, the museum's director, Yi Kyungsung, framed the works as metaphors of national history, a device that would be incessantly repeated in later shows of contemporary Korean art. They were "aestheticized expressions of Korea's unhappy modern history."[33] The show had no specific curatorial theme other than what Lee Yil criticized as a near-pathological desire to be "the first" and "the biggest" show of Korean art in the twentieth century.[34] Another reviewer, Jeung Biongkwan, argued that it would have been better to have a true free-for-all, where anyone who wanted to show, could.[35] That the show would have been better served by a less arbitrary and more consciously democratic selection was an argument that vibrated sympathetically with the numerous student demonstrations that called for an end to military rule. Yet despite its lack of direction, the show managed to depict a world in which one style inevitably gave way to another in a natural, untroubled progression.

Banned from view were works that might disrupt the flow of development, the attention to style, and most important, bring unwelcome ideas into a realm created to uphold a different set of politics. Minjung artists and their portrayals of the people in revolt or under duress were excluded from the show in no uncertain terms. Making liberal use of indigenous motifs, straightforward and sometimes deliberately awkward compositional structures,

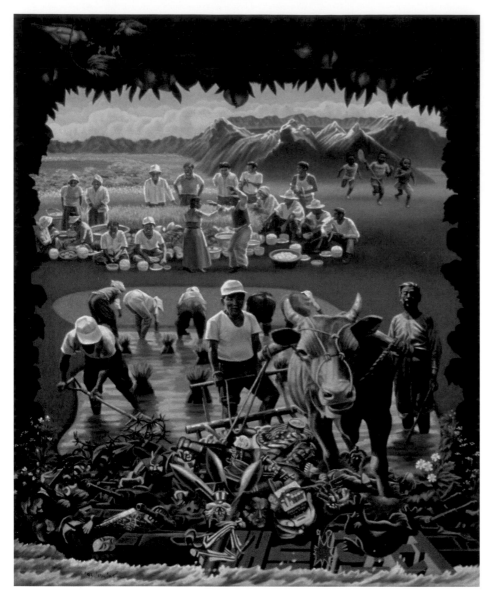

Fig. 11. Shin Hak-chol, *Planting Rice,* 1987, oil on canvas,
63¾ × 51¼ inches (162 × 130 cm), no longer extant.

and, in direct contrast to the neutral hues of Korean monochrome painting, bright saturated colors, Minjung artists like Shin Hak-chol tried to make their works as visceral an experience as possible. Shin was more successful in this regard. In one of the most notorious instances of government censorship of the visual arts in Korea, the state found Shin and his work *Planting Rice* guilty of glorifying life in North Korea (fig. 11). Under the pretense of upholding the tenets of the National Security Law, the government effectively took both the artwork and the artist out of circulation by confiscating the former and imprisoning the latter.[36]

Its ability to recall the power of the law notwithstanding, the state's ability to dictate the terms of inclusion and exclusion was increasingly running on borrowed time. The entry of private sources of funding undermined the state's near-monopoly over sources of monetary and institutional capital. Many of the new private funders, ironically enough, were themselves reliant on state support. Conglomerates like Samsung, the publisher of Korea's longest-running art magazine (*Gyegan Misul,* which later became *Wolgan Misool* in 1989), and the owner of the country's largest private museum, the Ho-Am Art Museum, founded in 1982, relied on the state for subsidies and security, especially in helping to keep the increasingly powerful labor unions in check. Another unexpected challenge to state authority lay in the Minjung's active integration into larger forms of internationalism. Its overt representations made it an ideal candidate for inclusion in shows based on themes of revolution or third-world liberation.[37] The level and amount of critical attention paid to Minjung art made it all but impossible to ignore, and in 1994, the National Museum of Contemporary Art hosted a retrospective of Minjung art organized by the People's Artists Association (*Minjok misulin hyeophoe,* also known as *Minmihyeop*) that became one of the most popular shows in the museum's history.[38]

Across the Pacific, or Worlds Asunder

In the years between 1986 and 1994, the trope of expansion became very real indeed. Eased restrictions on travel and improved access to capital allowed scores of Korean artists to live and study in the United States and Europe, with New York being a favorite destination. The migration dovetailed with the rise of identity politics as a topical subject in the New York art world, an ascendance that helped throw the spotlight on the works of both Korean and Korean American artists.

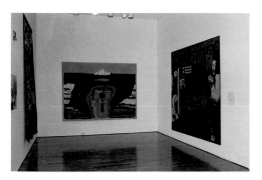

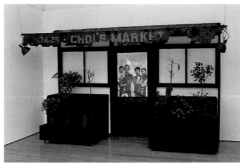

Fig. 12. Installation view of Jang Sup Sohn, *Rising Sun*, 1991, oil on canvas, 79 × 103 inches (200.7 × 261.6 cm) (on left) and *Window of History*, 1989, acrylic on canvas, 88⅛ × 88⅛ inches (224 × 224 cm) (on right).

Fig. 13. Installation view of Sung Ho Choi, *Choi's Market*, 1993, wood, photographs, and awning, 100 × 150 × 50 inches (254 × 381 × 127 cm).

In 1991, the Korean American artists' networking collective SEORO approached the Queens Museum of Art to mount a group exhibition of Korean and Korean American artists (figs. 12 and 13).[39] Located in close proximity to Flushing and other neighborhoods that had witnessed a heavy influx of Korean and Taiwanese immigrants, the Queens Museum was situated in the midst of the constituencies for whom identity politics was a very real issue. The museum agreed to stage the exhibition, if SEORO could find guest curators. Lee Young Chul, who had helped organize a show of Minjung artists at Artists Space in 1988, and a friend of one of SEORO's founders, Mo Bahc (later Bahc Yiso), was tapped to organize the Korean section. Jane Farver, then director of the Lehman College Art Gallery in the Bronx, with a demonstrated interest in nonmainstream artists, assumed responsibility for the U.S. part. She recounts that there was a "great deal of urgency to mount this kind of show."[40] Incidentally, the early 1990s was also a time when receptivity to the idea of a contemporary Asian art was on the rise in Western Europe and in the United States and had long been in the making in the greater Asia-Pacific region, especially in Japan.[41] Searching for common traits or conditions that might help identify the parameters of transregional art, curators and critics took special note of the proliferation of new democracies and accelerated rates of economic growth taking place simultaneously in several East and Southeast Asian countries.

Against this backdrop, Lee chose to stress major socioeconomic change as the common denominator.[42] The works selected for *Across the Pacific: Contemporary Korean and Korean American Art* stressed difficulty, contradiction, and in the case of Y. David Chung's paradoxically named *Satisfaction,* even nightmare (fig. 14). Much of the Korean portion of the show was drawn from the work of the Minjung artists, which by now had lost most of its radical charge. Some viewers praised the exhibition, while others questioned the show's curatorial restrictions.[43] Lee's selection and framing affirmed the Minjung standard in which the value of an artwork depended on its capacity to meet the tastes or needs of the common people, even as it was clear that those endorsing these standards frequently were in possession of distinctly nonplebian family or educational pedigrees. Figurative depictions of historical events, people, and symbols, as well as faux-naif modes of execution that consciously tried to eliminate the distinction between the artist and the viewer, were deemed as good works; these were seen as accessible to the masses.[44]

Fig. 14. Y. David Chung, *Satisfaction,* 1993, mixed media on paper, 55 × 156 inches (139.7 × 396.24 cm), collection of the artist.

The more compelling works open up onto a different experience. One of the show's most celebrated pieces was Kim Ho Suk's *Resistance VI,* an ink and color portrait of the legendary fifteenth-century Korean statesman Hwang Hui (fig. 15). Calling to mind a muddled television signal or a printing error, the four eyes of Hwang confuse the viewer, much in the way

Fig. 15. Kim Ho Suk, *Resistance VI,* 1988, ink and color on paper, 53⅜ × 39⅜ inches (135 × 100 cm), private collection, Seoul.

that Kim imagines his subject to feel, were he to be suddenly transported to the late twentieth century.[45] *Resistance VI* possesses many of the visual traits associated with Minjung art, including an abundance of mimetic detail, large absolute scale, and simplified figuration. The four eyes, however, unsettle the gaze and force it to wander the pictorial field without hope of a reprieve. The painting denies the viewer access to its depths.

Viewers on both sides of the Pacific recognized the gap between the artwork and its curatorial framing. Despite his sympathetic review, Holland Cotter was bothered by the narrowness of the curatorial view.[46] Upon the show's Seoul installation at the conglomerate-owned Kumho Museum of Art in 1994, critic Kim Hyun-do wondered why only a certain type of art—what he euphemistically referred to as "anti-reductionist" work—was being promoted as exemplary of the whole of Korean art.[47] By the same token, why hold a dystopian view of identity as the main premise of Korean American art? For Kim,

works like *Satisfaction,* a detail of which was published alongside Kim's review, was interesting on its own; to him, there was no reason why they had to be seen primarily as paeans to immigrant struggle. Again coming to the fore was the struggle over which themes, and therefore, values, would determine the field of contemporary Korean art.

Demise, the Elixir of Life

At the turn of the millennium two themes were paramount. One was the question of Koreanness, or more broadly, the parameters of inclusion. What qualified an artist—and by this logic, the artwork—as Korean? *Koreamericakorea,* held in 2000 at the Artsonje Center in Seoul, endorsed works by Korean American artists that reflected upon the chasm opened by their exposure to two disparate cultures. Replacing the heads of seated Buddha figures with that of well-known cartoon characters such as Donald Duck, Michael Joo drolly invoked the condition of cultural discrepancy in *Headless (mfg portrait)* (fig. 16). At the same time, *Koreamericakorea* ratified its own laws of inclusion by choosing to exclude Korean adoptees from its survey

Fig. 16. Michael Joo, *Headless (mfg portrait),* 2000, urethane foam, vinyl plastic, styrene plastic, stainless-steel wire, and neodium magnets, dimensions vary.

of Korean American art.[48] More recent shows, including this one, *Your Bright Future,* have chosen to include nonethnic Koreans so long as they live in Korea, thus gauging the degree to which perceptions of nationality and ethnicity can be pulled and stretched.[49]

Important too was the question of contemporariness. In 2004, Lee Young Chul organized *You Are My Sunshine (Dangsineun naui taeyang),* one of the few serious attempts to survey contemporary Korean art as a historical phenomenon. Held at the privately funded Total Museum of Contemporary Art in Seoul, the exhibition consisted mostly of works that tried to

represent, or embody, historical or social phenomena that were viscerally relevant to Korean society at the time of their creation (fig. 17). Minjung art, including a digital reproduction of Shin Hak-chol's *Planting Rice,* was again in full force while many of the canonical standbys, namely Korean monochrome painting, were relegated to supporting-role status or omitted altogether. Lee hoped to turn the space of the exhibition into a "present-tense situation" where artists past and present might come together.[50] He stressed this objective by interspersing recorded interviews of the artists with the actual material works. Though intended to set the historical record straight, the show made a stronger case for contemporary Korean art as a body of work intrinsically defined by its ahistoricity. The value of contemporary Korean art was solely identified through its relevance for the immediate present.

Those involved in organizing a form of display as loaded as the nation- or ethnicity-themed survey exhibition face a multitude of challenges. There is the presumption of having to represent the entirety of a given nation or ethnicity, or what numerous commentators have described as the burden of representation. There is the nature of ambition to consider as well. Whether the source of the ambition lies with the state looking to consolidate its authority, or with the individual curator seeking to make a name for him- or herself, ambition brings with it an expectation of gain. The show and its works become a means to an end that is hoped to benefit the organizer, a proposition that involves speculating on what it is that

the anticipated audience might expect. Little wonder, then, that the survey show of contemporary Korean art so frequently turns on how art might reflect contemporary society or exemplify the idea of Koreanness. Yet the question of whether art can be anything more than evidence weighs more heavily with every show that focuses mainly on exploring what it means to be a contemporary Korean artist in contemporary Korean society. Shows that evade the question seem increasingly passé, hollow, dead, even. Resuscitating the contemporary Korean art show from this state of affairs may be the greatest challenge facing organizers of such shows today.

As many viewers and reviewers have already suggested, the future of these shows actively depends on restating their present terms so that questions of contemporariness and Koreanness revolve around art rather than the other way around. Taking a more general view, it is perhaps time to actively embrace the potential of demise, an idea that simultaneously denotes both the end of a condition as well as a transfer of authority. As its own history shows, the contemporary Korean art exhibition is most remembered when perceived failure on the part of its "authors" becomes a significant part of its structure or reception. It is especially true when the failure in question brings forth other interpretative possibilities. In demise lies the hope of prolonging the longevity of the contemporary Korean art exhibition by urging its future authors to embark upon new paths.

NOTES

Author's note: Where possible, proper names conform to personal preference (e.g., Lee Ufan, Park Seobo) or common usage (Lee Yil). Romanization otherwise follows the Revised Romanization system.

1. The show featured works by students and four faculty members (ink painters Ro Soo-hyun and Chang Woo-sung, and oil painters Pak Duk-soon and Chang Uc-chin) at Seoul National University, Korea's most prestigious institution of higher education. The show was one instance of a collaboration between the University of Minnesota and Seoul National University via the International Cooperation Administration. Malcolm M. Willey, "Introduction," in *Korean Art: Faculty and Students Seoul National University* (Minneapolis: University Gallery, 1957), unpaginated. On the International Cooperation Administration's outlook on South Korea see *Korea Fact Sheet: Mutual Security in Action* (Washington, D.C.: International Cooperation Administration, 1960).

2. Interestingly, the first significant attempt to mount a historical survey of contemporary Korean art was hosted by a gallery. For some years the only venue where avant-garde forms could be viewed on a fairly regular basis, the Myongdong Gallery hosted two shows, *Abstraction=Situation* (*Chusang=Sanghwang*) and *Plasticity and Anti-Plasticity* (*Johyeong gwa Panjohyeong*). Gallery owner Kim Mun-ho looked to 1957 as the starting point for contemporary art in Korea; it was from this year that Korean artists began to engage with the rest of the world and had a direct consciousness of their own agency. Kim Mun-ho, "Insamal" {Greetings}, in *Chusang=Sanghwang, Johyeong gwa Panjohyeong*, {Abstraction=Situation, Plasticity and Anti-Plasticity} (Seoul: Myongdong Gallery, 1973), unpaginated. Selection of works were made by critics Lee Yil, Yoo Jun-sang, and Yu Kuin-jun.

3. Oh Hein-kuhn, cited in *Elastic Taboos: Within the Korean World of Contemporary Art* (Vienna: Kunsthalle Wien, 2007), 110.

4. The Korean organizers of the show were well aware of this politicization. Addressed to the culture department of the *Kyunghyang* daily newspaper, they sent a letter expressing the committee's hopes that the show might help cultivate "a proper awareness of Korea–Japan artistic and cultural exchange as well as on behalf of Korean residents of Japan." Undated draft, Collection of Yi Ku-yeol, Archives of Korean Art, Yongin, Korea.

5. Lee Se-duk, "Kankoku gendai bijutsu no haikei" {The background of Korean contemporary art}, *Gendai no Me* 165 (August 1968): 2.

6. Each judge was asked to nominate artists from which the final exhibition would be chosen by means of anonymous vote. Lee Se-duk in conversation with Honma Masayoshi in ibid., 3.

7. Arima Hiroaki, "Kankoku bijutsu ni kibakuzai o!" {To throw a bomb into Korean art}, *SD* (September 1968): 105.

8. Ishiko Junzō, "Kaiga no gendaika o tōe: kankoku gendai kaigaten o mite" {Inquiring about the contemporization of painting: on seeing *Contemporary Korean Painting*}, *Sansai* 235 (September 1968): 65.

9. "Ajiateki seikaku wa kireruka" {Can an Asian sensibility arise?}, *Asahi Journal,* August 18, 1968, 47.

10. Kim Chong-hak, "Hanguk hyeondae hoehwa donggyeong jeonsi" {Exhibition of contemporary Korean painting in Tokyo}, *Midae Hakbo* 3 (1969): 53.

11. Lee Yil, "68 nyeondo habangi misulgye" {The art world in the second half of 1968}, *Hongdae Hakbo,* December 15, 1968, 2.

12. Ibid., 2.

13. Ibid., 4.

14. Yoo Young-kuk and Lee Ufan, "Zadan: Kankoku gendai kaiga," *Gendai no Me* 165 (August 1968): 4.

15. Lee Ufan, "Jika dōchaku no bigaku" {The aesthetics of self-contradiction}, *Satō Garō Geppo* 128 (March 1967): 2.

16. Yoo Young-kuk and Lee Ufan, "Zadan: Kankoku gendai kaiga," 4.

17. Nakahara Yusuke, untitled foreword in *Kankoku gendai bijutsu no danmenten* {Korea: A Facet of Contemporary Art} (Tokyo: Central Museum of Art, 1977), unpaginated.

18. Kim Chang-sup, "Uriegeneun urijasinui sunbalryeogi isseo" {We have ourselves our own ability to respond}, *Space* (April 1979): 30.

19. Ellen Psaty Conant, *Contemporary Korean Paintings* (New York: World House Galleries, 1958), unpaginated. Conant was quoted by a Korean daily as stating that the basis of her selection turned on what she discerned as the presence of "Korean specificity." "Neomu ddeodeuljineun malja!" {Let's not make so much fuss!}, *Seoul Sinmun,* August 25, 1957. For a detailed summary of the exhibition's reception in Korea see Choi Youl, *Hanguk hyeondae misului yeoksa 1945–1961 II* {The history of Korean modern art} (Seoul: Youlhwadang, 2006), 502–4; 586–87.

20. Hugo Munsterberg, "In the Galleries: Contemporary Korean Painting," *Arts* 32, no. 6 (March 1958): 59.

21. The artists exhibited in the show were Kim Whanki, Yu Kyoung-chae, Kwon Yong-woo, Byun Chong-ha, Yun Hyongkeun, Park Seobo, Ha Chong Hyun, Lee Ufan, and Sim Mun-sup.

22. Lee Yil, "Hyeondae hanguk hoehwa" {Contemporary Korean painting}, *Secondes Recontres Internationales d'Art Contemporain: Corée 9 Peintures* (Paris: AFAA, 1978).

23. Jeanine Warnod, "Cinq nations confronteés," *Le Figaro,* January 16, 1979.

24. As reported by Kim Seong-u, "Pariseo jumok motggeun hanguk hwagadeul" {Korean artists fail to attract attention in Paris}, *Hankook Ilbo,* February 2, 1979.

25. Sin Yong-suk, "Seogu hyungnaeman naen 'hanguk chulpumjak'" {The 'Korean entrants' that only copy the West}, *Chosun Ilbo,* December 28, 1978.

26. Park Seobo, "Ododanghan jinsil gwa hanguk hyeondae misul ui jucheseong" {Truth perverted and the subjectivity of contemporary Korean art}, *Space* (April 1979): 44–52.

27. Won Dong-suk, "Malsseong gwa byeonmyeong" {Controversy and excuses}, *Bburigipeun namu* (March 1979): 21.

28. Chung Bo-won, "Uri tochangseong pyohyeonui eoryeoun gwaje" {The difficult task of expressing our uniqueness}, ibid., 30.

29. Ibid.

30. Sung Wan-kyung, "Cheoum chamgahan je 3 segyejeonui sunggwa" {The fruits of participating in the "Third World" exhibition for the first time}, *Gyegan Misul* (Fall 1986): 168.

31. Ibid., 169.

32. The National Museum of Contemporary Art was formerly housed in the Sokjojon, the immense Baroque stone building located in Deoksugung Palace in downtown Seoul. Originally built in 1900, it housed the collection of the National Museum of Korea, and from 1973, the National Museum of Contemporary Art. Yi Kyungsung, "Gunglip hyeondae misulgwan ui gwaje" {Tasks for the National Museum of Contemporary Art}, *AG,* no. 2 (1970): 5.

33. Yi Kyungsung, "Insa malsseum" {Salutatory remarks}, *Hanguk hyeondae misului eojewa oneul* {The yesterday and today of contemporary Korean art} (Gwacheon: National Museum of Contemporary Art, 1986), unpaginated.

34. Lee Yil, "Hanguk hyeondae misului eojewa oneul" {The yesterday and today of contemporary Korean art}, *Munhwa Yeosul* (October 1986): 102.

35. Jeung Biongkwan, "Gwacheon gunglip hyeondae misulgwan geagwan ginyeom jeondol" {Commemorative exhibitions of the inauguration of the National Museum of Contemporary Art in Gwacheon}, *Space* (September/October 1986): 311.

36. Shin was later found not guilty by the Seoul District Court in two subsequent trials in 1992 and 1994. For a discussion of this incident, including an interview with the artist, see the special feature "Pyohyeonui jayuwa geomryeol" {Freedom of expression and censorship}, *Misulsegae* 163 (June 1998): 45–55.

37. A show of Minjung woodcuts took place in 1989 at the Social and Public Art Resource Center gallery in Venice, California, as a result of one exhibition organizer who saw the works while curating a show for a conference on world revolutions. Laurie Ochoa, "Exhibit Looks at Oppression in S. Korea," *Los Angeles Times,* November 27, 1988.

38. Museum officials allegedly refused "to confirm the existence of the show, let alone discuss Minjung art." Mark Clifford, "Art for Politics' Sake," *Far Eastern Economic Review,* August 26, 1993, 30.

39. Funded by the New York State Council for the Arts, SEORO, which in Korean could mean "among" or "each other," was founded in 1989 by Park Hye Jung, Bahc Yiso (then known as Mo Bahc), and Sung Ho Choi. Min Yong Soon, e-mail communication with the author, May 23, 2003.

40. Jane Farver, telephone interview with the author, November 11, 2005.

41. Japanese curators, critics, and institutions had long been invested in the idea of a contemporary Asian art; noteworthy initiatives included the Fukuoka Art Museum's series of Asian Art Shows, which later became the Fukuoka Asian Art Triennale. Other projects taking place elsewhere included planning for the 1996 show *Contemporary Art in Asia: Traditions / Tensions.* Planning, which began in 1992, would culminate in a show that would open simultaneously at three venues in New York: the Asia Society, the Grey Art Gallery at New York University, and the Queens Museum of Art. Another example was the inauguration of the Asia Pacific Triennial at the Queensland Art Gallery in Brisbane, Australia, in 1993.

42. Lee Young Chul, "Culture in the Periphery and Identity in Korean Art," in *Across the Pacific: Contemporary Korean and Korean American Art* (Queens, New York: Queens Museum of Art, 1993), 15.

43. Alice Yang, "Looking for the Identity of Korean Art," in *Why Asia? Contemporary Asian and Asian American Art,* eds. Jonathan Hay and Mimi Young (New York and London: New York University Press, 1998), 71. The review was originally published about four months before *Across the Pacific* opened in Seoul in *Wolgan Misool,* Korea's leading visual art magazine. "Migugeseo hanguk misul jeongcheseong chatgi," *Wolgan Misool* (April 1994): 102–7.

44. This was expressed as early as 1975. Kim Yun-su, *Hanguk hyeondae hoehwasa* {A history of Korean modern painting} (Seoul: Hanguk Ilbosa, 1975), 207.

45. Kim Ho Suk, conversation with the author, January 9, 2008.

46. Holland Cotter, "Korean Works Coming to Terms with the West," *New York Times,* December 10, 1993. More positive was the review of Kim Levin, a participant in the panel discussion organized for Lee Young Chul's 1992 show on Minjung art at Artists' Space. See Kim Levin, "Seoul Searching," *Village Voice,* November 2, 1993.

47. Kim Hyun-do, "Minjok gwa sedae ui jeongcheseonge daehayeo taepyeongyangeul geonnuseo jeon" {About national and generational identity: *Across the Pacific*], *Gana Art* 40 (November/December 1994): 59. That the Kumho Group chose to host the show may be attributed to the fact that its owner was from the Jeolla region, an area that had long been a target of prejudice in Korea, and from whence several of the key Minjung artists and critics hailed.

48. *Koreamericakorea* and its decision to exclude Korean adoptees provoked strong criticism from adoptee artists like Kate Hers, who argued that definitions of a Korean American artist were purely left to other people's "convenience." Kate Hers, "Overseas Adopted Koreans, Where Do We Belong?" *Wolgan Misool* (July 2000): 167.

49. Examples include Malaysian Australian photographer and video artist Emil Goh and Chinese American Marc Voge, the other half of Young-hae Chang Heavy Industries.

50. Lee Young Chul, in conversation with Kang Su-mi, "Haessari pieonaneun hyeondae misul 45 nyeon" {Forty-five years of contemporary Korean art on which the sun shines], *Art in Culture* (December 2004): 87.

Lynn Zelevansky

CONTEMPORARY ART FROM KOREA
The Presence of Absence

Your Bright Future: 12 Contemporary Artists from Korea includes the work of twelve South Koreans born between 1957 and 1972. Coming of age amid political turmoil and increased freedoms, they are keenly aware of their position as citizens of a relatively small, increasingly prosperous but divided country in a rapidly globalizing world. By focusing—often humorously—on the ephemeral nature of life, time, and identity, as well as on the limitations of communication across languages, cultures, and generations, they make presence, absence, and change the center of their work.

Your Bright Future (fig. 1) is the title of a sculpture by the artist Bahc Yiso in which ten bright lights, augmented by reflectors and connected by a flimsy wooden structure, face upward, shining on a large white wall. The lights are anthropomorphic, recalling a crowd basking in the glory of a charismatic leader. This might be a positive scenario, or the crowd could be in thrall to an unseen diabolical presence. Similarly double-edged, the title suggests a genuinely hopeful outlook, as well as the clumsy obviousness of North Korean propaganda. It carries with it the ambivalence—and irony—with which many South Koreans seem to view their situation.

Marc Voge, a United States native living in Seoul and a member of the two-person collaborative Young-hae Chang Heavy Industries, routinely asks Westerners visiting South Korea for the first time whether they had a mental image of the country before arriving there. Invariably the answer is "No." The chances are good that the same individuals believe they know what Japan or China looks like, even if they've never been there. At the mention of those places, visual compendiums of traditional artworks, travelogues, movies, and television news reports spring to mind. Korea, in contrast, remains almost invisible to many Europeans and North Americans. This is particularly odd in regard to citizens of Los Angeles, New York, San Francisco, Seattle, and other major cities, who have as neighbors, friends, and coworkers Korean Americans and recent Korean immigrants.

The reception of contemporary Korean art abroad reflects the country's virtual absence from the Western imagination.[3] Over the last decade or more, the contemporary art world's markets and attention have careened from Japan, with its influential "Superflat" aesthetic propounded by artist and entrepreneur Takeshi Murakami, to the wildly burgeoning capitalism of China. While certain Korean artists—Kimsooja, Koo Jeong-A, and Do Ho Suh among them—have achieved widespread recognition, there has been relatively little focus on the small but strong art scene that has developed in South Korea during this period.

In South Korean art, the use of international visual idioms stretches back at least five decades. By the late 1950s, the country had an *Informel* movement; about the same time, members of *Mungnimhoe* (Ink Forest Group) melded traditional Korean ink painting with international forms of abstraction, often in original and unique ways. In the 1960s and 1970s, Korean artists created monochrome works that related to U.S. color field paintings and Minimalist art. Reacting against the formalism of the monochrome, 1980s *Minjung* art (art

Fig. 1. Bahc Yiso, *Your Bright Future*, 2002/2006, electric lamps, wood, and wires, dimensions vary.

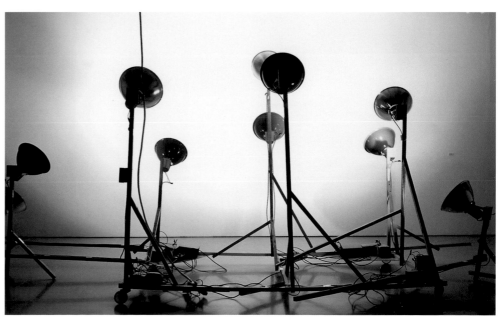

of the masses) was the first socially oriented collective movement in Korean art history. Growing out of the political upheavals of the period, Minjung rebelled against the internationalism of abstract styles, and was purposely local in its aesthetic references.[4] Realist, narrative, and nationalistic in nature, it looked to indigenous traditions such as folk art, Buddhist art, woodcuts, and genre paintings in an effort to define a distinctly Korean art.[5]

Despite these achievements, during the decades following World War II, Korea produced only one world-renowned artist, the pioneer of video art, Nam June Paik. From a wealthy family, Paik was able to study abroad beginning in 1956, a rarity at the time. He became an international figure, residing for most of his life in Germany and the United States. It was decades before a whole generation of Korean artists would have the advantages that Paik enjoyed, and it was only in the late 1980s that there began to develop a critical mass of young Koreans whose work was likely to resonate with the international art audiences for whom *Your Bright Future* is made.[6]

Korea's relatively late arrival on the international art scene can be explained in part by its difficult history. In the twentieth century alone, its people suffered a brutal Japanese occupation that lasted forty years, the division of the country at the 38th parallel, and from 1950 to 1953 the Korean War, which involved the communist and capitalist superpowers. During the conflict, the United States conducted air raids that rained napalm and other weapons of mass destruction on North Korea (anticipating U.S. tactics in Vietnam a decade and a half later). The civilian death toll at the end of the war exceeded two million.[7]

Against all odds, given the devastation and schism in the country, over time an impoverished South Korea transformed itself into an economic powerhouse. The so-called miracle on the Han, which had its heyday during the regime of Park Chung-hee (1961–79),[8] was realized with great ingenuity and very hard work on the part of the Korean people, but political stability proved more difficult to achieve. Park's regime began with a military coup and ended with his murder. Other governments collapsed under the weight of popular rebellions, some of which—like the Gwangju uprising of 1980—were suppressed with extreme violence. Many of the artists included in the exhibition were students during the 1980s, attending university amid potentially violent political protests. Spring 1987 saw mass demonstrations sparked by a government decision to suspend debate on constitutional reform. A broad-based democratic movement had developed, and it forced President Roh Tae-woo to call for direct presidential elections.[9] The Seoul Olympics, held in 1988, which brought many foreigners to Korea and offered the country an important opportunity to display its economic successes, also played a significant role in increasing freedoms there.

In a remarkably short time, South Korea has moved from urgent, subsistence-level problems to existential questions about its identity and lack of visibility in the outside world. The artist Minouk Lim talks about her country's perceived need for a symbol like the Eiffel Tower, the Statue of Liberty, or even Coca-Cola. She believes that the absence of widely recognized cultural icons suggests a lack of social and political stability, an effect of the speed of the country's economic development. Everyone, she says, understands the North American cowboy's regional and social context because of the enormous amount of information disseminated on the subject over decades. Korea has had little time to develop landmarks and icons. In a metaphorical sense, she says, the country is "again under construction."[10]

The 1990s were a time of great change in the South Korean art world, marked by the liberalization of travel restrictions, the presence of important exhibitions, such as the Nam June Paik retrospective (1992), the Whitney Biennial in Gwacheon, near Seoul (1993), the initiation of the Gwangju (1995) and Busan (1998) biennials, and the establishment of the Korean Pavilion at the Venice Biennale (1995). Curator Sunjung Kim wrote that "while the artists of the 1970s struggled to bring formal change in the Korean art world, the artists of the 1980s directly engaged themselves in the social and political movements, which left the binary opposition between tradition and modern reformation, between purism and realism."[11] The artists of the 1990s melded formal innovation with social, political, and philosophical content.

Bahc Yiso[12] anticipated many of the concerns that would occupy South Korean artists a decade later. Born in Seoul in 1957 as Cheol-ho Park, he moved to the United States in 1982, earning a master of fine arts degree at Pratt Institute in Brooklyn, New York. In the 1980s, debates about multiculturalism—the impact of race and gender on equal representation— raged in U.S. intellectual and artistic circles. This emotional and sometimes confrontational discourse greatly impacted academia and the arts. Multiculturalism had its origin in the 1960s

in the civil rights movement and other identity-based movements involving women and minorities. In the 1980s, these concerns took on new urgency, aligned with postcolonialism, which considered the massive movement of peoples brought on by rapidly globalizing economies; the formation of diasporas of various kinds, often the result of ethnic conflict; and the condition of postcolonial subjects, among them intellectuals and artists.

Fig. 2. Bahc Yiso, preparatory drawing for *Untitled (Drift)*, 2000, pencil and pen on paper, 9⅞ × 13¾ inches (22.8 × 35 cm), collection of the estate of the artist.

Multiculturalism and postcolonialism met in the person of Park, who in the United States identified with ethnic minorities, the poor and disenfranchised. He founded, and from 1985 to 1989 ran, an alternative art space, in the Greenpoint section of Brooklyn, called Minor Injury, the name itself a play on the notion of "minority." Minor Injury presented "theme-oriented shows within the categories of political, racial, and cultural minority issues and contemporary third world art."[13] He worked there with Sam Binkley, now a sociologist, who recalls that Bahc was "beset by a sense of displacement."[14]

In Brooklyn, Cheol-ho Park changed his name to Mo Bahc (putting his family name last in the Western mode).[15] "Mo" in Korean means "anonymity," and Bahc is an unusual transliteration of the name Park, which in Korean has no "r" sound. The scholar Lee Young Chul has suggested that this was an attempt to discard the self and overcome ego,[16] an interpretation supported by Bahc's impoverished lifestyle. He often fasted and went without heat and hot water even in the coldest part of the winter.[17] Binkley saw Bahc as "a modern day desert ascetic striving to access the divine through relentless purification of the body."[18]

Fig. 3. Bahc Yiso, *Untitled (Drift)*, 2000, view of Gulf of Mexico right after launching the bottle, C-print, 7½ × 4⅞ inches (17.8 × 10.1 cm), collection of the estate of the artist.

In English, Mo is a man's nickname—usually spelled Moe, short for Morris—so Bahc's new name involved a double entendre of sorts, one of which few New York art-world denizens would have been aware. Renaming himself was an artwork in itself, sharing elements vital to the installations, objects, and drawings that he created throughout his career: humor, spiritual quest, the deepest sense of displacement (from personal identity), and unremitting doubt about the possibility of communicating across linguistic and cultural barriers.

During his ten years as an artist in the United States, Bahc fused his Korean and North American experiences in works focusing on issues of identity. In *Homo Identropus* (1994), one of his many paintings on paper that mix references to U.S. daily life with traditional Korean motifs, a Buddha sits behind the net atop a Ping-Pong table that is supported by human legs. A recording of Bahc singing Billy Joel's "Honesty" in Korean is titled *Don't Look Back / Honesty,* referring to Bob Dylan's famous early album of the same name, as well as to Joel's song.[19] A cement boat, an emphatically unviable craft, which is called simply *Don't Look Back,* may be an ironic reference to his impending return to Korea. It was wholly consistent with his practice that he prepared for that return by marinating a baseball bat in soy sauce (*Untitled,* 1994).

Life in Korea freed him of the burden of dealing with U.S. multicultural politics. Upon his return, he changed his name from Mo Bahc to Bahc Yiso, reverting to the East Asian practice of putting the family name first, discarding anonymity, and reinforcing his ascetic inclinations: Yiso means "very simple." His work became more ethereal and abstract, less rooted in mundane existence. The sculpture *Something for Nothing* (1998) (see pages 76–77) comprises a bench with a large, empty, circular metal tray on one end and an identical tray filled with a mountainlike form on the other. The work begs certain questions: Is the abstract mountain shape the "something" referred to in the title? Is it somehow more valuable or present than the apparent emptiness of the tray sitting opposite it? What was lost or gained in the trade of something for nothing? Bahc's installation *Untitled* (1998) (see page 75) includes large electric fans, embodiments of his notion of wind, the element that he believed was "the fundamental base and energy for creativity."[20] For the performance *Untitled (Drift)* (2000) (figs. 2 and 3), Bahc launched a plastic bottle, with a GPS device inside, into the Gulf of Mexico with the idea that he would maintain contact with it

for as long as possible (it didn't work for long). There is a poignant, childlike impossibility and fragility to the work.

Bahc's final piece, realized only after his untimely death in 2004, is *We Are Happy* (see page 74), an enormous billboard with these words printed in white Korean script against a bright orange background. The scholar Jung Hunyee has linked the work to a propaganda image from North Korea, but it isn't necessary to understand that connection to appreciate the resonant ambiguity of the piece.[21] On its own, in the simplest and most direct way, *We Are Happy* generates doubt about what happiness is, and who is experiencing it.

It is significant that, like Bahc Yiso, all but one of the artists in *Your Bright Future* have studied

Fig. 4. Do Ho Suh, *Who Am We?*, 2000, four-color offset print on paper, dimensions vary, each sheet 24 × 36 inches (61 × 91.4 cm), Arthur M. Sackler Gallery, Smithsonian Institution, Washington, D.C.

and lived abroad; today, some reside most of the time in cities in the United States or Europe, spending extended periods in Korea when they can; they all travel frequently for exhibitions and residencies in other countries. Thus, issues of communication are tied to their experience as perpetual foreigners, and they are intimately aware of the limitations of translation. Do Ho Suh, who today maintains active studios in New York and Seoul, expressed this concern in *Who Am We?* (2000) (fig. 4), wallpaper composed of thousands of tiny high-school graduation

photos, which alludes to the collective nature of Korean society, in which the first-person singular is used much less frequently than in European cultures.

Suh, the son of the renowned artist Suh Se-ok, elected to study "Oriental" art at Seoul National University because he saw it as a rare opportunity not easily available outside Korea. (In his class, there were sixty painting majors; only ten chose to study "Oriental"—as opposed to Western—painting.)[22] In the United States, he attended the Rhode Island School of Design and Yale University, where he met the Thai artist Rirkrit Tiravanija. Tiravanija opened doors for him in New York; it was the beginning of a successful international career.

In 1994, Suh began making "fabric architecture," using filmy materials such as silk and nylon to create full-sized renditions of his traditional Korean childhood home and his adult New York apartment (fig. 5). Transparent or translucent, these fabric pieces meld inside and outside, personal and public, past and present, making seeming opposites inseparable. Ghostly and fragile, they evoke home, homesickness, and the sense of loss that is intrinsic to memory. With these often large installations, Suh contrasts the formal languages of Eastern

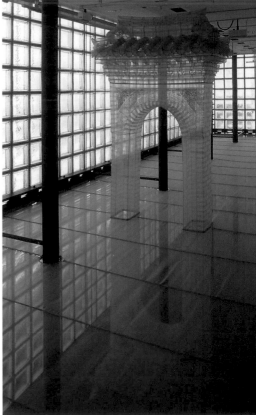

Fig. 5. Do Ho Suh, *Reflection*, 2004, nylon and stainless steel tube, dimensions vary, collection of Centro de Arte Contemporânea Inhotim, Mina Girais, Brazil.

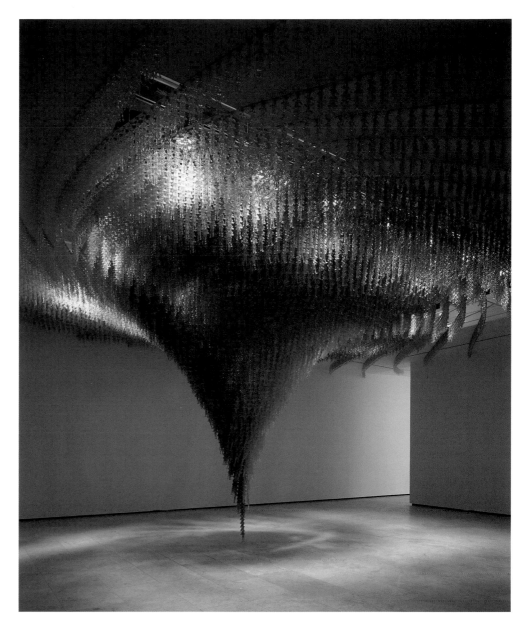

Fig. 6. Do Ho Suh, *Cause & Effect,* 2007, acrylic and stainless steel and aluminum frame, 142⅝ × 400 × 460 inches (362.9 × 1016 × 1168.4 cm).

and Western architecture, reflective of different social structures.

Recently Suh showed *Cause & Effect* (2007) (fig. 6), a site-specific installation in which thousands of small plastic figures, all male and most brightly colored, sit on each other's shoulders, forming long strips of humanity. When they are clustered together and hung from the ceiling to create a funnel-like shape that culminates in one standing figure, the effect is of a sunlit tornado. The linear buildup of elements and the twists and turns of the piece as a whole suggest a DNA double helix, an interpretation supported by the one figure whose feet touch the ground. He seems to carry the burden of a very long line of ancestors on his shoulders. Could this

be Suh's meditation on his own situation as the eldest son of an illustrious family? Is this an expression of the debt owed to his lineage? Or perhaps alone this figure is of no particular consequence. It is the collective power of all of the figures together that creates a whirlwind.

Like Suh, Haegue Yang "occupies the in-between spaces where cultures collide {and} where private and public meet."[23] In 2000 Yang created *Blue Meadow—Colored Language,* which includes fifteen short texts in white projected on backgrounds of different hues. The work uses color as a means of illuminating the obstacles to translation across cultural lines. Yang is aware that the Korean expression "blue meadow" is odd for Westerners, for whom meadows are emphatically green. In one of the work's projections, she explains that, in Korean, the color blue has positive connotations that imbue the notion of a meadow with "feelings

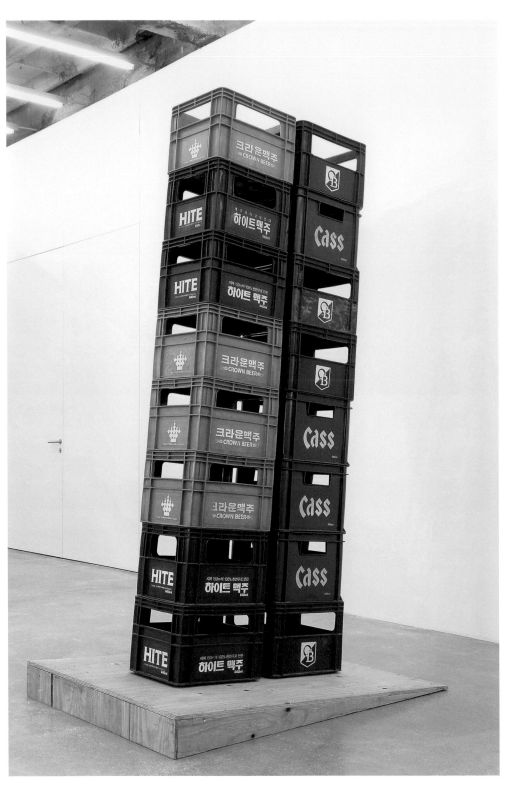

such as excitement and admiration."[24] This is in contrast to English, in which blue can be a metaphor for sadness, as in the expression "feeling blue," or for quantity and speed, as in "talking a blue streak."

Having studied in Frankfurt in the late 1990s, Yang remained in that city, working at odd jobs through the Korean financial crisis of 1997–98, and participating in residencies in various cities, before moving to Berlin in 2004.[25] She imports references to daily life in Korea into the European art context, paying tribute to details that are so familiar and banal that they are only subliminally recognized, and instilling them with new social significance. *Tilting on a Plane* (2002) (fig. 7) comprises two six-foot-tall towers made of stacked crates for Korean commercial beverages. The towers are situated on a carefully constructed wedge-shaped block of wood so that they lean precariously to one side. In Korea, refuse is often piled on the street in this way. There is tension—and humor—in the relationship between *Tilting on a Plane*'s conceptual origin and the successful formal sculpture it has become.

Storage Piece (2003/2009) (see pages 170–71), another cross between assemblage and Minimalism, with meanings well beyond the formalism that the latter implies, is composed of crated and wrapped works by the artist. Unsold, they were returned to her after an exhibition; she had a show coming up and, with no space to store her old pieces, she decided to exhibit them wrapped. The viewer is confronted with stacked plastic beverage crates, wooden crates, cardboard boxes, and packages covered in bubble wrap, all piled on wooden palettes as if ready for shipment. Like *Tilting on a Plane,* this is a visual, physical, and conceptual pun, and it is amusing, but there also is a genuine complaint embedded in the work. Artists have an ongoing problem with the accumulation of work, which they frequently can't afford to store, and which too often takes over their studios, a constant reminder of the failure to sell. Yang's gesture was meant to call attention to the disconnect between the public's expectation for artistic expression and her self-consciously absurd solution to a private storage problem. The two, she thought, would remain "non-negotiable and irreconcilable." As the artist herself noted, the work's purchase by a private collector injected a note of self-critique into the project, turning an ironic commentary on the gallery system into a saleable commodity.[26]

Autobiography plays a role in virtually all of Yang's work. She believes that emotional, "private sentiments of aloneness and vulnerability"

Fig. 7. Haegue Yang, *Tilting on a Plane*, 2002, 16 plastic crates, each 35⅜ × 47¼ × 5⅛ inches (90 × 120 × 13 cm), plywood wedge, total height 90⅝ inches (230 cm), later part of *Storage Piece*, 2003/2009, The Haubrok Collection, Berlin, Germany, 2007.

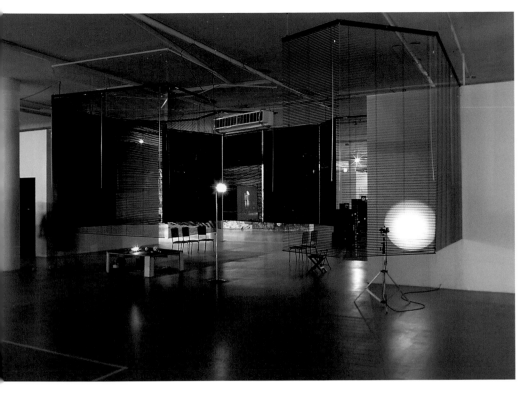

Fig. 8. Haegue Yang, *Series of Vulnerable Arrangements—Blind Room,* 2006, black aluminum Venetian blinds, a humidifier, infrared heater, wind machine, scent dispensers, and three video essays (*Trilogy,* 2004–6), collection Walker Art Center, Minneapolis, T.B. Walker Acquisition Fund, 2007.

provide an avenue into her art, a kind of participatory element that promotes viewer involvement, which in turn allows her to express sentiment without forfeiting the work's oblique but essential political meaning.[27] Yang also attempts to engage beholders by provoking sensory and kinetic responses. *Series of Vulnerable Arrangements—Blind Room* (2006) (fig. 8) is a constantly changing architectural installation (Yang purchases the components of *Blind Room* in each city in which it is installed, so it is never the same) that incorporates found furniture and other objects common to her work with video, heat sensors, humidifiers, electric fans, lights, scent atomizers, and sound.

Like Yang, Jooyeon Park has consistently attended to things glimpsed on the periphery of everyday experience, impermanent traces of human existence, that which is hidden or ephemeral. She has focused her attention on benches, mats, and *pyeongsang,* low wooden tables that Koreans use as seats; vacant, they signify absence as much as presence. (Yang's *Social Conditions of Sitting Tables* {2001} also focuses on *pyeongsang* {fig. 9}.)

Park's work uses performance, video, film, photography, found objects, and sculpture, as well as written words (fig. 10). In 2002–4 she produced an untitled image of an intersection

in Seoul in which all signage has been erased (see page 153). In its place are blank, colored billboards. It is a bleak and a beautiful vision. There are no signposts to orient visitors, an ideal situation in which to lose one's way, but the beauty of the colorful constructivist composition, revealed with the disappearance of words, compensates for any discomfort the image may elicit.

Park, born in 1972, is the youngest of the artists represented in the exhibition. She was educated, from secondary school on, in London, an experience that instilled a deep-seated belief in the inadequacy of language as a communication system.[28] She has said that her involvement in the limitations of verbal language arose "more {from} a concern than an interest, originating from everyday frustrations and insecurities. In time, I guess I started to accept the situation for what it was and saw it as an opportunity to explore in-between languages."[29] In 2005, while she was in Japan on a residency, Park confronted this problem in a video of two little girls chattering intimately to each other as they play on swings in a neighborhood playground. The artist, who does not speak Japanese,

Fig. 9. Haegue Yang, *Social Conditions of Sitting Tables,* 2001, nine colored photographs, each 11⅝ × 15¾ inches (30.5 × 40.5 cm), with text, collection Galerie für Zeitgenössische Kunst, Leipzig, Germany.

Fig. 10. Jooyeon Park, *Dragonfly,* 2004, bench and video projection, 3:00 min. loop, dimensions variable, collection of the artist.

Fig. 11. Jooyeon Park, *Full Moon Wish,* 2006, performance, drawing, projection, and curtain.

phonetically transliterated their conversation in subtitles. The nonsensical captions, which replicate the meaningless sound of Japanese to an untutored Korean ear, are a humorous expression of alienation.[30]

Park has been inspired by the expatriate Irish playwright, Samuel Beckett, among the most difficult of writers, who made the issue of translation intrinsic to his artistic process by writing first in French and then translating his scripts into his native English. Park's 2006 exhibition *Full Moon Wish* (fig. 11) was centered on a pro-

duction of Beckett's famous *Waiting for Godot.* The gallery installation acted as a set for the play, mounted by a group of Irish actors living in Seoul. (The very notion of Irish actors performing Beckett in Seoul for a Korean audience is daunting.) The exhibition included a variety of works: drawings made with soap bubbles mixed with ink, and the all-but-incomprehensible lines, spoken by Beckett's character "Lucky," written directly on the wall. Also included was *MONOLOGUE monologue* (see pages 150–51), Park's video in which three Irish actors, who support themselves teaching English in Seoul, describe the landscapes of their home counties. Pictured on the screen are three of their Korean students lip-synching their monologues.

Misunderstanding can function as a catalyst that makes understanding and interpretation possible. The total lack of understanding, however, is a different matter. In *Literal Reality* (2004) (fig. 12), in Seoul, the artist Gimhongsok exploited a lack of understanding to both camouflage and dilute a message. He wrote Vietnamese obscenities in giant, yellow, three-dimensional letters set against a purple background. The words "vó'v'ân" and "IMDI" mean "You son of a bitch" and "Shut the fuck up," respectively. The Vietnamese language, however, is largely unknown in Korea, so his audience, confronted with this visually arresting if incomprehensible display, was unaware of what some might have considered an attack.

Gim (who attended the famed Düsseldorf Academy) addresses South Korea's place in a world controlled by major powers in his video projection *G5* (2004) (figs. 13 and 14), which includes five Koreans (only two of whom are professional vocalists), each singing a heartfelt rendition of the national anthem of one of the G5 (Group of Five) countries (the United States, the United Kingdom, France, Japan, and Germany) in Korean. The discordance of hearing familiar, patriotic tunes sung with great passion in a language so foreign to the anthems' original ones is amusing, but the question arises whether the Korean singers are somehow in thrall to the powerful nations whose songs they sing. Ultimately, repetition seems to rob the songs of their nationalistic associations, the way saying a word over and over divests it of meaning.

Gim's recent video, *The Wild Korea* (2005) (see page 95), is a fiction done in documentary style that reflects the artist's experiences growing up watching Hollywood Westerns broadcast by the U.S. Army, and then attending college in Seoul in the 1980s, when student strikes and political actions were commonplace. It posits that, for a few months in 1997, the government of South

Fig. 12. Gimhongsok, *Literal Reality,* 2004, wall paint, polyester resin, and urethane, dimensions vary, collection of the artist.

Fig. 13a, b. Gimhongsok, *G5* (*Japan* and *USA*), 2004, two
single-channel videos from 16mm originals, 17:14 min. loop,
collection of the National Museum of Contemporary Art,
Seoul.

Korea, in an effort to express its belief in individual freedom (U.S. style), made guns legal. The results of this act were so chaotic and shameful that a cover-up ensued. The film claims that the period has never been discussed publicly, and that the many citizens who were injured by guns during this time were never compensated by the government.

The Wild Korea la a black comedy that depicts a world in which murder may be the response to poor service in a restaurant. It centers on an interview with a young man who tells of how he initially couldn't wait to purchase a Beretta but then found himself kidnapped and persecuted for having a red face. Eventually his face turns blue. The colors suggest the ongoing conflict between North and South Korea, as well as the U.S. role in that conflict. Gim has said, "*Wild Korea* does not only pertain to the Korean situation. It is about the contradictions of binary thinking in the West and its influence in the East."[31]

South Koreans may reflect on the situation that Gim explores with humor or with bitterness toward the United States. Of all of the art in the exhibition, Jeon Joonho's is the most didactically political. He believes that U.S. long-term intervention in Korean internal affairs has caused poverty, social unrest, and other social ills; his work is meant to assert Korean national identity in the face of U.S. power. His computer animation *In God We Trust* (2004) (see page 104) shows the artist inhabiting the illustration on the back of a U.S. two-dollar bill. In traditional Korean garb, he recites the Korean declaration of independence, lecturing to a seated Thomas Jefferson. There is something playful and charming about this and similar works, with their Alice-in-Wonderland-like miniature worlds through which the artist travels, but Jeon is quite serious about their intent. In *The White House* (2005–6) (fig. 14), a small figure uses a paint roller to slowly paint out the windows and doors on the presidential residence as it is depicted on the back of a twenty-dollar bill. Jeon turns the White House, meant to be open to its people, into a bunker, an act easily read as a commentary on the Bush administration's mania for secrecy.

The artist is far gentler on his own government, which he sees as immature in its value system but not corrupt and unscrupulous in the same way. In *Booyoo Hada (Drift / Wealth)* (2003), he wanders through the classic Korean temple architecture illustrated on the country's paper currency, the *won*. In Korean, *Booyoo Hada* means both "drift" and "wealth." He sees himself "drifting inside the won bill" and "illuminat{ing} the weariness of modern life."[32]

In Jeon's 2007 five-channel animated video presentation, *HyperRealism,* depictions of U.S. Army General Douglas MacArthur (who was in charge of the United Nations Command forces that defended South Korea against the North in 1950–51)[33] share space with images of Korean women weeping and a group of North Koreans seeking asylum by trying (and failing) to scale the walls of a South Korean school in Beijing. "Hyperreality" is a term coined by the French sociologist Jean Baudrillard to signify the erosion of the distinction between reality

Fig. 14. Jeon Joonho, *The White House,* 2005–6, digital animation, 32:16 min., collection of the National Museum of Fine Arts, Taiwan.

and imagination brought on by an excess of mass communication.[34] Accordingly, in an animation that uses a famous sculpture from a Korean War memorial of brothers on opposite sides of the conflict, who meet on the battlefield and fall into each other's arms, the brothers have multiplied in number, and come to resemble plastic action figures. Jeon describes "endless numbers of . . . brothers wander{ing} around the infinite white space {who} are never able to embrace each other. It seems that they have lost the object of their overwhelming emotions and found only the void."[35] (see pages 106–7) Interestingly, the animation based on a monumental statue of the founder of the North Korean state, Kim Il Sung, is titled *Alpram, the Absolute Command* (2007). Alpram is a treatment

Fig. 15. Kimsooja, *Cities on the Move: 2727 Kilometers Bottari Truck, Korea*, 1997, single-channel video projection, 7:03 min. loop, Sammlung Hoffmann, Berlin.

for panic disorder, suggesting that the leader was either a palliative for the anxiety suffered by his people or the cause of the affliction.

Kimsooja is Jeon's opposite in subject and tone, focusing on the spirit of the individual, and promoting the potential for a kind of universal kinship. She is best known for videos of performances that she conceptualizes, produces, and directs, and in which she acts. Like Bahc Yiso, she has been a pioneer, one of the first of a generation of Korean women artists to make her career abroad. She studied Western painting at Hongik University, one of the most advanced art schools in Korea at the time, but never felt part of what she terms "the system." She participated in a few group shows while living in Seoul (including *Ten Contemporary Korean Women Artists* {1991}, organized by the Seoul Arts Center, which traveled to the National Museum of Women in the Arts

in Washington, D.C.), but did not believe the environment there would allow her to realize her artistic potential.[36] In 1992, a residency at P.S.1 in New York led to the inclusion of her work in numerous international exhibitions. When she was able to get a visa, she moved to New York with her son.

Although Kim had no direct experience of feminist art in Korea, her work has probed identity in a manner that has affinities with that 1970s movement. *Bottari,* bundles made of the traditional Korean textiles that figured prominently in her work in the 1990s, have reverberations back to her childhood (fig. 15). Her imagery draws upon her experience making bedcovers with her mother—women's work. The colorful silk linens were placed in a white frame, like a painting, to be resewn each time they were washed. It was exhilarating for the artist when the needle pierced the fabric; she saw it as a means of questioning the nature of surface; the horizontal and vertical structure of the patterns, the fact that they engaged the richly symbolic site of the bed, suggested the human condition. In her work, the notion of the needle continues to be important because, as a metaphor, it embodies not just the feminine but both genders—its opening receives the thread, while its pointed shaft enters the fabric.

Fig. 16. Kimsooja, *A Laundry Woman—Yamuna River, India,* 2000, single-channel video projection, 10:30 min. loop, collection of Helge and Dorothee Achenbach, Düsseldorf, Germany.

In more recent years, Kim has taken on the role of *A Needle Woman* (1999–2001; 2005) (see pages 124–25), an unidentified figure, her back to the camera, who penetrates the world by remaining still. In Delhi, Lagos, Tokyo, London, and other teeming urban environments, she stands on streets bustling with humanity like a smooth rock in a rushing river that alters the flow. She is a constant, a static marker in an ever-changing situation. She has also been *A Beggar Woman* (2001), *A Homeless Woman* (2001), and *A Laundry Woman—Yamuna River, India* (2000) (fig. 16), standing at the Yamuna River in Delhi, always seen from the back. In most of

these works, the passersby, who respond to, ignore, or avoid her, play a major role.

There is a softness and delicacy to Kim's works that belies the enormous mental discipline and physical endurance required to produce them. This is particularly true of the videos in which she stands still. She has learned to keep her eyes open without making contact with anyone around her; she remains focused on what she terms "the central point of my eye level," which allows her to maintain her balance. She keeps her mind centered by concentrating on breathing from her stomach so that her shoulders do not move. She orders different parts of her body to relax sequentially to promote circulation. This practice insulates her from external noises and tensions and, she says, allows her to feel peace and love for the oceans of humanity that surge toward her. After half an hour her feet are numb, she gets a headache, and has to stop. Kim does not consider her work a meditation, rather she thinks "every moment of our daily life is {a} moment of meditation."[37]

Like Kimsooja, Koo Jeong-A creates works that are delicate and materially elusive, concealing the physical and psychic effort behind them. In Koo's case, that effort can become almost obsessive. *Mountain Fundamental* (1997/2009) (see page 136) is a tiny landscape made of stones that have been sanded into a fine powder.[38] *R* (2005) (see pages 132–35) comprises no less than 1,001 small drawings, making reference to the tale of *The 1001 Arabian Nights,* in which a young woman, Scheherazade, doomed to execution, saves her life by entrancing her husband, the king, with a tale; he repeatedly postpones the killing in the hope of hearing the end the following evening.

Koo fled Seoul in the early 1990s, resisting the politics and geographical isolation that prevailed at the time. She attended Paris's École Nationale Supérieure des Beaux-Arts, found Paris comfortable, and lived there for years. Today, although she has apartments in Berlin and London, her biography states that she "lives and works everywhere," a practice that she hopes to sustain.

Like Yang and Park, Koo is concerned with easily overlooked objects and situations, frequently photographing mundane environments; creating drawings that are so minimal in their physicality that they become elusive; and installing tiny sculptures high on a wall or down in a corner. She has said, "For me a work fails if you see its intention . . . when . . . the idea behind it is revealed within it."[39] When she needs a title, she has been known to invent words. "Ousss" is one, akin to the nonsense word "Dada." (The connection to that earlier movement is salient. Koo's work is playful and cryptic in the manner of the Dadaists.)

Although she doesn't think of her work as site-specific, Koo relates strongly to the environments in which she exhibits. In Aspen, Colorado, for example, she presented a snowman, rendering the most impermanent of materials in classical marble (fig. 17). Acupuncture needles protrude from the snowman's head: East meets West.[40] Koo's repertoire of materials ranges from marble to disposable substances, such as sugar, salt, or mothballs, always chosen for their physical rather than conceptual properties: sugar, for example, is "shiny, white, clean."[41] There is humor and paradox in much of her work. She created a book called *OUSSSGOOD* that is bound on all sides so that it is impossible to see the drawings within it. (Not one to deny her audience pleasure, she then showed the drawings separately {see page 137}.)

Kim Beom's provocative video works and small objects also share the cryptic humor and found-object sensibility of Dada. One of his pieces, *An Iron in the Form of a Radio, a Kettle in the Form of an Iron, and a Radio in the Form of a Kettle* (2002) (see page 114), is composed of three objects that sit on a single shelf. It is exactly what its title proclaims it to be.

Between 1989 and 1997, Kim lived in and around New York City. He attended the School of Visual Arts, earning a master's degree and enjoying the school's open-minded environment and the companionship of friends (including Do Ho Suh, whom he had known in Korea, and met again in New York).[42] Most important to him was the understanding he gained regarding the intellectual and personal difficulties involved in art making—that they exist everywhere and are not confined to Korea. Like many of the artists represented here, he returned to Seoul because that is where his roots were.[43]

Characteristically, his installations, which may mix sculptural objects, videos, and small ink drawings, tend to be intimate, with pointed references to domestic spaces. Videos appear on old-fashioned household monitors that sit on plain tables, their wires exposed. For one such work, *Untitled (News)* (2002) (see page 115), Kim engaged in the painstaking process of editing together numerous television news broadcasts in clips short enough to alter what the reporters were saying. The anchors are always the same, although their outfits change with each cut. Instead of reporting on the events of the day, these familiar figures spout statements that vacillate between the inane and the poignant. For

Fig. 17. Koo Jeong-A, *Snowmass*, 2007, marble sculpture with 14 acupuncture needles, 20 × 20 × 30 inches (50.8 × 50.8 × 76.2 cm), private collection, France.

example, "Probably, even now, various kinds of things are happening incessantly somewhere" expresses a desire for communication at the same time as the video, as a whole, questions its plausibility. *Untitled (News)* calls attention not just to the fact that electronic media is malleable, it also asks what these Barbie and Ken doll look-alikes, these cookie-cutter figures who change only slightly from one country to another and are ubiquitous internationally, ever really tell us. Are their actual words sub-

stantially more enlightening than the ones that Kim has put in their mouths?

Like Kim's *Untitled (News)*, Minouk Lim's three-channel DVD projection *Wrong Question* (2006) (see pages 142–43) serves as a reminder that difficulties in communication also occur at home, the result in this case of class and generational differences. Lim records an anonymous taxi driver moving through a rainy Seoul night. In heroic terms, he tells the story of how strongmen Rhee Syngman and Park Chung-hee saved South Korea. He doesn't understand the progressive elements in South Korean society, conflating democracy and communism: "Those worthless democrats are

ruining us," he says. "Why can't they see the ridiculousness of North Korea's system?" Lim says it is a monologue you could hear in many taxis in Seoul.[44] On the adjacent screen is a fuzzy image of Lim's little daughter, who says she dreams of her mother staying home. Her grandfather instructs her instead to say, "I'll be a great painter like Mom." "What's a painter?" the child asks. Lim's husband is a Frenchman whom she met when she lived in Paris. He is also the child's father. Questioned by her grandfather about her nationality, the little girl replies:

Fig. 18. Minouk Lim, *New Town Ghost,* 2005, video installation, 10:19 min.

"I'm Korean and French . . . and American." Her grandfather corrects her again: "No . . . you're half and half; half Korean and half French." The two seem to be participating in different conversations, the products of radically divergent life experiences.

In her previous video installation, *New Town Ghost* (2005) (fig. 18), Lim had explored a similar divergence—in this instance, between memories of the past and experiences of the present in towns undergoing rapid development.

Based in Seoul, Young-hae Chang Heavy Industries (YHCHI) is a collaborative of two artists who identify themselves as a "multinational conglomerate." The C.E.O. is Young-hae Chang, a conceptual artist, and the C.I.O. is Marc Voge, a writer of Chinese descent, born in the United States. The two met in France (Marc Voge is the pen name the artist adopted there). The French art and literary scenes proved inhospitable, and in 1998 they returned to Seoul. Self-defined as Web artists, they have never had a commercial gallery; they feel estranged from the Korean art world and maintain that their work could be created anywhere.[45]

They became involved with the Internet in 1999 when a Korean curator working in Tokyo forwarded a prospectus from Multimedia Art Asia Pacific in Brisbane, Australia, offering residencies to four artists along with $10,000 worth of software. They wrote a proposal and were accepted. Never interested in the technological aspects of the Internet, the two learned everything they needed to know about Flash animation in one day and ignored the rest of the materials. Their goal, they say, was to make work as entertaining as television and to do it quickly. That same year, and again in 2000, they won Webby awards for media art, given by the San Francisco Museum of Modern Art.

Their works combine text with music in animations that employ no images and little color, only written language—Korean, English, French, German—depending on the location of the institution commissioning their work. Everything is in Monaco font. Their words come at the audience with great rapidity, aided by jazz, blues, or other musical forms, pulsing in the mode of television advertising, insistent like commercial signage. The subject matter is often irreverent and politically pointed, especially in the South Korean context in which they work. One of their best-known pieces, *CUNNILINGUS IN NORTH KOREA* (2003) (see page 182), for example, is outrageous in the way it treats the division between North and South—an unending source of controversy and unhappiness in the country—as well as the critique it offers of South Korean mores. It purports to be a message from North Korean leader Kim Jong Il, who celebrates female sexuality in his country, where women have multiple ecstatic orgasms, which he claims are possible only because of the social and political equality of men and women. In the animation, the dictator claims that South Korean women cannot enjoy this kind of sexuality because they are saddled with bourgeois sexual inhibitions. This is a triumph of North Korean communism.

Today, YHCHI's basic format remains what it was from the beginning, but the soundtracks for their works are original rather than found, as they were earlier; the stories are often more involved, and the animation is somewhat calmer. Along with works for the Web, they create installation projections. Recently, at the New Museum in New York, they presented a seven-channel video work titled *BLACK ON WHITE, GRAY ASCENDING* (2007) (see pages 180–81), which tells the story of a political abduction and assassination from seven different

Fig. 19. Choi Jeong-Hwa, *Anybody, Any Thing, Any Way,* 2004, street banners, ephemeral installation at Art Center Arko, Seoul.

viewpoints, including that of a cat. The video on each channel is over eleven minutes long, so, given the gallery setting, a linear reading of the piece is virtually impossible; it is meant to be experienced in fragments.

Choi Jeong-Hwa uses the language of advertising in his work, but in a very different way than Young-hae Chang Heavy Industries. Arguably, his sensibility is more local. His banner projects (figs. 19 and 20), for example, are made from many unused vertically hanging advertising banners of the sort that festoon the sides of buildings in cities all over Korea.[16] Sunjung Kim credits Choi as being one of two artists who, in the 1990s, activated change in the Korean art world from the inside. The other was Bahc Yiso. The two of them, she says, acted "not only {as} artists, but also {as} thinkers and philosophers." They were role models at a time when cultural theory of various kinds was flooding into the country from other places. Choi and

Fig. 20. Choi Jeong-Hwa, *Anybody, Any Thing, Any Way,* 2005, street banners, ephemeral installation at Kunsthal, Charlottenborg, Copenhagen, Denmark.

Bahc responded by proposing distinctly Korean interpretations of, and contributions to, the discourses occupying international contemporary art.[47]

The only one of the artists represented in the exhibition who has not studied or lived abroad (although he has traveled extensively), Choi proudly proclaims that he was "made in Korea." Trained in Western painting at Hongik University, he rejected this formal education, founding Gasum, a studio that melds practices in art, architecture, and design, although he was not trained in the latter two disciplines. He is renowned in Seoul as the father of Korean Pop Art, and popular culture is a constant theme in his work. He has created chandeliers out of the plastic handbags that little girls covet (fig. 21), and at the 2005 Venice Biennale, he produced a stunningly beautiful architectural space on the roof of the Korean Pavilion made entirely of red plastic take-out containers imported from Korea (see page 87). The inspiration for his huge garlands of plastic flowers that slowly move up and down, appearing to breathe, is the enormous variety of Asian toys found in the markets and shops of Seoul and other cities in East Asia (see page 84).

The other artists represented here may have been educated abroad, but they are no less Korean than Choi, and the specificity of their experience remains crucial to what they create. This was no less true of the most famous Korean artist, Nam June Paik. Scholar Yongwoo Lee called Paik "an Eastern spirit who create{d} with a Western touch, and a Western thinker who manifest{ed} glimmers of Eastern reasoning." Lee posits that, in Paik's work, "there is no opposition between Western art and the artist's Taoist ideas, Confucianist background, and Oriental sensibility." He then asks whether ideology is not far more important than nationality in shaping an artist's work.[48] Ideologically, Paik was an internationalist, experimental, and antibourgeois. He was world-renowned as a member of Fluxus, the intercontinental art movement of the 1960s that specialized in mixed-media works and ephemeral actions or happenings geared to upset conventional notions of daily life and art. Most famous for a collaboration with cellist Charlotte Moorman, *TV Bra for Living Sculpture* (1969) (fig. 22), in which Moorman played her instrument wearing little more than a bra fashioned from tiny televisions,[49] Paik appears to be squarely within the tradition of the Western modernist avant-garde (a phrase that should be a contradiction in terms—the avant-garde is by definition defiant of tradition—but no longer seems so). This does not mean, however, that environmental circumstances are insignificant to the understanding of his work.

Fig. 21. Choi Jeong-Hwa, *Believe It or Not* (detail), 2006, installation view at the Ilmin Museum of Art, Seoul.

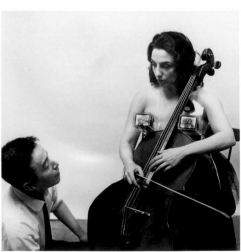

Fig. 22. Nam June Paik, *TV Bra for Living Sculpture*, 1969. Photo by Peter Moore © The Estate of Peter Moore / VAGA, New York, NY.

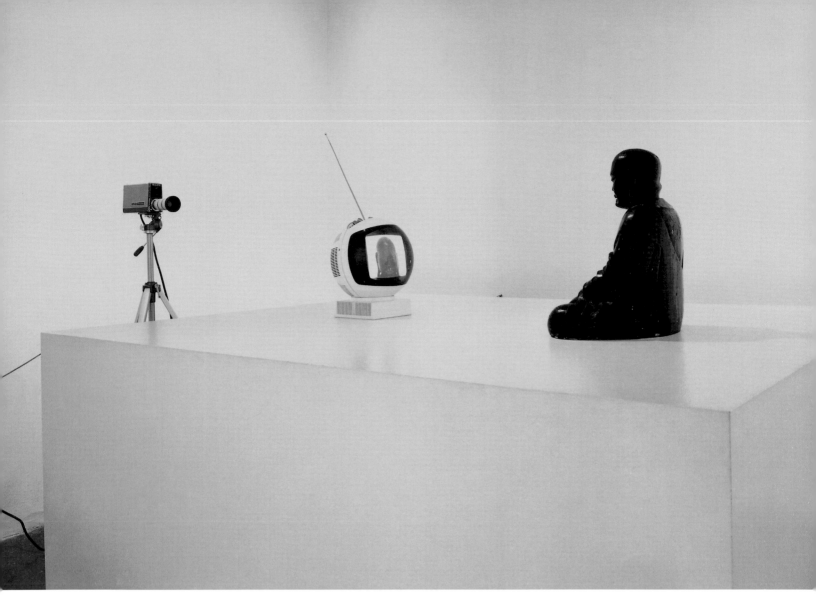

Fig. 23. Nam June Paik, *TV Buddha,* 1974, Buddha statue, camera, and monitor, 63 × 84⅝ × 31½ inches (160 × 215 × 80 cm), Stedelijk Museum, Amsterdam. Photo by Peter Moore © The Estate of Peter Moore / VAGA, New York, NY.

Paik never lost sight of his situation as a Korean working in the West. He took an active interest in his native country, and was instrumental in bringing about change in the Korean art world when such change became possible, offering advice to the government on arts policy and later becoming directly involved in international art events there.[50] This consciousness also figured in myriad ways in his work, writing, and thinking. Buddhas appear in his art (fig. 23); in 1962 he wrote a "Fluxus note" in the satirical spirit of the art movement that read "Yellow Peril! C'est Moi," and then he signed his name.[51] He also famously likened video art to the traditional Korean dish *bibimbap,* a mélange of rice, vegetables, beef, and pepper paste that, because it is made from leftovers, is never the same twice.[52] Similarly, his electronic art was improvisational, involving the rapid splicing together of randomly organized, unrelated images. He believed that continual change tied his work to nature and was the essence of beauty.[53]

Paik's melding of international art idioms and personal history, combined with an intense investment in the communications mix, was a harbinger of things to come. Since the 1990s, globalization has sent artists on the road, as biennials, triennials, and art fairs have proliferated worldwide. Those artists represented in *Your Bright Future* are no exception. They have been shaped by and have helped to create today's art environment. Their work, international in form but specific to the circumstances from which they come, shows them to be resilient in the face of change, sensitive to the nature of Korean cultural identity, and questioning of the viability of translation and communication across national divides. Whether humorous, didactic, intellectual, or spiritual (more likely some combination of the above), their art frequently expresses skepticism about the possibilities inherent in resolutions of any kind.

NOTES

1. Henri Bergson, "The Idea of Nothing," in Arthur Mitchell, trans., *Creative Evolution* (Mineola, NY: Dover Publications, 1998), 297.

2. Martin Buber, "Drama and Theater," in *Martin Buber and the Theater,* ed. and trans. Maurice Friedman (New York: Funk and Wagnalls, 1969), 83–84.

3. The curator Doryun Chong has suggested that "while Japan could find its place in the Western imaginary by dint of its long entanglement with European modern art and aesthetics, China in the same period represented a radical political alternative. . . . Korea, by contrast, was a land bound too hard and fast to History, its topography molded by a rigidly American model of modernization and conception of temporality." Doryun Chong, "(South) Korea, Circa 2005: State of the Art," in *Secret Beyond the Door: The Korean Pavilion, the 51st Venice Biennale* (Seoul: The Korean Culture and Arts Foundation, 2005), 66.

4. See Youngna Kim, *20th Century Korean Art* (London: Lawrence King Publishing, 2005), 180–95.

5. Ibid., 260–61.

6. Similarly, in the United States, despite the existence, before World War II, of highly accomplished figures like Marsden Hartley and Charles Demuth, it was only with the advent of the Abstract Expressionist generation during the postwar period that the United States became a force in the international art world.

7. Bruce Cumings, *Korea's Place in the Sun: A Modern History* (New York and London: W. W. Norton & Co., 1997), 289–90.

8. Ibid., 335. The Han is the river that flows through Seoul, and the phrase "miracle on the Han" refers to Korea's rapid economic development, which was faster and more successful than most people had expected.

9. See for example, Han Sung-Joo, "South Korea in 1987: The Politics of Democratization," *Asian Survey* 28, no. 1 (January 1988): 52–61.

10. E-mail from Minouk Lim to the author, February 5, 2008.

11. Sunjung Kim, "Secret Beyond the Door," in *Secret Beyond the Door,* 25.

12. In East Asia, the family name comes before the given name (Bahc is a family name; Yiso, an individual name). Some of the artists considered here continue to put their family name first, while others—for example, Do Ho Suh—have adopted the Western style, putting their family names last.

13. Jackie Battenfield, "An interview with Mo Bahc, Director of Minor Injury," in *Divine Comedy: A Retrospective of Bahc Yiso* (Seoul: Leeum, Samsung Museum of Art, 2006), 89.

14. Sam Binkley, "Impossible Pilgrimage: Mo Bahc in Brooklyn," in *Divine Comedy,* 64.

15. Koreans refer to him during his New York period as Bahc Mo.

16. Lee Young Chul, "Artist of Noon—'The Divine Comedy'," in *Divine Comedy,* 20.

17. Binkley, "Impossible Pilgrimage," in *Divine Comedy,* 65.

18. Ibid.

19. Bob Dylan's album *Don't Look Back* was released in 1967.

20. Bahc Yiso quoted in Jung Hunyee, "Yiso Bahc's Happy 'Bakangse'," in *Divine Comedy,* 34.

21. Jung Hunyee in ibid.

22. Unless otherwise noted, Suh's comments come from an interview with the author, October 24, 2007, New York City.

23. Daniel Birnbaum, "Red Means Occupied, Green Mean Vacant," *Artforum* 41, no. 5 (January 2003): 123.

24. Haegue Yang, "Blue Meadow—Colored Language," in *Haegue Yang: Sonderfarben, 1998–2001* (Berlin, Germany: Wiens Verlag, 2001), 65.

25. Unless otherwise noted, Yang's comments and ideas come from a telephone interview with the author, January 18, 2008.

26. See Binna Choi, "Community of Absence," an interview with Haegue Yang, in *Haegue Yang: Unevenly* (Utrecht: BAK, 2006), unpaginated.

27. Ibid.

28. Unless otherwise noted, Park's comments come from an e-mail to the author, January 18, 2008.

29. Interview with the artist by Ly Yunju in *Jooyeon Park, Full Moon Wish* (Seoul: Bosho Editions, 2006), 39.

30. The work in question is *Yuan Yuyon Yuyayuyon* (2005).

31. Gimhongsok, interview with *Art Asia Pacific,* no. 54 (July 2007): 78.

32. Jeon Joonho quoted in "Interview with Hwang Do," in *The White House,* an undated pamphlet, no publisher noted.

33. MacArthur was removed from the command by President Harry S. Truman for publicly disagreeing with Truman on his war policy. MacArthur was field marshal of the Philippines during World War II and oversaw the occupation of Japan after the war.

34. Madan Sarup, *An Introductory Guide to Post-Structuralism and Postmodernism* (Athens, GA: The University of Georgia Press, 1993), 165–66.

35. Sook-Kyung Lee, "'Hyperrealism': An Unfinished Project," in *Jeon Joonho: Hyperrealism* (Seoul: Arario Gallery, 2008), 17.

36. Unless otherwise noted, all comments from Kimsooja are from an interview with the author, October 10, 2007, New York City.

37. This account from Kimsooja is from an e-mail to the author, February 28, 2008.

38. Once Koo discovered that a related work in pulverized aspirin could be made in a coffee grinder, she employed that device, but that was after she had produced it, painstakingly, by hand.

39. Federico Nicolao, "Yes, That Too, But Not Necessarily," *Janus* 21 (January 2007): 36–45.

40. The work is titled *Snowmass* (2007). It is 20 × 20 × 30 inches (50.8 × 50.8 × 76.2 cm).

41. Unless otherwise noted, quotations and characterizations of Koo's ideas are from an interview with the author, Los Angeles, February 28, 2008.

42. E-mail from Kim Beom to the author, April 7, 2008.

43. Unless otherwise noted, Kim's comments are drawn from an e-mail to the author, January 17, 2008.

44. Unless otherwise noted, Minouk Lim's comments come from discussions with the author in Korea in November 2006.

45. Unless otherwise noted, quotations and comments by Young-hae Chang and Marc Voge come from an interview with the author conducted in Los Angeles, November 15, 2007.

46. The work, titled *Anybody, Any Thing, Any Way,* was originally produced at the Art Center Arko, Seoul, in 2004.

47. Sunjung Kim, "Secret Beyond the Door," in *Secret Beyond the Door,* 26.

48. Yongwoo Lee, "Hybridity and Anonymity," in *Nam June Paik: Fluxus und Videoskulptur* (Duisburg, Germany: Stiftung Wilhelm Lembruck Museum, 2002), 46 and 48.

49. See Robert Atkins, *Artspeak: A Guide to Contemporary Ideas, Movements, and Buzzwords, 1945 to the Present* (New York and London: Abbeville Press Publishers, 1997), 96–97.

50. For example, curator Elisabeth Sussman confirms that Paik played a major role in bringing the Whitney's 1993 biennial to Korea. Elisabeth Sussman in a conversation with the author, March 27, 2008.

51. Reproduced in Lee, "Hybridity and Anonymity" in *Nam June Paik,* 42.

52. Lee, ibid., 40.

53. "My experimental TV is
not always interesting
but
not always interesting
like nature, which is beautiful,
not because it changes beautifully,
but simply because it changes."
Nam June Paik, "Afterlude to the Exposition of Experimental Television, 1963, March. Galerie Parnass," reprinted in *Nam June Paik: Video 'n' Videology, 1959–1973* (Syracuse, NY: Everson Museum, 1974), unpaginated.

Christine Starkman

LONGING FOR PLACES ELSEWHERE
Kimsooja, Do Ho Suh, and Bahc Yiso

By the beginning of the twentieth century, many Korean artists had already traveled to Japan and China to study fine arts. Korean modern art began when Western-style painting became available in Korea through Japan and China. By the late 1950s, Korean artists and critics were traveling to Paris to study and write about art. A decade later, in the 1960s, New York became the new destination for many Korean artists who had already lived abroad and had participated in the São Paulo Biennial. The majority of the artists featured in *Your Bright Future: 12 Contemporary Artists from Korea* are in many ways continuing the timeline started by their predecessors a century ago of searching for freedom of expression, new ideas and experiences, elsewhere. But these are artists of this time; they are part of the international art scene. They are invited to prestigious solo and group exhibitions, and to biennials in Asia, the United States, and Europe. They are not learning about the current art trends within Korea or in Japan, Europe, or the United States; they are setting them.

Bahc Yiso (1957–2004), Do Ho Suh (born 1962), and Kimsooja (born 1957) are some of the new generation of Korean artists born after 1950 who studied abroad in the late 1980s and early 1990s and who achieved success and international acclaim in the late 1990s and in the new millennium. They were all born in Korea and lived and worked in New York and Seoul. Kimsooja lived in Paris and later in New York, and both she and Suh continue to divide their time between New York and Seoul. Their works reflect the culture, history, and social landscape of both worlds and beyond. They have created metaphorical maps of their worldly travels and have drawn attention to the common humanity that connects us all—Kimsooja by using her body as a constant to actively weave or "sew" together the lives of people from different places; Do Ho Suh by duplicating and transporting sites of culture and personal memory into new spaces; and Bahc Yiso by using the superficial language barrier as the access point for addressing deeper connections and realities that transcend a specific culture, time, and space. As these artists moved from one place to another, their ideas, places, and materials acquired transformative qualities.

Kimsooja

A Laundry Woman—Yamuna River, India (2000) (see page 41), shown at the Hirshhorn Sculpture and Garden Museum in April 2008, is a meditative film that features Kimsooja in the foreground, with her back to the camera, observing the slow-moving current of the Yamuna River flowing with debris, plants, ornaments, and flowers that, according to the artist, came from a nearby platform used to cremate dead bodies. Kimsooja's own body is a marker of place and the passage of time.[2] Her still form, seen from behind, is a signature of her other films as well. In *A Laundry Woman,* she serves as a witness to the sacred rite of cremation, honoring the passing of life. Her presence in the film invites the viewer to take part in the moment that is unfolding, a rare experience for most.

Even as a child, Kimsooja encountered many different places. Born in Daegu, Korea, she lived an itinerant life in her early years due to her father's military service while stationed in Daegu and at other Korean bases.[3] The constant moving of the family from place to place shaped Kimsooja's impression of herself as an anchor or a center, independent of the shifting surroundings and unattached to any one location. At a young age, she enjoyed looking at maps and dreaming of travels to far-off places. Later in life, after receiving her BFA (1980) and MFA (1984) in painting at Hongik University in Seoul, she fulfilled her dreams of traveling abroad by attending the École Nationale Supérieure des Beaux-Arts in Paris, France (1984–85), and then by going to New York as an artist-in-residence at the P.S.1 Contemporary Art Center (1992) and again in 1998 to participate in the World Views residency program at the World Trade Center. Kimsooja became a permanent resident of New York in 1999.

Prior to her departure from Korea, she began working with cloth, needle, and thread, sewing together pieces of old fabric from her deceased grandmother's silk dresses to create *The Heaven and the Earth* (1984) (fig. 1). She used the process of sewing, connecting the fabric with the memories contained in the used cloth, to inform and open her work to many possibilities. Sewing

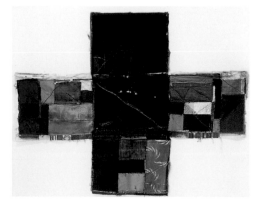

Fig. 1. Kimsooja, *The Heaven and the Earth,* 1984, used clothing fragments, acrylics, and Chinese ink on canvas cloth, 75¾ × 78¾ inches (192.4 × 200 cm), collection of the artist.

freed Kimsooja from the limitations of the canvas and the frame. The used fabric also embodied the essence of a life lived, "memories and histories, though their bodies are no longer there—embracing and protecting people, celebrating their lives and creating a network of existences."[4]

Kimsooja's three-dimensional fabric collages and hangings filled spaces and created a new experience of those spaces. This new dimension later made her aware of the potential of her own body to serve as a kind of needle, a means of connecting the metaphorical fabric of people and places. In the Gwangju Biennale of 1995, she showed one of her first pieces that introduced the body in the act of sewing: *Sewing into Walking—Kyung Ju* (1995) (fig. 2). For this work, Kimsooja placed bundles of used traditional Korean fabrics, or *bottari,* and old clothes in scattered heaps near the site of the Gwangju uprising of 1980, an anti–martial-law demonstration in which two thousand Korean students and civilians were shot and killed by the military. She invited visitors to act as human needles to both mentally and physically connect the fabrics by walking over their surfaces. For the artist, the installation became a reenactment of the horrible event, with these fabrics reflecting and commemorating those who lost their lives during the uprising. Whereas before she had used specific fabrics from her own personal experiences, she was now using fabrics from other people, weaving and connecting the exhibition participants, the previous owners of the fabrics, and the Gwangju site together to become part of the event, and at the same time changing them in the process of the experience.

In *Cities on the Move: 2727 Kilometers Bottari Truck, Korea* (1997), Kimsooja continued and expanded her work with connecting different people in time and space, but now in a new medium—film. To make this work, she recorded her travels throughout Korea over the course of eleven days, visiting places she had known and remembering moments and people she had met while growing up. She journeyed while sitting on top of piles of *bottari* tied together and lashed to the back of a truck. *Bottari* are richly colored, decorative bedcovers, woven in silk or cotton, and are used to store or transport clothes, books, and other household items.[5] Traditionally, *bottari* are given as wedding presents; they are used as cradles, and also as blankets for the sick and dying. The term *bottari* is also used in common language as a metaphor for leaving home or being thrown out of the house; for instance, "Take your *bottari* and leave this house now!" In her film, Kimsooja, perched on top of these bundles and facing forward with her back to the camera, appears like one of the *bottari*—a receptacle for memories and places, a bundle shuttling between the past and the future, yet eternally present. In 1999, Kimsooja parked the truck in the d'APERTutto hall of the 49th Venice Biennale (fig. 3). By relocating the collected experiences of the familiar (places and memories) to an international venue, she symbolically connected Korea and herself to the people in Venice, repeating the idea of sewing the world together.

Fig. 2. Kimsooja, *Sewing into Walking—Kyung Ju,* 1995, single-channel video projection, 19:40 min. loop, collection of Enea Righi and Lorenzo Piani, Milan, Italy.

Fig. 3. Kimsooja, *d'APERTutto, or Bottari Truck in Exile,* 1999, 2½-ton truck stacked with bottaris, 65⅝ × 21¼ feet (20 × 6.5 m), with 65½ × 21⅜ feet (20 × 6.5 m) mirror structure at Arsenale, Venice, collection of the artist.

Fig. 4. Kimsooja, *A Needle Woman—Kitakyushu,* 1999, single-channel video projection, 6:33 min. loop, collection of the Museum Folkwang, Essen, Germany.

In *A Needle Woman—Kitakyushu* (1999) (fig. 4), a film of a performance held in Kitakyushu, Japan, Kimsooja named and identified herself as "A Needle Woman" for the first time. On the screen, the artist appears in a still, horizontal position with her feet and arms stretched out and with her head resting on top of a large rock formation, again with her back to the camera, inviting the viewer to look beyond the foreground marked by her body. The only movement or visible change is the faint breeze and the shifting sunlight as cirrus clouds move across the sky. During this performance, Kimsooja had to maintain great control of her breathing to remain as still as possible. The artist as a "Needle Woman" becomes not only the needle, but also the knot and end point of the thread that will sew the earth, sky, heavens, and people together.

In her later work of the same name, *A Needle Woman* (1999–2001) (see page 124), Kimsooja threaded herself into the fabric of society by placing herself with her back to the camera in the middle of crowded streets in eight major cities (Delhi, Lagos, Tokyo, New York, London, Mexico City, Shanghai, and Cairo). Then, in 2005, she created a new version of *A Needle Woman,* this time traveling around the world to war-torn, dangerous places—places caught in civil, religious, and economic conflicts. In Havana, Cuba, we see the damage of the colonial and Communist experiences; in Rio de Janeiro, Brazil, we become aware of the danger of street warfare; in N'Djamena in Chad, we see evidence of great poverty; in San'a, Yemen, we see well-dressed young men with daggers and a few covered women brave enough to venture out, who appear astonished to see Kimsooja uncovered and vulnerable in the middle of the market. Then in Patan, Nepal, we see soldiers in their army fatigue uniforms, and in a busy street in Jerusalem, Israel, we see Jews and Muslims sharing the same space with Kimsooja (fig. 5a, b). When this work was screened at the

Fig. 5a, b. Kimsooja, *A Needle Woman,* 2005, Patan (Nepal) and Jerusalem (Israel), two of a 6-channel video projection, 10:40 min. loop, collection of the artist.

51st Venice Biennale in 2005, Kimsooja slowed the film by 50 percent, heightening the viewer's awareness of the passing of time. In the center of the screen, we see the artist standing in the middle of the street with passersby walking in slow motion around her, occasionally glancing her way, perhaps wondering about this strangely still woman amid the moving crowd. The 2005 *A Needle Woman* film is not just about the experience of time and space, but also about the struggle to survive. The artist took a lot of risks to obtain the footage. For example, Yemen is considered an underdeveloped country where tribal leaders exert a strong influence on government officials. There is widespread lawlessness and random violence, and kidnappings are common occurrences. Standing still

in the middle of a busy market in San'a as an uncovered woman, Kimsooja becomes a silent protestor of the violent situation.

In *Cities on the Move: 2727 Kilometers Bottari Truck, Korea* (1997), Kimsooja traveled to familiar places to reconnect with the past and the present. In *A Needle Woman* (2005), she put herself in the middle of relatively underdeveloped places. Her appearance in the middle of the crowd, viewed from the back with her long braid and gray robe consistent in each screen, makes us experience our failure to understand the way people live their lives in other cultures. But at the same time, we also recognize that these other people are like ourselves, individual beings. In *Mumbai: A Laundry Field* (2007–8) (fig. 6a, b, c), Kimsooja does not appear on the screen. Instead, this three-channel video projection focuses on an aspect of Indian society. In one of the projections, the camera takes us down the alleys of squalid, dirty neighborhoods in Mumbai, where people live in poverty amid the strong smell of rotting

trash and waste, bathing, washing, and drinking contaminated water and depending upon each other for survival. In spite of these dismal conditions, Kimsooja discovers beauty in the colors of the walls, the fabrics worn, and the hanging laundry. The second projection shows the hardworking men and women of Dhobighat whose caste status has relegated them to a life of washing laundry in a river. Once again, we find the beauty in their sun-bleached, wrinkled, and aged faces and bodies and in the spectacular rainbow colors and the patterns of the clothes being washed and dried. The third projection shows an overcrowded Mumbai commuter train with travelers sitting on the roof and hanging on to every inch of the train, inside and outside. The daily struggle for life is evident in their thin and worn-out bodies. Yet Kimsooja captures the beauty of the fluttering *duppatta* (scarves), saris, and multicolored shirts and pants. *Mumbai: A Laundry Field* documents a specific group of people, and Kimsooja seems to suggest that, though they might be among the lower caste members and the most neglected by society, they are perhaps the happiest and most content, living life from day to day and from moment to moment. This search for simplicity in life, and the interconnectedness of humanity, regardless of far-flung and unfamiliar locales, reoccurs in Kimsooja's works as threads that weave people and places together in a vast fabric of life.

Fig. 6a, b, c. Kimsooja, *Mumbai: A Laundry Field,* 2007–8, 3-channel video installation, 10:25 min. loop.

Do Ho Suh

Cause & Effect (2008) (fig. 7a, b), Suh's most recent work at the Towada Art Center in Japan (and previously shown at Lehmann Maupin in New York in 2007), features a red funnel shape that expands exponentially to the ceiling with a white canopy hanging down around the central form. The sculpture is made of suspended strands of tiny resin figures, each sitting on the shoulders of the one below, with each strand terminating in a single standing figure.

The subject and title of *Cause & Effect* relate to the Hindu belief in *karma,* which refers to actions and their reactions in this and previous lives. Suh's work offers a new object of contemplation, guiding the viewer toward a philosophical revelation of how our individual identities and destinies are interlinked. Similar to Kimsooja in her *Mumbai: A Laundry Field, A Needle Woman* (1999–2001), and *A Needle Woman* (2005), Suh takes the idea of interconnectedness and invites us to experience it in a constructed space. The lone figure at the tip of the vortex, near the floor, embodies the actions and consequences of the previous generations—he is both the beginning and the end. Like this lone figure, *Cause & Effect* is connected to, and developed in relation to, Suh's previous bodies of work.

When Suh arrived in the United States in the early 1990s, he felt "as if he was dropped from the sky, then all of a sudden living in someone else's body. He was not comfortable with his new body and he had to established new relations with his new surroundings."[6] He began measuring spaces: hallways, his studio, and his apartment. Suh did not really know what he would do with the measured spaces until several years later. The process of measuring led him to the idea of duplication and the transportability of spaces.

Since 1993, Suh has been measuring, surveying, and mapping the relationship of space to the body and to abstract ideas. In the early and mid-1990s, he measured spaces to help him understand his new surroundings. In *Hallway* (1993) (fig. 8), he added a laminated birch panel to an existing hallway floor. He painted this addition to match the original floor, essentially creating a duplicate. The alteration was barely perceptible, except for the fact that the edges of this new floor curved where they touched the walls. Further down the hallway, Suh added a rod, bent into an elliptical form, through which a person traveling down the hallway must pass. These minor disturbances made those who passed through the hallway become aware of these transitional spaces.

In New York, Suh expanded his artistic approach: rather than altering or merely duplicating preexisting spaces, he began transporting spaces. In *Room 516/516-I/516-II* (1994) (fig. 9), Suh sewed muslin to create a room with four walls, a floor, and a ceiling, replicating to scale the minute details of an actual room's electrical outlet panels, door handles, window panes, and steam radiator. This fabricated room could be rolled up like a map, transported, and then unrolled in another place, bringing with it the memory of the original space.

In the mid-1990s, Suh continued his survey of space and its relationship with the body and abstract ideas, but he also started investigating how identity is generated or imposed through the duplication of spaces that are meaningful to him. In *Who Am We?* (2000) (see page 34), Suh collected high-school yearbook pictures spanning three decades and transferred these images onto wallpaper, which was then applied to a wall or column. These yearbook pictures evoke specific memories of friends, school, and events for the viewer. Yet Suh observed that seeing all the faces together made him aware of their similarities; he was curious about what we share, and what we don't, and how individuals converge.

Fig. 7a, b. Do Ho Suh, *Cause & Effect* (Towada City) (and detail), 2008, acrylic, aluminum disc, stainless-steel frame, stainless steel cable, and monofilament, 318½ × 196⅞ × 279½ inches (809 × 500 × 710 cm), collection Towada Art Center, Towada, Japan.

Fig. 8. Do Ho Suh, *Hallway,* 1993, laminated birch, pine, 157⅛ × 75 × 50 inches (399 × 190.5 × 127 cm), ephemeral installation at Rhode Island School of Design, Providence, no longer extant.

Fig. 9. Do Ho Suh, *Room 516/516-I/516-II*, 1994, muslin, 105 × 84 × 144 inches (266.7 × 213.4 × 365.8 cm), collection of the artist.

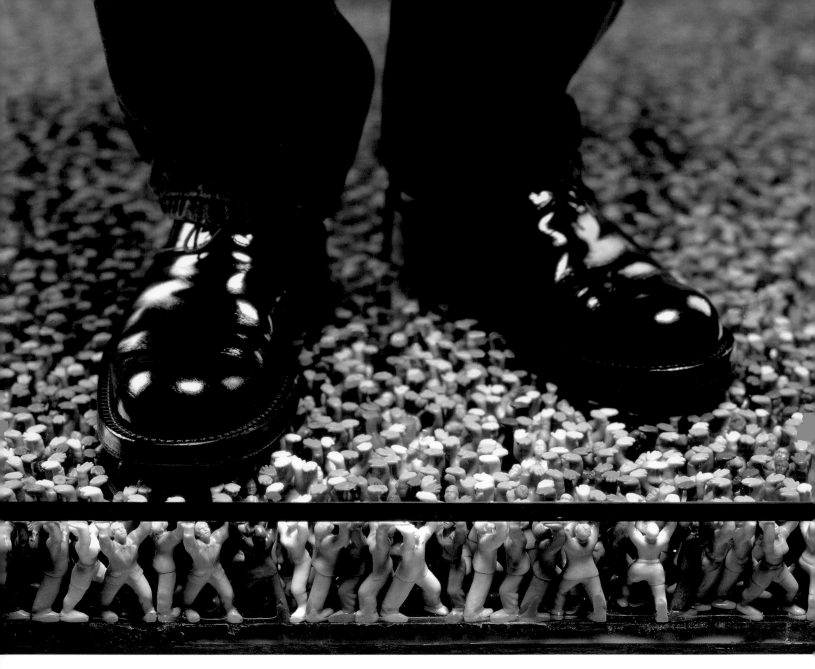

Fig. 10. Do Ho Suh, *Floor*, 1997–2000, PVC figures, glass
plates, phenolic sheets, and polyurethane resin, 40 parts,
each 39⅜ × 39⅜ × 3⅛ inches (100 × 100 × 8 cm).

Fig. 11. Do Ho Suh, *Seoul Home/L.A. Home/New York Home/Baltimore Home/London Home/Seattle Home* (detail), 1999, silk, 100 × 76 × 24 inches (254 × 193 × 61 cm), collection Museum of Contemporary Art, Los Angeles, purchased with funds provided by an anonymous donor and a gift of the artist.

Suh furthered this investigation of bringing personal experiences into site-specific installations in *Floor* (1997–2000) (fig. 10), once again using the image of the multitude. He raised the floor of the gallery by covering it with 180,000 cast PVC human figures whose arms reach overhead to support forty glass panels, forming the "new" floor over which the viewer is invited to walk. Suh was interested in the work becoming an integral part of the architecture. He wanted to transform the room to represent and define the boundaries of personal or individual space.[7] The relationship between the supporting figures, the floor, and the viewer is an active one. The duplicated floor serves as a stage where the action of support, both literal and metaphoric, is performed each time the viewer walks across its surface. Here, Suh sets up the symbiotic relationship between the viewer and the work.

Suh resumed producing architectural simulacra with *Seoul Home/L.A. Home/New York Home/Baltimore Home/London Home/Seattle Home* (1999) (fig. 11). Made of transparent blue silk, this work is a full-scale re-creation of the interior of his childhood home in Seoul. Suh's parent's house was modeled after a private gentleman's residence built in Changdeok Palace in Korea during the nineteenth century.[8] *Seoul Home* is a duplicate of a duplicate.

After living in New York for a few years, Suh felt a strong longing for this childhood home and thought about how he could carry it with him, like a snail. For *Seoul Home,* Suh made a pattern of the actual measurements of the home in Korea and sewed together panels of silk to create its duplicate. The process of making *Seoul Home* made Suh recollect his past experiences in that space. After finishing its construction, Suh rolled it up, transported it across the Pacific Ocean, and unfurled it from the ceiling of the Korean American Center in Los Angeles, carrying with it all the emotions, memories, and relationships that it had accumulated over the years. Unlike its predecessor, *Room 516/516-I/516-II,* which was strictly about duplicating and transporting space, *Seoul Home* conveys not only the form of the space, but its evocation of departure, longing, and recollection, its ability to project daydreams and to recover forgotten gestures. For Suh, the mapping of spaces in Korea became a gesture of departure and opened a new path for his life and work. He realized that memories of personal spaces and people could be transportable and, when installed in another space, could take on new meanings.

At the start of the new millennium, Suh expanded this practice to explore the symbiotic interconnection and interrelation with others by duplicating and transporting not just spaces, but personal relationships. In *Paratrooper-I* (2003) (fig. 12a, b), Suh embroidered the names of five thousand of his family members, friends, and acquaintances on fabric in the shape of a parachute, with each name connected to a thread pulled to a single point by a figure—a paratrooper—standing on a platform. This collection of individuals is reminiscent of the work *Who Am We?,* yet *Paratrooper-I* represents individuals through their names rather than their faces, making them no longer anonymous.

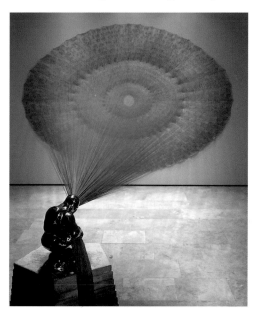

Fig. 12a, b. Do Ho Suh, *Paratrooper-I* (and detail), 2003, linen, polyester thread, cast stainless steel, cast concrete, and plastic beads, 122 × 153 × 254 inches (309.9 × 388.6 × 609.6 cm), collection of Danielle and David Ganek, New York.

In a lecture at the Fabric Workshop, Suh said that "the point where all the threads come together is at the paratrooper's hand and that is the moment and place of what makes me exist."[9] Suh brings to the foreground his relationships and how they have constructed and defined who he is. He uses the image of the paratrooper as a metaphor for being dropped into unfamiliar terrain (the United States), and the parachute to symbolize those involved in his safe passage.

In the summer of 2006, Do Ho Suh was an artist-in-residence at Artpace in San Antonio, where he worked on his *Speculation Project 2005,* a thirteen-chapter autobiographical narrative of his emotional journey from Korea to the United States. Suh presented the first and fourth chapters of this project in the Artpace gallery. In chapter one, *Fallen Star: Wind of Destiny* (2006) (fig. 13a, b), a large white tornado

Fig. 14. Do Ho Suh, *Fallen Star: A New Beginning (1/35th Scale),* 2006, plywood, pinewood, basswood, polyurethane, resin, plaster, Styrofoam, lightbulbs, paper, styrene, ABS, polycarbonate sheets, PVC sheets, glass, and paint, 33½ × 44⅜ × 64½ inches (85 × 112.8 × 164 cm), originally commissioned by Artpace, San Antonio, private collection.

Fig. 15. Do Ho Suh, *Fallen Star: Epilogue (1/8th Scale),* 2006, plywood, pinewood, basswood, resin, styrene, ABS, polycarbonate sheets, PVC sheets, glass, and paint, 76 × 118 × 121 inches (193 × 299.7 × 307.3 cm), originally commissioned by Artpace, San Antonio.

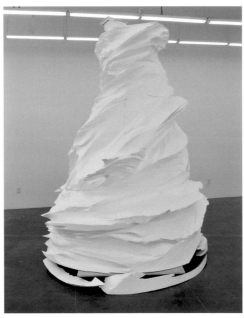

Fig. 13a, b. Do Ho Suh, *Fallen Star: Wind of Destiny* (and detail), 2006, Styrofoam and resin, approximately 108 × 36 × 36 inches (274.3 × 91.4 × 91.4 cm), originally commissioned and produced by Artpace, San Antonio.

form made of Styrofoam and resin appears to be transporting a miniature traditional Korean house to a new, unknown destination. In *Fallen Star: A New Beginning (1/35th Scale)* (2006) (fig. 14), a traditional Korean house crashes through an apartment building—in fact, a miniature version of the Rhode Island building in which Suh once lived. This moment of impact signifies his moment of arrival in the United States. Suh worked out the floor plans for these models by measuring and duplicating these specific structures at different scales, thereby charting

the defining moments of his departure and reorientation.

Later that same year, in a solo exhibition at Gallery Sun Contemporary in Seoul, Suh displayed these two works along with the fifth chapter, *Fallen Star: Epilogue (1/8th Scale)* (2006) (fig. 15), which shows the aftermath of this architectural collision, but with signs of repair—scaffolding supports the two tiny structures, which appear to be merging into one: a home within a home.

Suh's future plans take this vision one step further by mapping himself symbolically inside the environment he now calls home. In *Perfect Home: Home within a Home,* Suh intends to suspend two nylon buildings, one inside the other, from the ceiling of a large space: a Korean house inside a New England-style house. The viewer, looking up, should be able to see the interiors of both houses simultaneously, as if they were overlapping blueprints. The two worlds, once separated by an ocean, would then converge. For Suh, this "perfect home" makes manifest

his realization that he carries his "home" within him wherever he goes.

Bahc Yiso

In 2004, the news of Bahc Yiso's sudden death saddened his many friends and the art community in Korea and around the world. Two works proposed by Bahc were realized after his death: one of these, *We Are Happy* (2004) (see page 74), was included in the 3rd Busan Biennale, which opened in August 2004. According to Bahc's specifications, a monumental billboard with the words *Urineun Haengbokhaeyo* (We Are Happy) in bold, white Korean letters against an orange background was installed outside the building housing an exhibition titled *Point of Contact.* Bahc had seen a similar propaganda sign in North Korea in the news.

Those who can decipher the Korean text are left to ponder: Who are these happy people, and why are they happy? Those unable to read the message would have to ask someone to translate it for them. On the surface, "We Are Happy" is a simple message, but it is charged with manifold meanings. In *We Are Happy,* Bahc sets up a performative utterance "in which to *say* something is to *do* something; or in which *by* saying or *in* saying something we are doing something."[10] The "We" of the message is performed each time it is read and translated and spoken aloud to a foreign viewer. The billboard binds people together in the common experience of uttering these words. Bahc left a brief note in his proposal for the work:

> I want to show everyone a massive, but disturbing message of hope that happiness does exist somewhere, while giving a fleeting view of the general yearning for happiness, the discouragement caused by seeing so much unhappiness, the meeting points and overlapping and fissures between the values and misunderstandings of happiness itself among the viewers.[11]

While Suh is adept at constructing spaces that are enriched with emotions and abstract ideas, and Kimsooja is a master at activating our imagination and connecting us to the world through her films and installations, Bahc was a modern poet in his use of language as an important tool to connect us to the world in his own way. He used words to create a fissure between what the viewer could see and the secrets revealed by the artist. After completing his BFA at Hongik University in Korea in 1981, Cheol-ho Park, as he was originally known, moved to New York to pursue an MFA at the Pratt Institute in New York. In 1985, after graduating, he opened a nonprofit alternative art space in Brooklyn called Minor Injury and actively wrote about the New York art scene for Korean art journals under the name Mo ("anonymous" or "nobody") Bahc. To negate his name was to become a neutral receptacle for a new vision and awareness. Soon after, Bahc held a fast with the intention of emptying his mind and body of mental and physical attachments. Bahc's tenure in New York marked the beginning of his twenty-year initiative to map his personal experiences and his relationships with the place he had left and the place where he had settled.

From the mid-1980s to early 1990s, Mo Bahc (Bahc Yiso) produced paintings and installations that represented his orientation and disorientation in New York. His images relied on what he knew (Korean language and culture) and elegantly interwove them with images of U.S. culture and language. The works painted between 1985 and 1986 contain a variety of images, from rice, oil drums, rice kettles, and potatoes to rocks, rain, tears, Korean maps, and Korean text.

In New York, Bahc began juxtaposing Korean language and images to reinforce their convergence. Because most U.S. residents are unable to read Korean, many viewers see these characters as just images, without inherent meaning. In a way, the Korean text represents Bahc himself—his experience as a foreigner, as an ethnic minority, and as a Korean man in a place where he felt unreadable and untranslatable. But it was not just in New York that Bahc felt displaced; he was also deemed unacceptable in Korea because of his political beliefs—his opposition to the rule by martial law in his home country at the time. His sense of disconnection from Korean events and of being "unreadable" in his new surroundings was made manifest in his work. Bahc's painting *Simply Weeds* (1987) (fig. 16) depicts three blades of grass executed in quick brushwork alongside a calligraphic inscription in Korean. Bahc borrows from the Joseon dynasty (1392–1910) literati painting tradition,

Fig. 16. Bahc Yiso, *Simply Weeds,* 1987, ink on paper, 9¾ × 22¾ inches (25 × 58 cm), collection of the estate of the artist.

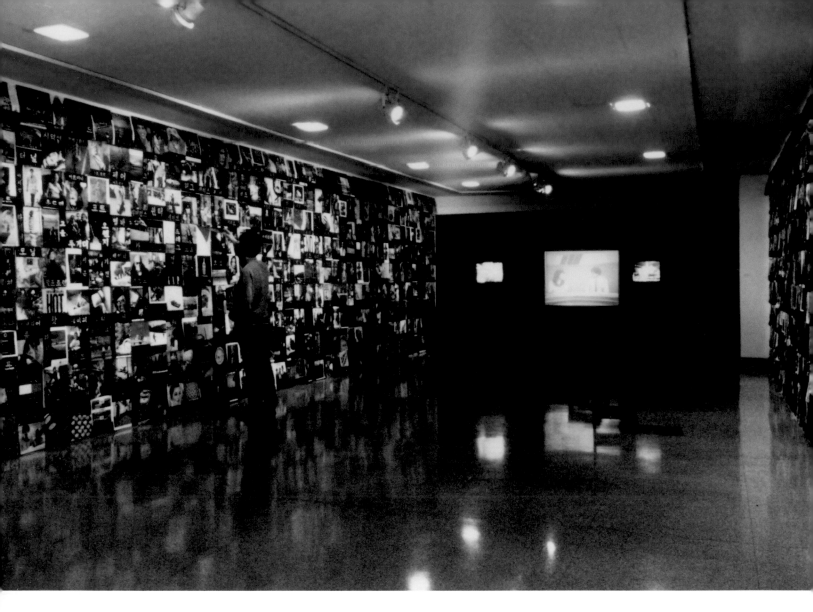

Fig. 17. Bahc Yiso, *Speak American,* 1990, video projection, monitors, and magazine pages with enamel paint, ephemeral installation at the Bronx Museum of the Arts, no longer extant.

in which orchids depicted in calligraphic brushstrokes were a popular motif. The painting is a play on the Western viewer's expectation of what Asian traditional paintings should look like. The calligraphic inscription "*geu nyang pul*" translates as "simply weeds." Even though the work is stamped with his name seal, as if reinforcing Bahc's presence or existence, the artist is still "Mo," or anonymous. This abnegation could also refer to early Korean literati tradition, in which the goal of the scholar–painter was to achieve noble-mindedness, virtue, and withdrawal from public life—anonymity.

Bahc furthered his investigation of language, texts, and their uses in *Speak American* (1990) (fig. 17). For this work, Bahc covered two long walls with wallpaper made from eight hundred pages of the *New York Times Magazine,* over which were written English words spelled phonetically in Korean characters. Some Koreans might be able to understand the text but might also be bewildered by the transliteration of such

English terms as "Liquor," "Mink Coat," "Interesting Guy," "Woman," and "Scenery." Those viewers unable to read Korean would be equally confused, operating under the assumption that the Korean characters represent actual Korean words, and not words that, once pronounced, would be recognized as English terms. Whereas Bahc had previously used Korean and English texts separately, here he merged them, embedding English meanings within Korean texts. He further underlined the potential for miscommunication and interchangeability between words and their meanings by including videos of an English conversation lesson as well as footage of American and Korean talk shows (featuring Johnny Carson and Johnny Yoon, respectively) in this installation.[12]

Bahc's tenure in New York left him disillusioned about art, language and communication, and cultural exchange and freedom. He wanted to be seen as an artist, rather than as a Korean. Yet by supporting works (through Minor Injury)

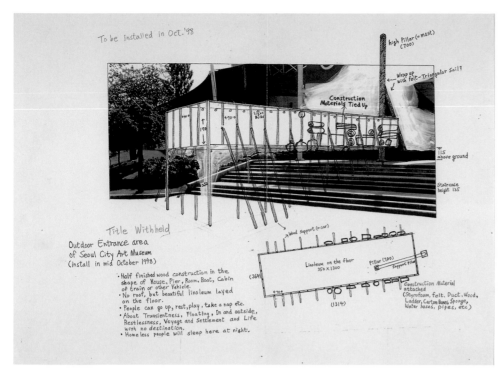

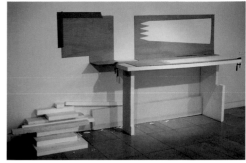

Fig. 19. Bahc Yiso, *The Remains,* 1996, Styrofoam, wood, clamps, and tape, 59⅛ × 98⅜ × 40¼ inches (150 × 250 × 102 cm).

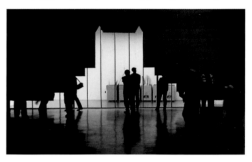

Fig. 18. Bahc Yiso, drawing for *Untitled,* 1998, 8¼ × 11¾ inches (21 × 30 cm), collection of the estate of the artist.

about minority struggles, he in effect further isolated and defined himself and other artists associated with Minor Injury as the "Other." Upon his return to Seoul in 1994, Bahc discarded the name Mo Bahc and created another identity with a new name, Bahc Yiso. He staged another fast, this time for fifteen days, as a way to remake and reorient himself in the city and country he once called home.

During this time, Bahc created makeshift dwellings, vessels, and simple sculptures as a way to find his bearings in these new surroundings. In the last four years of his life, he was preoccupied with mapping the earth, sea, and sky. He desperately wanted to communicate to the world a message of interdependence using both simple and high technology. In Seoul, Bahc made detailed records, instructions, diagrams, and plans for sculptures and installations. He continued exploring the mechanics of language, but this time in relation to objects, materials, and space. Using found objects and everyday materials such as plywood, Styrofoam, foil, and plastic, he tested and measured the boundaries of art, recording the results in his journal. He valued ordinary objects and materials for having the ability to take on meaning according to an artist's rules and specifications.

For several works made between 1994 and 2000, Bahc constructed makeshift, uninhabitable dwellings or vessels. On the preparatory drawing for one such work, *Untitled,* 1998 (fig. 18), he wrote that it was to be made "in the shape of a House, Pier, Room, Boat, Cabin of train or other vehicle."[13] He began cutting and

Fig. 20. Bahc Yiso, *UN Tower,* 1997, plywood, cardboard boxes, galvanized iron sheets, discarded construction materials, Styrofoam, and drawings, dimensions vary, ephemeral installation at the Gwangju Biennale, no longer extant.

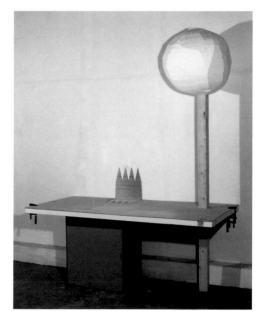

Fig. 21. Bahc Yiso, *A Worktable for Designing the Bright Future,* 2000, plywood, Styrofoam, clamps, wood, and tape, 94½ × 74¾ × 35¾ inches (240 × 190 × 91 cm).

taking down walls and using leftover materials to make works such as *The Remains* (1996) (fig. 19), *UN Tower* (1997) (fig. 20), and *A Worktable for Designing the Bright Future* (2000) (fig. 21). These works show Bahc's interest in changing our perceptions and the way we see art and the world.

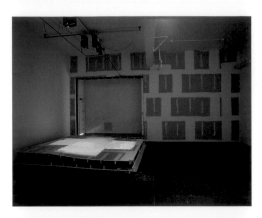

Fig. 22a, b. Bahc Yiso, *Untitled (The Sky of San Antonio)*
(and detail), 2000, four cameras, four projectors, wood, and
drywall, 15 × 120 inches, 10¾ × 167 inches (38.1 × 304.8 cm,
27.3 × 424.2 cm), ephemeral installation, commissioned and
produced by Artpace, San Antonio.

Bahc Yiso returned to the United States in
2000 to participate as an artist-in-residence at
Artpace in San Antonio, Texas. While there, he
once again cut out part of a wall, this time plac-
ing it on the floor to serve as a horizontal screen
on which to project real-time images of the
sky. For *Untitled (The Sky of San Antonio)* (2000)
(fig. 22a, b), Bahc installed four video cameras
on the roof of Artpace and projected the skies of
San Antonio onto the floor-screen. He aimed the
cameras' wide-angle lenses in the four cardinal
directions to record the movement of the sun
across the sky, allowing the viewer to witness
the passing of time while inside the gallery.
Bahc once related the following story:

He used to lie down staring blankly at the ceil-
ing. Often the ceiling became the sky in his
imagination, making him feel helpless and
lonely—a mere being in an infinite universe.
The untouched sky is open and infinite—

perfect all the time. The sky is empty, yet full.
Unlike humans who ceaselessly try to achieve
something, the sky just is. The sky may be per-
fect and beautiful because it does not attempt
anything.[14]

Bahc projected the sky onto the floor, open-
ing up a makeshift skylight on the floor of the
gallery.

Bahc's *Untitled (Drift)* (2000) (see page 33)
offers a different kind of window on the world.
The artist sealed a Global Positioning System
(GPS) tracking device in a plastic bottle with
a video camera and transmitter, intending to
chart the bottle's progress and to project on
one wall of the Artpace galleries live, stream-
ing video images of the Gulf of Mexico. A pre-
recorded image of the ocean would be projected
onto a different wall when there was no recep-
tion. Bahc expected to receive signals from the
bottle for about a week or two, but the signal
disappeared after only two hours and twenty-
two minutes.

His exploration of the world was ultimately
best conveyed through his utilization of lan-
guage. *Wide World Wide* (2003) (fig. 23) was pre-
sented posthumously at the Istanbul Biennial
in the summer of 2004 and at the San Diego
Museum of Art in the exhibition *Past in Reverse:
Contemporary Art of East Asia* in November
2004. According to Bahc, *Wide World Wide* was
a play on "World Wide Web." The work includes,
painted in Korean, the phonetically transliter-
ated names of 184 unfrequented locales around
the world, placed in relation to their actual geo-
graphic coordinates to form a text-based map
of the continents. Above the Korean texts, Bahc
placed small paper labels identifying the cities
in Romanized letters. Those viewers who are
able to read the Korean text soon realize that
the words are not Korean but unknown for-
eign names. Those unable to read Korean, but
able to read the Romanized labels, come to the
same realization. Bahc intended the Korean and
English texts to be "floating signifiers reflecting
on the meaning of (un)real, world, communica-
tion, places and experiences."[15]

In *Wide World Wide*, Bahc addresses the
limitations of the Web as the source of all
knowledge and information. The work is
fraught with notions of information/disinfor-
mation, communication/miscommunication,
ignorance/knowledge, place/nonplace, and
memory/loss of memory. Bahc's work makes

Fig. 23. Bahc Yiso, *Wide World Wide,* 2003, acrylic and oil on
canvas, lights, and paper labels, 104¼ × 200¾ × 9¾ inches
(265 × 510 × 25 cm), collection Leeum, Samsung Museum
of Art, Seoul.

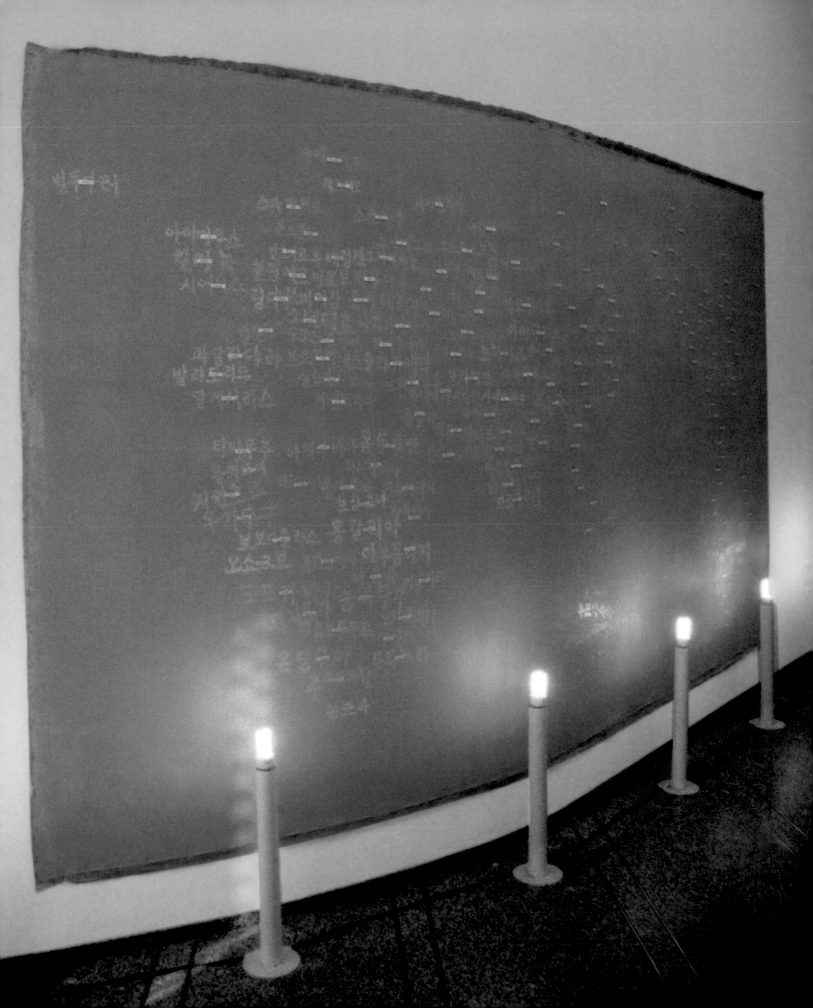

Fig. 24. Bahc Yiso, *Wide World Wide* (detail), 2003.

these places, we bring them into existence in our minds for contemplation (fig. 24). Both the words and their images function as vehicles of meaning, providing "direct, unmediated access to the things they represent."[18] According to Bahc, the fluorescent bulbs set on the floor in front of the painting are meant to be reminiscent of lighthouses, memorializing the "memory of relationship between wideness of the wide world and triviality of life."[19]

In one of Bahc's earlier works, *Your Bright Future* (2002/2006) (see page 31), he had used lights in a similar way, assembling a multitude of lights on stands to illuminate a plain white wall. The title, with its double-edged meaning, invites viewers to mentally project their own futures onto the bright space. The wall appears like a stage on which the creative drama has yet to unfold. The light apparatuses, like many of the works in the exhibition, mark a sense of place and the passage of time. Bahc shines the light upon the blank wall to draw our attention to the present and perhaps to the hope for a brighter future.

Bahc's experience of the art world in the 1980s was quite different than the experience offered in the 1990s and beyond. From the mid-1990s to the beginning of the new millennium, as this transition was taking place, Kimsooja, Bahc Yiso, and Do Ho Suh were sewing or constructing floors, walls, and dwellings: Kimsooja using fabric, film, and performance to sew herself and the world together; Suh using fabric, resin, metal, and paper to explore the permanence of memory and the spatial experience through duplication and transportability; and Bahc using language, as well as plywood, plastic, and found objects to make unrepeatable, ephemeral sites of contemplation. Bahc's use of language was not about translating between languages; it was about communication between people. It was his way of connecting everyone through language.[20] These artists sought to order and construct their vision of the world and the self—both physical and metaphorical (and also cultural, remembered, and historical).[21] Their works have opened up, clarified, renewed, multiplied, and imagined the shared spaces that are within us all.

the viewer realize that the truth can easily be manipulated, even through conventional forms of communication such as maps and the Internet. *Wide World Wide* is similar to Kimsooja's *A Needle Woman* (2005), in which she visited underdeveloped cities. These places exist, but not in the consciousness of mainstream society. Both Kimsooja and Bahc acknowledged the power of the information age offered by the World Wide Web, but also wanted to raise awareness of places and cultures that are and will always be unknown, "fragmented, superficial and out of focus."[16] *Wide World Wide* is a kind of "topopoetry."[17] We read these words, such as "Araraquara, Fakfak, Nunachuak, Quezaltenango, Bobo Dioulasso, Salsomaggiore," and by speaking the names of

NOTES

Research for this essay was conducted in Menerbes, France, at the Dora Maar House during my stay as a Brown Foundation Fellow in the summer of 2007. I want to thank Joan Kee for her careful reading and insightful suggestions to the essay. I am especially grateful to James Clifton for his comments and suggestions on literary and linguistic matters.

1. Gaston Bachelard, *The Poetics of Space,* trans. Maria Holas (Boston: Beacon Press, 1969), 56.

2. From a conversation with Edward (Ned) Dodington, third-year graduate student in architecture, Rice University, about architecture/art and a critique of permanence, February 26, 2008, in Houston, Texas.

3. Daegu has long been considered a historical crossroad because it is situated between two rivers. According to historical texts, Daegu was the site of significant battles that determined the rulers of different dynasties. As a transportation center during the Joseon dynasty (1392–1910), Daegu was an important city between Seoul and Busan.

4. Kimsooja in conversation with Mary Jane Jacob in *In the Space of Art: Buddha and the Culture of Now,* 2003, http://www.kimsooja.com/texts/jacob.html.

5. David Neuman, *Kimsooja* (Stockholm, Sweden: Magasin 3 Stockholm Konsthall, 2006), 32.

6. Do Ho Suh, artist's talk at the Fabric Workshop and Museum, Philadelphia, June 27, 2007. See http://www.fabricworkshop.org/artists/video/suh.php.

7. Do Ho Suh, in *Art: 21—Art in the Twenty-First Century: Artist, Video: "Floor" Installation,* http://www.pbs.org/art21/artists/suh/index.html.

8. Do Ho Suh, in "Interview: 'Seoul Home/LA Home'—Korea & Displacement," in ibid., http://www.pbs.org/art21/artists/suh/clip1.html.

9. Suh, artist's talk at the Fabric Workshop and Museum.

10. J. L. Austin, *How to Do Things with Words,* eds. J. O. Urmson and Marina Sbisà (Cambridge, MA.: Harvard University Press, 1962), 12. I want to thank James Clifton, director of the Sarah Campbell Blaffer Foundation, and curator, Renaissance and Baroque painting, for suggesting this reference.

11. Jung Hunyee, "Yiso Bahc's Happy 'Bakangse,'" in *Divine Comedy: A Retrospective of Bahc Yiso* (Seoul: Leeum, Samsung Museum of Art, 2006), 35.

12. Mo Bahc (as he was known in New York) wrote articles about postmodern theory for Korean art journals while he lived in New York (1983–94), and his articles were often cited by art scholars and critics in Korea, according to Joan Kee. See *Yiso,* Artist's Biographies, Asian Contemporary Art, Grove Art Online. http://www.groveart.com/shared/views/article.html?section=art.097897&authstatuscode=200).

13. Ibid., 135.

14. Sunjung Kim, *Yiso Bahc,* brochure, Artpace, A Foundation for Contemporary Art, San Antonio, Texas, 2000.

15. Bahc Yiso, in *Divine Comedy,* 185.

16. Ibid., 185.

17. Edward S. Casey, *Representing Place: Landscape Painting and Maps* (Minneapolis: University of Minnesota Press, 2002), 30.

18. Liz Kotz, *Words To Be Looked At: Language in 1960s Art* (Cambridge, MA.: The MIT Press, 2007), 222.

19. Bahc, in *Divine Comedy,* 185.

20. From a conversation with Hawon Ku, postdoctoral fellow at Seoul National University, May 23, 2008, in Seoul, Korea, during a visit to Bahc Yiso's studio.

21. Priya Malhotra, "Space Is Metaphor for History," *Tema Celeste,* no. 83 (January–February 2001), 53.

12 CONTEMPORARY ARTISTS FROM KOREA

12 Contemporary Artists from Korea

Exhibitions of Korean art have been organized only intermittently in the past in the United States, and Korean artists have rarely had an opportunity to be properly introduced. The interviews that accompany the following biographies and images intend to convey directly to the reader the thoughts of the twelve Korean artists in this exhibition. Each of these artists has been actively practicing since the 1990s and addresses the various characteristics and social issues of Korean society in his or her respective work. Through the waves of globalization in the 1990s, most of them studied overseas, and almost half of them continue to live in the United States or in Europe. Instead of seeing Korea as a nation, they view it as a kind of community and deal with the memories and experiences of that shared space. In their works, they address particular issues, such as mobility caused by globalization, contradictions within a society unevenly focused on economic development, and longings for disappearing and nonexistent places, while observing the societal structures unique to Korea from an artist's point of view. This exhibition of contemporary Korean art is not about the particular nation/country of "Korea," but seeks to show similarities found in the contexts in which these artists work within a shared community. These interviews vividly convey the artists' own voices in hopes of minimizing the aspects of the artists and their practices that may become obscured by their national identity or by regionalization. Furthermore, these interviews started from a wish to discuss the artists' own thoughts and the contents of their works. When observing the contents of these artists' individual works, which tell about various aspects of Korean situations, one comes to discover something common among them, which originates in shared experience. Although the works display certain overlaps, and could be classified in various ways based on these shared elements, each work is nonetheless unique and possesses complex layers of meaning. It is my hope that the following interviews will reveal those layers.

Sunjung Kim
Director, SAMUSO: Space for Contemporary Art/Independent Curator

Bahc Yiso

Bahc Yiso (1957–2004; born in Busan, Korea) was one of the most recognized Korean artists of the 1990s. After obtaining his BFA in painting from Hongik University in Seoul in 1981, he spent nearly fifteen years in New York before returning to Korea. In the following years, his artworks increasingly garnered international attention and recognition. In the late 1990s and early 2000s, Bahc participated in numerous art biennials and exhibitions in Asia, Europe, and the United States. Bahc's oeuvre spans from his early paintings and collages that interplay Korean and English words and images to his later architectural installations and unassuming sculptures made of everyday materials that serve to disarm the viewer's confidence in the finite definition of place. In his project, created at Artpace in San Antonio, Texas, *Untitled (The Sky of San Antonio)* (2000), he projected live video images of the serene sky over San Antonio onto an uprooted wall of the gallery that was then placed on the floor. In another project conceived during his Artpace residency, *Untitled (Drift)* (2000), Bahc likewise pointed to the true infinite quality of place by launching into the Gulf of Mexico a GPS in a plastic bottle, which could then be tracked on a wall in the gallery. Bahc presented location and place—the San Antonio sky located on the wall–floor piece in the gallery and the bottle in the Gulf of Mexico located on the gallery wall—as ambiguous and fluid concepts.

Education BFA, Hongik University, Seoul, Korea, 1981; MFA, Pratt Institute, New York, 1985 **Selected Solo Exhibitions** *Divine Comedy: A Retrospective of Bahc Yiso,* Rodin Gallery, Seoul, Korea, 2006; *FALLAYAVADA: Bahc Yiso Project and Tribute,* University of Irvine Art Gallery, Irvine, California, 2005; *Hermes Missulsang,* Gallery Hyundai, Seoul, Korea, 2002 **Selected Group Exhibitions** *Secret Beyond the Door,* 51st Venice Biennale, Korean Pavilion, Venice, Italy, 2005; *Past in Reverse: Contemporary Art of East Asia,* San Diego Museum of Art, San Diego, California, 2004; *Point of Contact,* 3rd Busan Biennale, Busan, Korea, 2004; *Landscape of Differences,* 50th Venice Biennale, Korean Pavilion, Venice, Italy, 2003; *ASIANVIBE,* Espai d'Art Contemporani de Castello, Castello, Spain, 2002; *MEGA-WAVE,* Yokohama Triennale, Yokohama, Japan, 2001; *Site of Desire,* 1st Taipei Biennial, Taipei Fine Arts Museum, Taipei, Taiwan, 1998; *Power,* 2nd Gwangju Biennale, Gwangju, Korea, 1997; 5th Havana Biennale, Havana, Cuba, 1994; *Across the Pacific,* Queens Museum of Art, New York, 1993

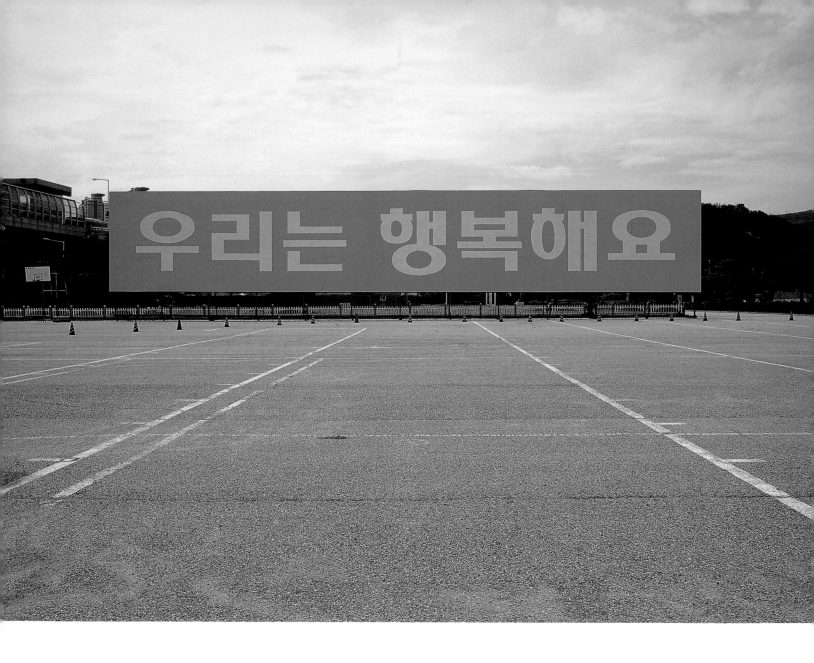

WE ARE HAPPY / 2004 / billboard / dimensions vary

UNTITLED (detail) / 1998 / fans, plywood, vinyl, fluorescent lights, TV monitor, and VCR /
144 × 708 × 240 inches (370 × 1610 × 600 cm)

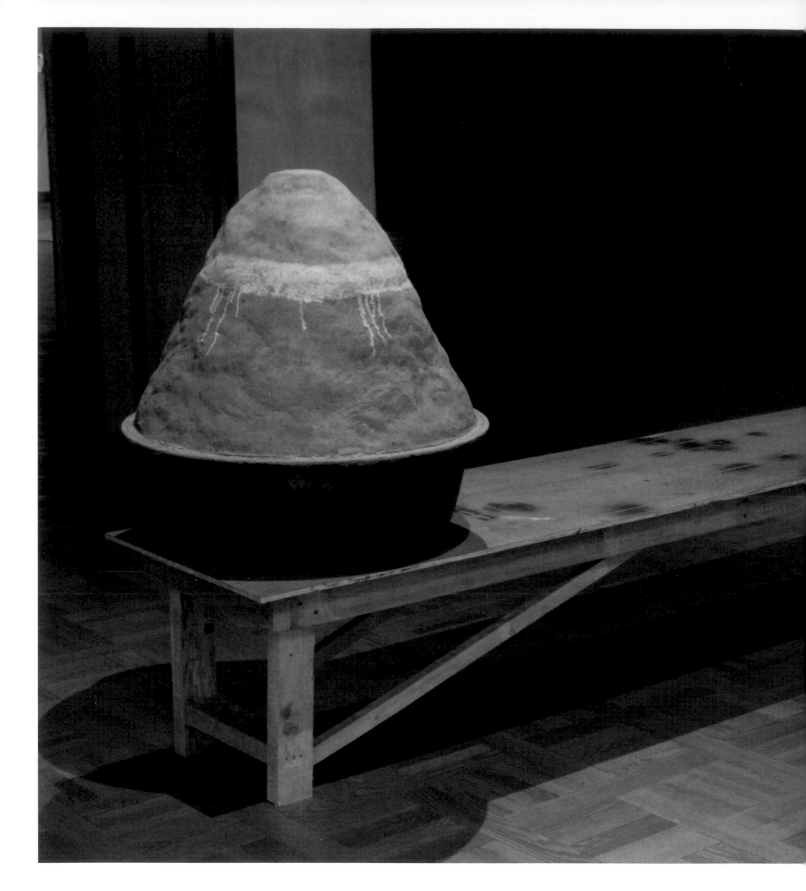

SOMETHING FOR NOTHING / 1998 / concrete, rubber containers, gesso, and wood /
49¼ × 29½ × 157½ inches (125 × 75 × 400 cm)

Bahc
Yiso

This interview with Bahc Yiso is a compilation of segments from the artist's previous interviews and working notes, created in consultation with Hawon Ku, the executor of the artist's estate. The first section is excerpted from a 1998 interview with Mo Bahc, as he was then known, by the artist Se-joon Hwang in the newsletter Forum A; *the second section is excerpted from an interview originally published in the second issue of* Forum A *in 1998; and the final section is a fictional interview with Bahc Yiso edited by Sunjung Kim, based on texts from the catalogue for the exhibition* Divine Comedy—A Retrospective of Bahc Yiso *at Rodin Gallery in 2006.*

Se-joon Hwang: After you returned from the United States, you were passionate about art education and influenced many younger artists. What was the Korean art-college and art-education experience like for you?

Bahc Yiso: I remember entering my art college out of a motivation that resembled an escape from reality and then feeling shocked to discover that it wasn't all that different from junior high or high school. Thinking that I needed to escape to another place, I looked into the possibility of studying abroad, but I couldn't do that without a university degree. So I spent my college years as if buying a qualification for overseas studies and barely managed to graduate. Even now, looking back on the art education I received, I feel that it was a clear waste of time. I was comparatively satisfied with the quality of the education I received in the graduate program in New York. Even so, after graduation, I again discovered that the contents of that education were really behind the times—the 1980s. I felt yet again that the wrong choice of school led to a waste of time, but then, how many things in life are not a waste of time? From the development or productivity-oriented point of view, in actuality, life is perhaps full of such wastes of time.

SH: You often work with unconventional art materials such as plywood, cement, plastic, and even soy sauce. Is there a particular reason why you especially pay attention to such materials?

BY: Rather than for any particular reason, it seems to have to do with my cynical tendency and personality. When one uses typically used artistic materials without really thinking about it, there's the trap of the materials becoming needlessly sincere and serious and easily aligning with institutions and conventions. That's not why I make special efforts to use such materials, however. I still use pencil, paper, and watercolor a lot. I don't pay particular attention to materials and mediums, nor am I all that interested in them. I just use them, and it's only later that others remind me that I used those materials.

SH: I often see writings that explain your practice in terms of society and politics. What are the aspects of the world that you try to reveal in your art?

BY: I suppose there are incidentally social and political contents in my work, but most of the time, I don't think so. The aspects of the world I try to reveal are not there clearly. I tend to be an agnostic, and I believe that confusion, which humans cannot ultimately comprehend, is the real face of this material world.

SH: I have heard that you once used a recording of your own singing of a direct translation of Billy Joel's song "Honesty" in one of your works. What does "honesty" mean to you?

BY: I think "honesty" is a preposterously important universal value, which is why there is so little space for "honesty" . . .

Interviewer: Let's talk about your *UN Tower* (1997), which you exhibited at the 1997 Gwangju Biennale {see page 63}. This work started from the image of the UN Tower found on the box of matches one could find easily in Korea in the 1970s and consisted of a pencil drawing, a Plastiline model, and an installation.

BY: Even if an artwork hanging on the wall does not have tremendous impact or is not effective and forceful vis-à-vis given fictive circumstances, I still see that it has a highly interesting potential for resistance. I am actually more interested in the ineffectiveness and lack of communication in the work of art. This is because I have little faith in the possibility of transparent communication and expression.

Most of my works deal with tensions between two seemingly contrary operations. This tension is less a collision than a "distance" between this and that, or the vague indeterminacy of "both" or "neither, nor." And this force may also be the boundary between strength/weakness, political /apolitical, center/periphery, East/West, solidity/softness, tradition/modernity, male/female, reality /unreality, and even functional object/artwork. For me, art is a journey in the generous and endless "gap" unfolding between the established realm of such objects and perceptions and their meanings.

In the process of legitimizing this relentless suspicion of all, the personal traits like cynicism, pessimism, and hypocritical disinterest cannot help but get mixed up with the abovementioned layered meanings. I am interested, therefore, in serious jokes through ordinary things and materials and thus in stimulating viewers' "independent subjective interpretation."

I: In your *Big Dipper in Eight Stars* (1997–99), you added an additional star to the seven stars of the Big Dipper. What is the meaning of this addition? {In Korean, the Big Dipper is called *Bukdu chilseong,* which can be translated as "Seven Stars of the Northern Ladle." Thus, Korean speakers automatically think of the constellation in terms of the number of stars in it.}

BY: While I often make a work with a specific intention, equally often, I follow a meaning accidentally discovered in the process of trying this or that. This particular piece started from trying to make the Big Dipper with star-shaped stickers I bought in a stationery store and adding the eighth star by accident. Someone who happened to be visiting my studio commented that the shape of the stars was nice, and I myself came to like it a lot. If I were to explain more intelligently why this was so . . . perhaps I could say that it seemed to show a border between misunderstanding and communication. Even if there are eight stars, instead of seven, as long as the overall shape resembles a dipper, anybody can recognize what it intends to be. If I were to describe it again in a rather infantile manner, just like the [Korean] children's ditty, "One star, one me," my star found its way into the Big Dipper—in which case, it would signify a personal hope or wish. I learned afterward that there is a mural of the eight-starred Big Dipper found in an ancient Korean royal tomb. I was delighted to find out about this and imagined that I was a reincarnation of the ancient artist who made the mural.

Interviewer: The works you presented in the Korean Pavilion exhibition at the 2003 Venice Biennale felt rather obscure to foreign critics and viewers. How do you want your art to be read by different audiences in different venues?

BY: Most contemporary artworks cannot be properly comprehended without an introduction or introductory text. My work appears "difficult to understand" only when compared with the visually pleasing or spectacular works by other artists that convey their message in very direct ways. I am always interested in how my work is read. Some of my pieces may very well have a meaning for Korean tourists or Asian viewers, especially when language plays an important role in it. But that's not to say that I don't think about foreign audiences. Some people say that they listen to foreign songs rather than songs in their own language because it feels more comfortable. Misunderstanding and miscommunication can at times lead to highly creative acts. Ultimately, there are a lot more things we don't know than those we know.

I: *Untitled (The Sky of San Antonio),* which you made in 2000 for an exhibition at Artpace in San Antonio, Texas, consists of projections on the floor of images of outdoor landscapes captured by surveillance cameras facing the four cardinal directions {see page 64}. This work further evolved into another version, presented in the 2001 Yokohama Triennale; there, the projection on the floor showed the changing image of the sky as the camera followed the movement of the sun from 10 a.m. to 6 p.m. Could you discuss these works?

BY: The collapsed walls and the ambiance of a construction site recall the limitedness and meaninglessness of cultural and human efforts, while the sun's movement suggests that nature exists as is, with no stated intention. There are paradoxical contents here—a dazed gaze at the flow of time, along with an observation of the origin of life—and, at the same time, it is an expression of sympathy for the unfair position of the great sun deemed as a merely bright lighting. Or, it could also be a comment on the artist's and people's . . . difficult everyday life, waiting for a day when the sun will shine brightly. If one were to see the white wall as a canvas or an artistic symbol, it could also be an act of drawing by the protagonist of the solar system.

I: When we worked together in Shanghai to exhibit your work *Wide World Wide* (2003) {see page 65}, I got to witness your process of making. I would like to hear you describe your notes for the work.

BY: The title of this work is a parody of the World Wide Web. Although it seems that words like globalization, neoliberalism, and the Internet rule reality, in actuality, human life, as it has always been, knows little about the world and is shabby, trivial, superficial, and unfocused.

Dealing with the wide, broad world through the form of a clumsy map, this work consists of a large-scale painting—a primitive artistic medium—and lighting placed in front of it on the floor like candles. The painting itself comprises strange names of small cities no one knows, awkwardly inscribed against a pale blue background. The impression one gets here resembles that of little flotsams on an infinite sky or sea. The names of these cities that no one will ever go to—Araraquara, Fakfak, Nunachuak, Quezaltenango, and so on—become signs of emptiness, reflecting and recalling meanings of reality, the world, communication, places, and identity. The pale blue lights placed like light towers in front of this world map, which is both empty and densely filled with names, seem to interfere with the viewer's gaze, but in fact, they memorialize and commemorate the relationship between the generosity and poverty of the world.

It is also a thread of hope for understanding, a testimony to desperate ignorance, and a sentimental memory of that which we know yet don't know, that which we don't know yet know, and that which we don't know now and will not know in coming days. Perhaps it also tries to show that the unknown parallel universe is not far away but actually exists with me here and now.

I: Could you discuss *We Are Happy* {see page 74}, the large billboard that you plan to produce?[1]

BY: I once saw an enormous propaganda billboard inscribed with those words on top of a building in North Korea. I think I saw that in a TV program in Seoul or in a news program that was about North Korea and was shocked by its gargantuan scale and its direct expression and complex irony. Rather than propaganda, I viewed this as a philosophical question about happiness and people's acknowledgment of their ignorance about what to do in order to be happy or unhappy. So, I planned to make this into an artwork of mine somewhere in Korea. In this particular case, my misunderstanding was the point of departure for a future project. And if I get to make this someday, the viewers' responses will include all possible (mistaken) interpretations, encompassing all kinds of emotions from a smile to anger, sadness, and other mixed feelings. If this actually happens, misunderstanding can be painful as well as interesting.

I: What are your thoughts on traditional Korean art? What do you think is the identity of Korean tradition, and what should be inherited?

BY: Honestly speaking, I don't really think about such questions. What's more important for creative makers is uninhibited free thinking and practice. There are considerable side effects brought on by excessive self-consciousness about tradition and reverse Orientalism—i.e., exaggerating local or traditional elements in order to gain international attention.

I: What does making art mean to you? What is art making? What kinds of work are you making, and what kind of artist do you wish to be?

BY: For me, art making is a process of justifying my endless suspicion of everything through using images and materials. And this is also like traveling in reverse into the endless and infinite "gap" unfolding between established meanings and realms. Of course, I try to realize the abovementioned ideas in my work, but I don't even expect my viewers to clearly understand them. For I believe that confused, mixed feelings, the two faces of love and hate, and hesitation and inconsistency approach closer to the true face of the human being.

My greatest private desire is to become an awfully inventive artist who endlessly churns out masterpieces. According to ancient Chinese and Greek philosophy, there are certain basic elements that constitute the universe—that is, iron, fire, water, wood, earth, and wind. Of them, I think "wind" is the most important element and force for creativity, and that's why I would like to be a strong wind. . . . If I keep telling myself that I'm making lots of winds, that might perhaps help me actually overcome my problems.

NOTE

1. *We Are Happy* was produced posthumously for the 2004 Busan Biennale.

Choi Jeong-Hwa (born 1961 in Seoul, Korea; lives and works in Seoul) is a versatile artist who works with a wide range of media—video screens, molded plastic animals, real and fake food, shopping carts, and massive inflatable sculptures. The established leader of Korean Pop Art since the 1990s, Choi is concerned with the ephemeral and variable nature of material life and consumer culture, as is reflected in the very unstable nature of the materials he employs, like plastic. Many of his recent works of bright and colorful monumental sculptures and installations draw inspiration from this abundant plastic life. They are simply made by piling or stacking disposable consumer items together, such as the numerous orderly stacks of red take-out containers he installed on the roof of the Korean Pavilion for the 2005 Venice Biennale, or the multicolored overlapping banners that wrapped the facade of Wolverhampton Art Gallery in the UK. As part of his working process for site-specific installations, Choi prefers to work with the local markets and sellers to obtain his needed materials.

Education BFA, Hongik University, Seoul, Korea, 1987 **Selected Solo Exhibitions** *Truth,* Gallery at REDCAT, Los Angeles, California, 2007; *Welcome,* Wolverhampton Art Gallery, Birmingham, UK, 2007; *Believe It or Not,* Ilmin Museum of Art, Seoul, Korea, 2006 **Selected Group Exhibitions** *Secret Beyond the Door,* 51st Venice Biennale, Korean Pavilion, Venice, Italy, 2005; Liverpool Biennial, Liverpool, UK, 2004; *Happiness. A Survival Guide for Art and Life,* Mori Art Museum, Tokyo, Japan, 2003; *Yangguang Canlan,* BizArt Center, Eastlink Gallery, Shanghai, China, 2003; *Time after Time,* Yerba Buena Center for the Arts, San Francisco, California, 2003; *P_A_U_S_E,* 4th Gwangju Biennale, Gwangju, Korea, 2002; *MEGA-WAVE,* Yokohama Triennale, Yokohama, Japan, 2001; 26th São Paulo Biennial, Ciccillo Matarazzo Pavilion, São Paulo, Brazil, 1998; *Site of Desire,* 1st Taipei Biennial, Taipei Fine Arts Museum, Taiwan, 1998

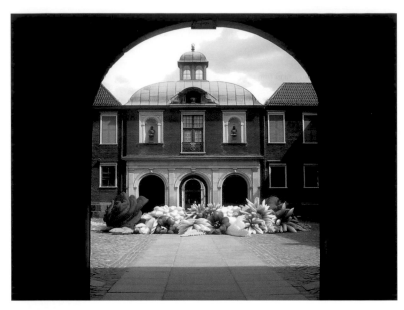

FLOWERFLOWER / 2005 / ephemeral installation / inflatable plastic / dimensions vary

HAPPYHAPPY / 2006–7 / ephemeral installation / chain-link fence and plastic containers / dimensions vary

SUGARSUGAR / 2006 / plastic baskets / dimensions vary

SITE OF DESIRE / 2005 / ephemeral installation / red plastic take-out containers / height: 215⅜ inches (547 cm) / installation view at the Korean Pavilion, Venice Biennale / Venice, Italy / no longer extant

Choi
Jeong-Hwa

Sunjung Kim: What does art or arts mean for Choi Jeong-Hwa?
Choi Jeong-Hwa: Business art, art business, business art business.

SK: You are working in many different capacities —as a designer, architect, artist, curator, and so forth. What is the most important role that you pursue?
CJH: Choi Jeong-Hwa who's like sprouting grass.[1]

SK: What does Korea mean for you?
CJH: Moran open-air market.[2]

SK: You often deal with irony in your work. What would you say is the most important element in your work?
CJH: Proper and well-done copying.

SK: Early in your career, you worked in an artists' collective named "Museum" (with other artists such as Lee Bul, Go Nak-beom, and Lee Donggi). I'd like to hear about how the group came together.
CJH: All our schedules worked out.

SK: Your work addresses popular culture and many contradictions in everyday life in Korea. What are the things you are particularly interested in?
CJH: I don't know.

SK: You are showing your work quite a lot overseas recently. What is your position on this?
CJH: I'm not getting any exhibition offers in Korea.

SK: You have worked a lot on underground cultural events and in clubs since the late 1980s. You often showed your art in clubs or cafes rather than in formal exhibition spaces, at the same time organizing your own exhibitions and events. Is there any particular reason for this? What is the relationship between underground culture and your art?
CJH: Underground? I like most general and popular things.

SK: You showed not only your work but also other artists' works in your solo exhibition *Believe It or Not* at the Ilmin Museum of Art in Seoul in 2006 and in your solo exhibition in the UK in 2007. What was your intention behind this?
CJH: They were combinations of great collections.

SK: What is your position on appropriation?
CJH: It's something we all do, just like eating.

SK: What do you think is the role of art in society?
CJH: No comment.

NOTES

1. "Sprouting grass" is a phrase customarily used to refer to children—especially children as uncorrupted, hopeful, and representing the future.

2. Since the 1960s, Moran open-air market, in Seongnam, Gyeonggi Province, has been the largest market in South Korea, held every fifth day on dates ending with the numbers four or nine. On the market day, almost fifteen hundred merchants and vendors gather around the open-air market and sell all kinds of goods, including a large variety of flowering plants, grains, medicinal herbs, clothing, shoes, fish, vegetables, pepper, food, pets, poultry, and so forth.

Gimhongsok (born 1964 in Seoul, Korea; lives and works in Seoul) fabricates and orchestrates fictional realities in a diversity of forms—video, sculpture, performance, paintings, and installations. All of his works convey his interest in visual and linguistic interaction, conflict, and play. Gimhongsok carefully creates elaborate frameworks and vessels through which to view the absurd roundabout and inexact science of translation and languages. In his videotaped performance *The Talk* (2004), an actor posing as a migrant worker dressed in foreign garb explains his rights to the artist and to an actress posing as an interpreter. The migrant worker converses in a nonexistent language explained by unrelated English subtitles. In *Oval Talk* (2000), Gimhongsok tells a concocted tale of how a make-believe nation's founders were born from an egg. The resulting gigantic egg sculpture houses a recording of the artist reading the English translation of the story. The artist also stages unsettling situations through his performances and video works to test society's limits, such as *Neighbor's Wife* (2005), where he rephotographed photographic reproductions of artworks in a catalogue of a well-known artist. In his 2008 installation of *The Bremen Town Musicians* (2006–7) at Hayward Gallery in London, Gimhongsok staged full-size models of the tale's characters to see how the viewers would react to his claim that he paid a Mexican family to be in the character costumes.

Education BFA, Seoul National University, Seoul, Korea, 1987; Kunstakademie Düsseldorf, Düsseldorf, Germany, 1996 **Selected Solo Exhibitions** *In Through the Out Door,* Kukje Gallery, Seoul, 2008; *Neighbor's Wife,* CAIS Gallery, Seoul, Korea, 2005; *Cosmo Vitale: Gimhongsok and Sora Kim,* Gallery at REDCAT, Los Angeles, California, 2004; *Retro Bistro,* Alternative Space Loop, Seoul, Korea, 2001; *Heromaniac,* Gallery Hyundai, Seoul, Korea, 2000; *I'm Gonna Be Number One,* Keumsan Gallery, Seoul, Korea, 1998 **Selected Group Exhibitions** *Laughing in a Foreign Language,* Hayward Gallery, London, UK, 2008; *All About Laughter,* Mori Art Museum, Tokyo, Japan, 2007; 10th International Istanbul Biennial, Turkey, 2007; *Brave New Worlds,* Walker Art Center, Minneapolis, Minnesota, 2007; *Peppermint Candy: Contemporary Art from Korea,* Museo de Arte Contemporáneo, Santiago, Chile, 2007; *Secret Beyond the Door,* 51st Venice Biennale, Korean Pavilion, Venice, Italy, 2005; *ANTARCTICA: Sora Kim & Gimhongsok,* Artsonje Center, Seoul, Korea, 2004; *Stranger than Paradise,* Total Museum of Art, Seoul, Korea, 2004; *Dreams and Conflicts,* 50th Venice Biennale, Arsanale, Venice, Italy, 2003; *P_A_U_S_E,* 4th Gwangju Biennale, Gwangju, Korea, 2002; *ASIANVIBE,* Espai d'Art Contemporani de Castello, Castello, Spain, 2002; *Under Construction,* Tokyo Opera City Art Gallery, Tokyo, Japan, 2002; *Listening to New Voices,* P.S.1 Contemporary Art Center, New York, 2002; *The Sky Is the Limit,* 3rd Taipei Biennial, Taipei Fine Arts Museum, Taipei, Taiwan, 2000; *Asian Exhibition,* Mattress Factory Museum of Art, Pittsburg, Pennsylvania, 1999

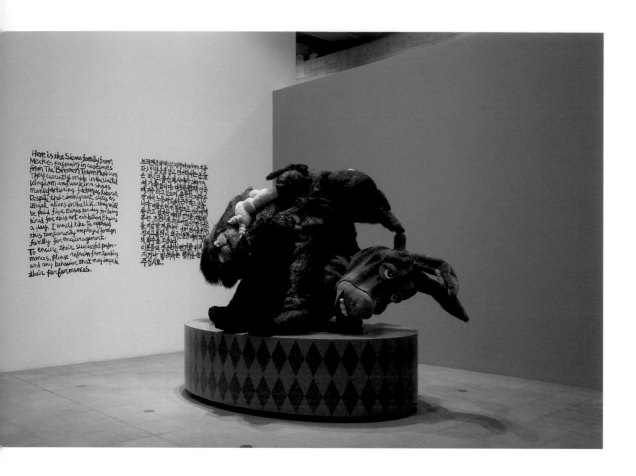

The people performing in the costumes of characters from Grimm's Bremen Town Musicians is the Sierra family from Mexico. They currently reside in the United Kingdom and work in a shoe factory. They are currently illegally employed in the U.K., and they have been illegally employed here as well. Despite such unfavorable circumstances, they will each be paid five Euros per day for acting in this exhibition for eight hours a day. Let us applaud this temporarily employed Mexican family. To ensure a successful performance, we ask that you please refrain from touching or disturbing them.

THE BREMEN TOWN MUSICIANS (and detail) / 2006–7 / foam rubber, fabric, wood, and paint / 102⅜ × 82¾ × 98⅜ inches (260 × 210 × 250 cm), plinth: 87 × 57½ × 21¾ inches (221 × 146 × 55 cm) / collection of Art Pension Trust, Beijing

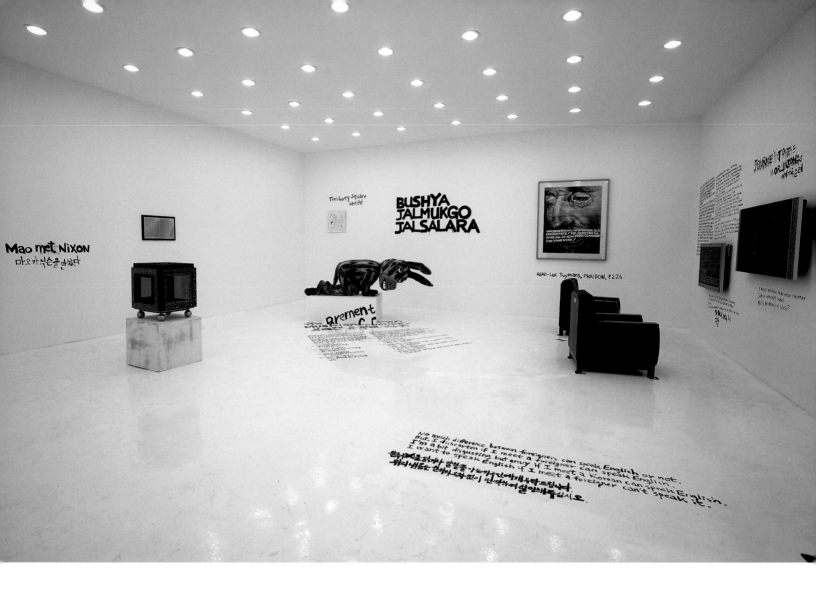

SALON DE BELLE-SEOUR / 2006 / mixed media / installation at the 6th Gwangju Biennale

BUNNY'S SOFA / 2008 / foam rubber, fabric, and wood / 77⅝ × 32¼ × 25⅝ inches
(197 × 82 × 65 cm) / private collection

AN ORATOR—ICH BIN EIN BERLINER / 2006 / single-channel video, HDD from 16mm original /
11:26 min. loop / collection of the artist

THE WILD KOREA / 2005 / single-channel DVD from HD original / 16:20 min. loop / collection of the
Museum of Fine Arts, Houston, museum purchase with funds provided by the Caroline Wiess Law Accessions
Endowment Fund, 2007.1279

Gimhongsok

Sunjung Kim: Let's start a discussion about your two-person exhibition with Sora Kim at the Artsonje Center, Seoul, in 2004. The exhibition presented two solo exhibitions in one shared space rather than the collaborative projects you had made. You showed a range of works—such as performances, sculptures, murals, and text-based works—and they seem to me to be related to *How Deep Is Our Love?* (2000), one of the works from your project *Live Archive*. Could you first describe your work before the exhibition?

Gimhongsok: I have a very fond memory of the Artsonje Center exhibition because it was a summary of my work from 1998 to 2003. When I started making art in 1998, what motivated me artistically was anger and frustration. And these emotions arose from disappointment with the general situation of Korean culture and from resistance against the violent methods of expression in Western art. And these emotions, which were kind of like a psychological complex, constituted the foundation of my early work, but I never made a work filled with a sense of inferiority.

The method of resistance I could deploy at the time was to create an extension of the Western artistic context, and by doing so, I instilled in myself a belief in the potential of an Asian resolving this problem. And my use of diverse mediums was an example of this. At the time, there were vibrant debates about postcolonialism and Korean identity. I remember that they tended to imitate discourses originating in the West and weren't as developed and diverse as they are now, but they were still sincere reflections, nonetheless. In this situation, I wanted to be proud and free like a Western artist in my artistic expression. I felt that taking pleasure in what I was doing was more important than an obsession with changing our way of thinking. I wanted only to escape from the overwhelming, unresolvable weightiness of the so-called Korean problem and Asian identity and to find a place in some corner of contemporary art.

Most of my works at the time were part of one of my projects, *Cheating Art*,[1] and took the form of performance, video, recording, and so forth. It was the beginning of not art making, but the art of reading, and the works were mockeries of society and parodies of representation. Since 2000, however, there have been changes in the contents and methods of my art.

SK: You collaborated with Sora Kim from 2000 until 2003. How did you start the collaboration, and what was its methodology? I am curious about your processes and how you split responsibilities.

G: Artistic collaboration operates in a different way than individual expression. It is founded on conversation and arises from anticipation of mutually beneficial effects. I was very encouraged by the conversation-based methodology, and Sora Kim was a very gratifying partner in this. The differences in our stances and perspectives toward the same events or phenomena generated interesting results in our collaboration.

The current ongoing collaboration with Chinese artist Chen Shaoxiong and Japanese artist Ozawa Tsuyoshi began from another angle. The basic conditions—for instance, each work starting from a conversation and respect for one another's interpretation—are identical to those of my collaboration with Kim. Most people seem to have anticipated that our collaboration would produce a highly unique dialogue born out of our different nationalities and languages, as well as our related histories and the shared geography of Asia. But three of us decided intentionally to reject political, ideological, and nationalist positions and instead talk about universal humanist values, which satisfy us very much. Our conversations are conducted in English, in which we are all limited, so they progress only through extremely primitive expressions. Yet, ironically, this stimulates our imaginations far more. At first, we felt that linguistic communication was extremely important, but we were very satisfied with discovering that the completely reverse situation can unfold as a conversation with much more potential. It wasn't our original intention, but we expect that this method will continue to show us a lot of possibilities.

SK: I think the subjects and contents you address in your art can be divided into four categories: first, text-based works about "translation" and "mistranslation"; second, works about institution; third, works about social behavioral rules; and fourth, works about the essence of art and the problem of representation. Could you share your thoughts on each of these categories?

G: I think all of them start from one point of departure. Let's take the example of the car: first it is a concept, and then it is manufactured as an object; it has a producer, a plan for its sale, a customer, a manual; and there is also the act of driving. This functional object possesses many meanings and processes. Similarly, those four categories in my art represent extremely basic attitudes toward the larger discourse of art.

SK: What is the subject matter that interests you?

G: World histories written in Korean, foreign literature translated into Korean, TV dramas made in the West, and foreign-language textbooks bring me inspiration. I'm fearful of traveling to unknown places. I'm especially passive about looking for new things myself. This arises from my own personal preferences. It's not a certain intention that determines the protocol of my actions. Therefore, I'm very familiar with observing the world through indirect experiences. Texts that are interpreted by others give me pleasure, and it is in interpreting them again that I can discover possibilities of offering something that is new. While this mode of working is parasitic, it's not being subservient to or changing other subjectivities. I, thus, often mistakenly feel that I am on a perfect journey. It seems to me that this is a kind of play on metalanguage.

SK: Could you speak more about the process and methodology of your work?

G: Most of my projects begin with a single word or a combination of words. Sometimes these words originate from the theme of a particular exhibition, but they are derived mostly from television. Whenever I have time, without fail, I watch television. Watching the TV lying on the floor in my room pleases me greatly. My relationship with the TV is one-directional and selfish. I don't get information or comfort from it. It just runs with electricity, and I lie in front of it. But I often think about the intentions of those who make TV programs. Then, words begin to arise vaguely, and I randomly select one from those words in my head. I change the dictionary meaning of the word into another meaning, and combine this word with a changed meaning and other objects. Of course, these objects are combined not as a material but as a text. Afterward, these conjoined words are turned into fictional stories, which could be a history, fairy tale, or slogan. Then I apply these narrations that I tell to reality. I would tell such fictional histories to young students or explain other artists' works in my own ways. Most of these fictional narratives are lies. I manipulate them to appear as plausible as possible so that people can't necessarily tell that they are fictional. These lies could become photographs or video recordings, or the videos themselves could turn into fictions.

When I feature an object, it gets accompanied by a fictional text about its provenance: for instance, presenting the secret history of an unknown conversation between Mao Zedong and Richard Nixon, which was collected and preserved at the time by the CIA in collaboration with scientists (*Mao Met Nixon,* 2004); turning collaborating modern dancers into corpses, with the theme of a massacre, and making them lie on the floor with no movement for two hours (*The Seoul Massacre,* 2004); and rephotographing photographic reproductions of artworks in a catalogue of a well-known artist to turn them into photographic works (*Neighbor's Wife,* 2005).

In these three examples, there are three other problems: first, the relationship between my lies and the audience; second, participants in the performance and the exchange of money; and third, the debate of forgery with regard to other artists' works. These three kinds of issues often produce ethical collisions and create two camps: those who celebrate them and those who are antagonistic toward them. The most controversial of the three is the second case. A series of uncomfortable situations happened because of the intentions and contents of works like *6-Way Talks* (2005), in which the national anthems of the countries involved in the six-nation talks—South Korea, North Korea, the United States, Japan, China, and Russia—were sung by foreign workers living in South Korea; *Pickets* (2004), in which the underpants of women in their twenties were collected and sold as a benefit event for an underage girl who was sexually assaulted in the United States; and *Literal Reality* (2004), in which curse words written in Vietnamese were installed in Korean and American museums [see page 38]. The ways that such works of mine developed arose completely from TV, and I don't think their intentions and contents caused any physical damage to others.

At the 2006 Gwangju Biennale, I gathered all of the abovementioned artworks in one place and created a linguistic space in which they became one story. The installation consisted of three videos, three photographs, two paintings, two objects, two photographs, and one performance. I installed all of these in one large room in a way that connects all of their meanings in the totality of one work. None of the works was newly created for the exhibition, and they had been completed as individual pieces. Although they were preexisting works, in this white cube, they operated with new meanings. In that sense, the installation was an experiment to see how completed individual works can have another interpretation when they are seen in new contexts. It also means that completed works by other artists could change into new works when seen in different venues and with different intentions.

One of the three videos, *The Talk* (2004), is about translation and communication and shows a stage actor explaining his rights to me and to an interpreter in a nonexistent language. The subtitles in the video are in English and tell a story of an Indonesian laborer's success story in Korea, which is completely unrelated to what the actor is saying.

Another video, *An Orator—Ich bin ein Berliner* (2006) [see page 95], begins with the Korean translation of the famous speech that the former American president John F. Kennedy gave to West Germans in 1963 in front of the Berlin Wall. I trained a Korean grade-school student and recorded him giving the speech.

As explained above, these videos feature not myself, but other participants, and the rather heavy subjects of human rights, ideology, and ethics that they are asked to deal with are alleviated by financial compensation that I provide to the performers. But at the same time, I personally deem the contractual relationships created by this payment to be more important than the works' heavy subjects. It is exactly this point about which viewers feel uncomfortable.

Because of this series of works—that is, because of the collision between my works and the viewers—I devised a performance in which a performer wears a life-size puppet costume and maintains a particular position specified by me, the artist. But in fact, I didn't employ a performer and instead placed a mannequin inside the costume. This is *The Bremen Town Musicians* (2006–7), which was also included in the Gwangju Biennale installation [see page 93]. The text, which I wrote on the floor of the gallery and which served as a kind of introduction, provided the false information that a Mexican laborer was doing the performance for a specified

period of time in exchange for money. If the viewers knew that, in fact, it was just a mannequin, they might no longer feel uncomfortable. This work combines the formal motif of *Love Lasts Forever* (1999), a piece by Italian artist Maurizio Cattelan, and the contents of the work of Mexico-based artist Santiago Sierra. In addition, the installation also included a text-based work by the Danish artist group Superflex and a photographic appropriation of a painting by Luc Tuymans. All the works that were installed in the room shared the theme of communicative potential with the "other" (the West). All the texts written on the floor and walls were related to individual works and, at the same time, were independent texts, capable of generating their own meanings. And the linguistic problems of these texts ultimately propose questions in regard to the possibility of communication.

SK: Your video *The Wild Korea* (2005) {see page 95} is based on a fiction. Could you speak about the motivation behind the work and its process of production?

G: The most important country in the founding of modern Korea and its history is the United States. The television and radio broadcasts run by the American military stationed in Korea from the 1960s through the 1980s provided Koreans an avenue of communication with the outside world for a long time. The Western movie I came across at the time was less a history than a kind of science fiction or fantasy. Gun possession and one-on-one duels are still attractive to me. Good and bad are clearly distinguished, and answers are clear, which is cathartic.

After the end of the Korean War in 1953, two Koreas were at the height of confrontation between democracy and communism. With Park Chung-hee's coup d'état in 1961 and the subsequent military rule, the structure of confrontation changed into one of autocracy versus democratization, which continued until 1986. As someone who attended college in the 1980s, I had to find my political position rather passively through protest strikes and demonstrations. In fact, the confrontational binary continues to the present, and it has the very convenient structure that if you are not on our side, you are an enemy. Because there is no middle area, it makes it easy to fight, curse, and even change your own ideology. *The Wild Korea* contains more than just a story of Korea. Rather, it tells about the Western dualistic way of thinking and the contradictions of Asia under its influence. The fiction of gun possession itself, therefore, is not important.

SK: I would like to hear your thoughts on your works classified under *Cheating Art*. They seem light, fun, and also confusing. While their forms are entertaining, they are also perturbing. Could you please discuss *Egg-Hockey-Pockey*, *Vertigo*, and *Making a Star*?

G: The works classified under *Cheating Art* form the basis of my early work and began as a parody of the problem of representation in art and viewers' attitudes toward art. *Egg-Hockey-Pockey* (1998) and *Vertigo* (1999) were both records of performances and videos; that is, performances were first done, and then re-presented in the museum, thus reversing the conventional artistic method of displaying actual conditions of the past.

Vertigo was a performance done on the top of a building on the day of the exhibition's opening, and the hosting museum and I officially promoted the event. There wasn't much to write home about the content of the performance; I sat in a chair on top of the ten-story-high building and intended to make a kind of declaration into the emptiness. The site of the performance had limited access because of the lack of safety measures, so the performance's process was projected as a real-time video inside the museum. On the day of the opening, the museum's director informed me by mobile phone that many visitors had arrived and requested that I begin the performance. Soon, my face appeared on the projection inside the gallery, and with my greeting, the process started. As I approached the chair placed at the corner of the rooftop, I plunged from the top of the building to the ground. And this free fall was recorded by a small video camera that I was holding and was shown to the viewers in real time. After the fall, I stood back up with no injury, let the viewers know that I was alright, and with that, the performance was over. The video shown in the gallery had been previously shot, and I was watching it from the back of the audience. This video fraud deceived most of the viewers, which could be done successfully because I didn't let even the museum know of my plans.

What I did here was to represent inside a specialized environment (the museum) the action of falling that is difficult to see in reality but which we are familiar with through mediums like film. I was paying attention to the fact that one reserves aesthetic or reflective assessment on a dramatic and violent action when a cinematic fiction is realized as an actual situation. That is, only an incident and a fact existed here. Furthermore, there was also a parody of the history of the mediums of performance and video and of the conventional means of artistic expression that utilize them. Artists have performed certain actions in certain places to show to others, and when it wasn't possible to show them, they have completed their works through other mediums like photography and video. Then the specificity of the location is emphasized, and viewers of the work have found meaning in such a process and the artist's intention. While I was using the two mediums—performance and video—in traditional ways, I wanted to say that, in fact, they function quite differently.

Making a Star (2000) unfolded in a different way. Although it has a similar structure as the other work discussed above, the performer wasn't the artist but another person, thus creating a bit of an ethical problem. The work began with my offer to make a woman I met at a karaoke bar into a professional singer. Accepting the offer and all the conditions regarding costume, makeup, stage production, and song composition, she started a two-month-long training program. In her debut at the opening of the exhibition, she presented a very satisfactory performance. Her choreography was especially superb, but despite her request, I made no comment on it. This was the main intention of the work; I wished to test how she would handle the stage without having trained in that aspect. She perfectly handled her own choreography, fitting the music, and I was thus able to conclude that her movement was a representation of what she had learned through mass media. Although I was criticized for not revealing my intention to her and for testing her ability, it was for me an opportunity to confirm that a movement acquired through the media could apply to an artistic action. This particular work later became the motif of *Live Archive,* my project about social behavioral rules.

SK: You studied in Germany. How would you describe the influences of your life and experiences there?

G: I think linguistic acquisition for the sake of survival or out of curiosity about another culture leads to changes in thinking about and in understanding a different culture. I myself was helped in understanding the Western way of thinking through my own process of learning a language. Other than that, I don't particularly remember how my life there influenced me. Germany is a country without vitality. It is like a guidebook about a travel destination rather than the process of travel. Perhaps its precision, rationality, and clarity of cause-and-effect could be attractive to some. For me, however, because it's a country with all the right answers, it's not a place for extended residence.

SK: Another early work by you, *Vertical Sleep-Narcotic Piggy* (1998), was also a performance. What were the intentions and content you hoped to show in this work? Could you describe the circumstances as well as what you struggled with as an artist at the time?

G: During the opening of my one-person show *I'm Gonna Be a Number One* at Keumsan Gallery in 1998, I did a performance of hanging on a wall under anesthesia. I was put under by an actual anesthesiologist and intended to show the sleeping artist to the visitors at the opening. Through this performance, I wanted to show the artist, who made the work and who was simultaneously present and absent, and, at the same time, a work of art hanging on the wall. I also prepared and provided a dinner for the visitors, in order to create confusion in their minds with regard to my attention. While eating the meal offered to them and watching me asleep hanging on the wall, they tended to focus more on the meaning of the dinner rather than that of my performance. Here, the visitors weren't mere viewers but passive participants, a part of a manipulated work of art. I played the roles of artist, host, and performer, and the viewers were located as viewers, guests, and participants in the work.

SK: What do you think of Korea?

G: Korea is a sovereign nation that has accepted diverse religions thanks to freedom of religion and is also a country flexible to changing times, as seen in the legal recognition of transsexuals. But at the same time, in terms of its politics, it is a hypocritical nation that worships liberalism and democracy without quite understanding their exact meanings. It is still trapped in the dualistic way of thinking—either this or that—and has little will to adopt the true significance of liberalism. Therefore, it tends to exhibit a highly culturally xenophobic tendency, and its ethnic nationalism reinforces the xenophobia.

Its people easily use English without knowing Latin, and I think such flexibility (or fluidity) can wield a strong influence in the age of immediate action in the future. In other words, to major in physics without knowing calculus doesn't necessarily mean that it's going to be a problem. On the other hand, Korea is equipped with particular national conditions that can work to its great advantage in an age in which multitaskers are more valued than specialists. Korea possesses a population that doesn't know how to give up, along with the national character that prefers the "best out of three" rule of the game.

SK: Do you take an interest and play a role in sociopolitical situations as an artist? What do you think is the artist's role in society and politics?

G: It might be important for art to comment on the essence of aesthetics—or formalism—and for artists to spell out their emotions. Many modern artists, however, have reacted sensitively to social and political situations and have expressed their responses artistically. When confronted with social and political problems of the time, artists seek to express their opinions through art. When the American Republican Party's new foreign policy brought disadvantages to Asian countries, or when Samsung announced the new development of the megacapacity memory chip, architects, musicians, writers, animators, and so on expressed their reactions in their own ways to the imaginable images of the future. I believe artists have done so as well and will continue to play their part.

I am not interested in the extreme methodology of the Situationists, or in the belief that social and political issues, as they are real, must be expressed in direct and clear ways. Although it is true that my recent works address structural problems of society, they aren't about the social role of the artist. This is because of the contemporary philosophical structure in which reality can no longer exist as reality, and this, itself, is the reality. While it is a fact that the current Iraq War originated as a war between the United States and Iraq, the American bombing of Baghdad was broadcast around the world as an image. The images of Iraqi children after the defeat of their country and child refugees from the Somali civil war still provide us with the reality. The assessments and attitudes of those receiving such images are a post-facto problem. In actuality, the consciousnesses and actions of those individuals and groups that go to those places to help these children have nothing to do with artists questioning social responsibility and expressing it in their art. If a will to help them arises in the mind of an artist, that artist should actually be there as a rescue worker (in the spirit of the Situationists' activism). If the artist merely offers a work that claims a social, political position (for instance, a painting that clearly indicates the painter's political stance), that may be a cowardly or dumb act. An expression and the image of the bombing of Iraq are the same problem. Therefore, if an artist made a representational painting of a bombing (for instance, a painting that does not suggest the artist's political position), then the artist is satisfactorily carrying out his or her responsibility. The work, then, can be judged from an artistic point of view.

Just as war and starvation are real problems, the institutional problem of art is real. Just as poverty and race problems are real, the landscape one sees outside his or her window is real. I am positive about art that functions not through relative comparison, but as a means of absolute reflection.

SK: What does the present mean for you?
G: It means reality.
It means an imitation of imitation.
It means modernity.

NOTE
1. This is the title of one of his projects comprising a group of different works. *Cheating Art* consists of *Egg-Hockey-Pockey* (1998), *Vertigo* (1999), *Making a Star* (2000), *Mao Met Nixon* (2004), and *Marat's Red* (2004).

The hierarchy and burden of politics and history figure largely in the stark computer animations, paintings, and sculptures by Jeon Joonho (born 1969 in Busan, Korea; lives and works in Busan). He satirizes popular icons, such as McDonald's, the Statue of Liberty, and the all-American football player, to comment on dominant power structures and capitalism. In the computer animation *The White House* (2005–6), a figure representing the artist is seen effacing the facade of the White House illustrated on the U.S. twenty-dollar bill. Jeon also inserts his virtual avatars to wander and interact with historic places pictured on the banknotes of South Korea and North Korea to humanize these revered yet alienated sites of cultural memory. Other of Jeon's works evoke Korea's tragic past to comment on its present painful situation as a divided country, such as *Escapees from the North* (2007), a video depicting people repeatedly failing in their attempts to climb over a wall, and *Statue of Brothers* (2008), a video showing several toy soldiers moving as if to embrace each other, but then whirling so that their backs are turned to each other.

Education BFA, DongEui University, Department of Fine Art, Busan, Korea, 1992; Vermont Studio Fellowship, Johnson, Vermont, 1997; MA, Chelsea College Art & Design, London, UK, 1997 **Selected Solo Exhibitions** *Jeon Joonho,* Galerie Thaddaeus Ropac, Paris, France, 2008; *HYPERREALISM,* Arario Gallery, Cheonan, Korea, 2008; *HYPERREALISM,* Perry Rubinstein Gallery, New York, 2006; *INSTANT REPLAY,* Posco Art Museum, Seoul, Korea, 2004; *11&11 Korea Japan Contemporary Art 2002,* Gallery 21+Yo, Tokyo, Japan, 2002; *Tomorrow's Artist,* Sungkok Art Museum, Seoul, Korea, 2001 **Selected Group Exhibitions** *Of That Which Remains,* Nassauischer Kunstverein Wiesbaden, Wiesbaden, Germany, 2008; *Peppermint Candy: Contemporary Art from Korea,* Museo de Arte Contemporáneo, Santiago, Chile, 2007; *Contemporary Korean Art in China—Wonderland,* National Art Museum of China, Beijing, China, 2007; *Have You Eaten Yet?,* Asian Art Biennale, National Taiwan Museum of Fine Arts, Taipei, Taiwan, 2007; *27th Biennial of Graphic Art,* Ljubljana, Slovenia, 2007; *All About Laughter,* Mori Art Museum, Tokyo, Japan, 2007; *Circuit Diagram,* Cell Project Space, London, UK, 2006; *On Difference,* Wurttembergischer Kunstverein Stuttgart, Stuttgart, Germany, 2006; *Critics Choice,* Foundation for Art & Creative Technology, Liverpool, UK, 2005; *ShowCASe: Contemporary Art for the UK,* Contemporary Art Society, City Art Centre Edinburgh, Edinburgh, UK, 2004; *A Drop of Water A Grain of Dust,* 5th Gwangju Biennale, Gwangju, Korea, 2004

IN GOD WE TRUST / 2004 / digital animation / 8:10 min. / collection of Arario Gallery, Seoul

THE WHITE HOUSE / 2005–6 / digital animation / 32:16 min. / collection of the
National Museum of Fine Arts, Taiwan

STATUE OF BROTHERS / 2008/2009 / digital simulation of installation including motorized
resin statues, surveillance cameras, projector, speakers, and steel wire

STATUE OF BROTHERS (detail) / 2008 / cast resin models

Jeon
Joonho

Sunjung Kim: You have made a series of video works that uses currency bills. In the videos, the images of bills become the backdrops, and certain things take place in them. *In God We Trust* (2004) {see page 104} takes its title from words that are inscribed on U.S. dollar bills. Let's start with a discussion about this series.

Jeon Joonho: As you described, the text "IN GOD WE TRUST" can be found on all United States dollar bills. I remember, when I first saw this inscription, feeling that it was quite strange, and I also felt a certain resistance. The series arose from the question—who is this "God" that brings those people into "we"? And I felt an antagonism toward the in-your-face, ethnocentric attitude, implying a rejection of all gods except their own.

The video starts with an image of a Korean protagonist who asks people standing in front of the United States Treasury building for directions. The protagonist speaks in Korean, not English, and the video embodies the absence of communication and the lack of comprehension. In the following scene, the image of Thomas Jefferson reading the Declaration of Independence on the back of the two-dollar bill is replaced with the protagonist, dressed in traditional garb, reciting the Korean Independence Declaration. Here, I wanted to create an ironic situation and hoped to maximize and highlight an ironic scene, which is often taken for granted as a reality. Moreover, I wanted to add a bit of a subplot—that is, I wanted to suggest, in this rather comical situation, that the independence Americans desired and Koreans' longing for their own independence aren't so far from each other. In the final scene of the video, the end of the journey, the hero leaves the Hall of Independence, which is depicted on the back of the hundred-dollar bill, to the soundtrack of a well-known song from the 1930s, "Living Abroad," concluding in a typically melodramatic way like in soap operas. Some viewers have commented, "Isn't propaganda too obvious in this video?" I always reply, "Yes, perhaps it may seem that way."

SK: Another video, *The White House* (2005–6) {see page 105}, takes the image of this building on the back of the twenty-dollar bill and shows you appearing to erase its windows one by one. What is the meaning of this act of erasing the windows?

JJ: Although I went to college during the 1980s, I didn't participate in demonstrations and political activities. Rather than being part of ideological battles, I only watched them. Perhaps this video may seem like a work about anti-American ideology because of its image of erasing the windows on the White House, but I am in actuality a rather timid realist who's interested in expressing emptiness, meaninglessness, or the pity I feel. In this work also, the act of erasure does not exhibit any aggression. Rather, the impressions one gets from the figure are those of uselessness and forced labor. The image of the White House, after all the windows and the door have been erased, becomes a completely ironclad castle that refuses any approaches from the outside. But this is also an empty dream.

SK: Your 2003 work *So Rich* consists of images of a figure wandering in empty places with the backdrops of the Gyeonghui Palace, the Raven-and-Bamboo House (*Ojukheon,* the birthplace of the sixteenth-century philosopher Yi Yi), and the Dosan Library (built to commemorate Yi Hwang, the early-sixteenth-century scholar), which appear respectively on the back of the 10,000-won, 5,000-won, and 1,000-won notes. Moreover, things progress in the video in a quiet, subdued way, without any major event; it is far less dramatic than *The White House* and *In God We Trust.* You actually made this work before the two better-known works. Would you say that, as your "bill" series has progressed, it has become more dramatic? I would like to hear your thoughts on the relationships between your different pieces.

JJ: *So Rich* may very well seem less dramatic, but I actually feel that it is the most dramatic and best expresses my personality. Those beautifully printed images on the bills are highly symbolic icons representing certain periods and the spirit of the times. I really wanted to use such representative icons—especially the images that are inscribed on money, the ultimate goal of capitalism—as a subject in my work. The videos I made after *So Rich* have more complex layers, and I included in them more visual and dramatic characteristics from which viewers can understand them in multiple ways. Perhaps that's why these later works seem more dramatic. But *So Rich* and *The White House,* in actuality, have similar structures.

SK: I would like to hear you discuss sound elements, such as wind, birds, and speeches, in your work. What roles do they play and what meanings do they have in your work?

JJ: This is a quite pointed question. My work is a complete fiction. I create fictions like writing a novel, and sounds play a role in making—or faking—these fictions into seeming real. I consider audio in my work to be very important and pay a lot of attention to it.

SK: Are your "money" works meant to be the image of our everyday lives represented by daily necessities, and do you intend to show us our desires for and twisted views of it? Did the series begin with an intention to continue to deal with social and political issues that you address in your art in general?

JJ: Yes to both.

SK: Let's go back to your early work. I remember that it was often about water—such as your video work that showed an image of a waterfall running vertically across the exhibition space, and works titled *Sleeping Water, Heavy Water, Depressed Water,* and so on. Could you discuss them a bit?

JJ: The waterfall piece you describe is titled *Gwanpokdo* (*Viewing Waterfall*). In the past, the literati used to hang a painting of a waterfall in their room and look at it as part of their spiritual training. They believed that as water always flows from high to low, they should lower themselves. By maintaining their spirit even under the waterfall [symbolic of the vagaries of the world], they sought to reach an extreme level of human consciousness. It was in this spirit that they made paintings of waterfalls. Sungkok Art Museum, where this piece was shown, was a residential house remodeled into an exhibition space, so all three floors had the exact same space. I wanted to take advantage of this spatial peculiarity, so I made a column of water run through all three floors. Of course, this wasn't real water but an image of me inside a column of water. It's really cold and painful to be under a waterfall. And the image of me enduring the pain was shown in three separate sections—the head on the third floor, the torso on the second, and the legs on the first—projected on round screens. Inside the screens were rooms where the sculptural installations *Sleeping Water, Heavy Water,* and *Depressed Water* were placed. I wanted to show the extremely detailed and personal dilemmas and stories behind the picture of bearing pain and disciplining oneself toward a certain dimension or ideal.

SK: Could you discuss the work you showed in the 2004 Gwangju Biennale?

JJ: It was called *For Another Memorial.* At the time, war memorials were being built all over the country. There was also a large sculpture of strong soldiers being made near where I lived. Perhaps rather unfortunately, it was the time of the beginning of the United States' Iraq War, and the South Korean army was deploying its Zaytun Division.[1] Memorials for a past war are meant to remind us to not repeat such a tragedy, yet at the same time we were making these memorials, we were sending troops to war. It was this ironic situation that became the background for this work. I borrowed the prototypes for these bronze memorial sculptures, wrapped them in cheap wrapping paper, and displayed them all around the exhibition hall.

SK: Could you discuss *People Walking on Water,* **which you made as part of the Cheonggye Stream Project?**

JJ: This was done for an exhibition that celebrated the will to return the Cheonggye Stream to its original form, which was part of the urban beautification project put forward by Lee Myung-bak, the former mayor of Seoul and current president. The stream is fraught with a lot of histories, and for residents of Seoul, it holds a particularly symbolic power. It was a natural stream that was turned into an open sewer when Seoul was made into the capital in the late fourteenth century, and during the Japanese occupation, it was dredged because it was deemed unsanitary. During the period of military regimes, as part of an urban modernization project, it was covered up, and a raised highway was built over it. Yet again, due to environmental advocacy, the highway was torn down, and the stream was reopened. In short, Cheonggye is a vessel that holds our own changing image and demonstrates the history of modern Korea.

I interpreted the Cheonggye Stream, which links different periods, as the image of an old bridge that crossed it and installed it in the central atrium of the Seoul Museum of Art. Under the installation, you could see an image of people crossing the bridge, and above it, you could see the image of flowing water.

SK: Are you currently planning any works?

JJ: I am thinking of a few video and installation works but cannot discuss them yet.

SK: What does Korea mean to you? Would you share your opinions and thoughts on Korean art?

JJ: I work with both of my feet planted on the ground. What I mean by this is that Korea and my work are in an inseparable spiritual and environmental relationship. And this belief isn't simply limited to the ideology of "Unity of Body and Earth" [*Sinto bulyi*—literally, "body and earth are not two (separate things)"; this expression has gained much cultural popularity and social currency in recent years]. Not only do I view and assess all perceptions about the world from this particular land, but also I know that all types of life in the world are here —even if they are foreign and exotic. Korea is, for me, the center of the world.

NOTE

1. The Zaytun Division is a contingent of Republic of Korea Army troops currently operating in Northern Iraq, carrying out peacekeeping and reconstruction tasks.

By cleverly and meticulously transforming some of the most banal objects in our environment, such as a broom, an iron, or a news report, into fanciful objects and ideas for his drawings, videos, and books, Kim Beom (born 1963 in Seoul, Korea; lives and works in Seoul) stretches the conventional limits of reality on both a literal and conceptual level. In such pieces as *An Iron in the Form of a Radio, a Kettle in the Form of an Iron, and a Radio in the Form of a Kettle* (2002), where the function of each object is swapped without altering the object's appearance, and *Dog Standing #2* (1994), where a canvas placed on the floor appears impressed with four paw prints, Kim draws attention to the limitations of visual perception and reminds viewers of the awesome, though often untapped, power of the imagination. In his concise how-to guide-book, *The Art of Transformation* (1997), Kim also gives instructions to the reader on how they can transform themselves into such things as a tree or a rock.

Education BFA, Seoul National University, Seoul, Korea, 1988; MFA, School of Visual Art, New York, 1991 **Selected Solo Exhibitions** *Kim Beom,* Sun Gallery, Seoul, Korea, 2007; *Kim Beom,* Artsonje Museum, Gyeongju, Korea, 2002; *Flower,* Trans Hudson Gallery, New York, 2000; *Utility Objects,* Trans Hudson Gallery, New York, 1997; *Kim Beom,* Arena Gallery, Brooklyn, New York, 1995 **Selected Group Exhibitions** *Fast Break,* PKM Gallery, Beijing, China, 2007; *Namespace,* Cubitt Gallery, London, UK, 2007; *Through the Looking Glass,* Asian House, London, UK, 2006; *Transmediale 06: Smile Machines,* Akademie der Kunste, Berlin, Germany, 2006; *Secret Beyond the Door,* 51st Venice Biennale, Korean Pavilion, Venice, Italy, 2005; *Parallel Life,* Frankfurter Kunstverein, Frankfurt, Germany, 2005; *Stranger than Paradise,* Total Museum of Contemporary Art, Seoul, Korea, 2004; *Poetic Justice,* 8th International Istanbul Biennial, Istanbul, Turkey, 2003; *Time after Time,* Yerba Buena Center for the Arts, San Francisco, California, 2003; *Yangguang Canlan,* BizArt Center, Eastlink Gallery, Shanghai, China, 2003; *Under Construction,* Japan Foundation Forum, Tokyo, Japan, 2002; *P_A_U_S_E,* 4th Gwangju Biennale, Gwangju, Korea, 2002; *Site of Desire,* 1st Taipei Biennial, Taipei Fine Arts Museum, Taipei, Taiwan, 1998; *Power,* 2nd Gwangju Biennale, Gwangju, Korea, 1997; *Promenade in Asia,* Shiseido Gallery, Tokyo, Japan, 1997

AN IRON IN THE FORM OF A RADIO, A KETTLE IN THE FORM OF AN IRON,
AND A RADIO IN THE FORM OF A KETTLE / 2002 / mixed media / dimensions vary /
collection of the National Museum of Contemporary Art, Gwacheon, Korea

"흙먼지 차에 과실"

But this does not mean that we always act
surprised and cry out

UNTITLED (NEWS) / 2002 / single-channel video / 1:42 min. / collection Artsonje Center, Seoul

ENTRANCE KEY / 2001 / acrylic on canvas / 8½ × 13 inches (21.5 × 33 cm) /
collection PKM Gallery, Seoul

A DESIGN OF AN IMMIGRATION BUREAU COMPLEX ON A BORDERLINE (PERSPECTIVE) /
2005 / pencil on paper / 22 × 31⅛ inches (56 × 79 cm) / The Museum of Fine Arts, Houston, museum
purchase with funds provided by the Caroline Wiess Law Accessions Endowment Fund, 2007.1289

Kim
Beom

Sunjung Kim: Let's begin with the works that were shown in your solo exhibition at the Artsonje Museum in Gyeongju in 2002. In *Untitled (News)* (2002) {see page 115}, you recorded one particular news program for a number of nights, then you purposefully cut the recording up word by word or syllable by syllable to make it read a script of your own making, and finally played it as the audio for another news program. What is the relationship between the text and the images in this work?

Kim Beom: In the scenes of *News,* recomposed by me, the news anchors appear (or reappear) to read the texts written by me as the result of my manipulation of fragments of the original audio. The texts' contents deal with the mass media, which has a monopoly on informing us of what takes place in the world, and with the personal thoughts of an individual, who is accustomed to viewing the world just through the mass media every day. That is, I used news, which incorporates images and spoken language, as the material here in order to broadcast what I think of as "news."

SK: In another work, *Untitled (A Job on the Horizon)* (2005), you carved an image in the handle of a commercially available broom. In fact, handicraft is a notable aspect of your art making. Could you discuss this?

KB: Because I have been drawing and making shapes as a basic part of my art, I tend to devote a lot of my efforts and time to approach forms I desire. I am also personally very interested in crafts, which is why I make, at times, works that have that tendency. And it seems that I make "crafty" works not only for their own formal characteristics but also because of their narrative aspects, which could affirm me and my behaviors or actions. In my view, handmade "crafty" works show more of the "touch" of the artist's hands and more of the personal vision of artistic expression. And usually the process of making is visible in the works (such as the cut marks or fingerprints on clay). My crafty works are usually a little bit different from (academic) sculpture. They are kind of rough and raw, like works of amateur artists. And I try to begin with the idea of making images and the labor of making them as a behavior not of an artist, but of an individual person with some reason or motivation. I often try to begin making works with the idea of daily life and the idea of an individual (rather than an artist) because it is more real to me. In this sense, I want to include narrative or descriptive expressions of how a work was made, what it was made of, how hard or easy it was to make it, why it was made, and so forth.

SK: I understand your *Key Painting* series (2000–2002) as a work about perception {see page 116}. While the shapes you paint on canvases at first appear to be landscapes, their titles include the word "key," and with that understanding, you see the images again as close-up views of the ends of or middle parts of keys. In that way, the series deals with what is seen before the viewer knows the title and how that perception changes once the title is known. Would you see this as a critique of the Western tendency to privilege visual perception?

KB: I wouldn't say that this work is such a critique, but it may very well be about discourses like "what you see is what you see" or "what you see is not what you see." The truthfulness and fallacy of imagery is, for me, the most alluring aspect of art. In the past few years, in works like *Swan* (2004), *Spy Ship* (2004), and the *Prop (Drawing)* series (2001–present), I have wanted to demonstrate perceptual fallacies of imagery in relation with "falsehood" or "camouflage." I have wanted to think of such actions that trick and betray human perceptions, though they tend to arise from rather negative intentions, in terms of the fallaciousness of imagery. In that sense, the subject of the *Key* series is the relationship between object and perception.

SK: *An Iron in the Form of a Radio, a Kettle in the Form of an Iron, and a Radio in the Form of a Kettle* (2002) consists of objects that have switched their forms and functions {see page 114}. And these objects—like René Magritte's *This Is Not a Pipe (Ceci n'est pas une pipe)*—address the relationship between reality and image. Could you share your thoughts on this relationship?

KB: As I mentioned before, this work embodies the visualization of "what you see is not what you see" by means of disguise or camouflage. What I wanted to accomplish here was to create that which is other than the perceived and that which is not its image but something that becomes functional in actuality. I often try to make my pieces not mere images but certain actualities, and for me one of the things that defines "actuality" is "function." In that way, in this work, one can confidently call the objects an "iron" or a "kettle" because they possess the functions befitting their names. As I discussed above, the question of the truthfulness or fallacy of the image is important for me, but what is really important for me is not so much relationships like reality-image-image as how the image can become actual or come to possess actualities, for as long as possible, and thus come to own actual images.

SK: In works such as *Untitled ("Arrow" from Patient #403)* (1999), *Self-Accusation Dictionary* (1994), *Self-Injury Handbook* (1994), and *Untitled (Nailed Two Feet)* (1995), one senses a self-blaming tendency and an interest in death and pain.

KB: I think everybody has such a tendency. Or perhaps I'm especially sensitive to my own mistakes and shortcomings. I find the collisions between different, irreconcilable aspects of my own self very difficult. I used to express this feeling more frequently, but I seem to have gotten more familiar with these problems.

SK: Your installation *A Supposition* (1996) consists of eight drawings and four everyday objects. The first drawing begins with the words "Suppose there is a beastlike man," then continues with "Suppose that is a broken window in the kitchen." The work also commands viewers to suppose objects to be other objects—the water spray as a grandmother, the garden trowel as a cat, and so forth—much like your installation of the standing axe with a handwritten note saying "DO NOT SUPPOSE THIS IS HIM." Because of their preconceptions and experiences, viewers find these commands difficult. I would like to hear about the relationships here between commands and images and the reasons why you used the method of "command."

KB: I use "command" in my work as a means to create particular actions and reactions, which are realistic, and I used this method because it confers more interactive and actual roles to the work. In some ways, the actuality of a work of art is determined by the "response" of the viewer.

In this particular work, commands are used as means of supposition. Suppositions like "let's say this is that" can create a space of multiple meanings in which "this doesn't need to be that," and the two dimensions of "this" and "that" can coexist in a space where objects are placed, such as in a garden, and in a story. I was making a lot of paintings and drawings that incorporate texts, and this allowed me to make more literary and narrative expressions in my work.

SK: You studied both in Korea and in the United States. What influence would you say this experience had on you?

KB: The fact that I felt that stories and questions, dreams and concerns, about art are more or less the same in both places helped me understand "art" in the world. In terms of the experience of everyday life, I got to experience the commonalities and differences in both places, which perhaps gave me a more prudent perspective.

SK: I'd like to hear about your thoughts on the place called Korea. Your *Blueprint* series (2002), which you made after returning from the United States, seems simultaneously to be about a universal place and to address the specific place of Korea. What does this place mean for you?

KB: Korea, in relation to my *Blueprint* series, is a place with a long history of political and social misfortunes. The rather cynical and even misanthropic aspect in the themes and expressions of my work clearly emerged during my formative period. Because this series finds its subject in the image of the human being in society against the backdrop of politics and institutions, the arbitrariness and contradictions I have felt about the world seem to manifest themselves in it. I have a lot of memories about images of common people who accept their places and perfectly perform their roles in this society or in this world without expressing any private emotions in their lives, as drawn in my blueprints. The people who do their jobs—all kinds, including soldiers and police—seem to do their jobs no matter if the thing they do is right or wrong, proud or shameful, easy or dangerous or dirty. They do it without expressing personal emotions, like parts of a machine. At the same time, Korea is a country with a lot of positive aspects as well. It is also the place where the most important things for me are, and for that reason alone, it is the most satisfactory place for me.

SK: *The Art of Transformation* (1997) is an artist book by you. It consists of a text with no images, and the text proposes ways of transforming oneself into a door, a tree, a leopard, a stream of water, a ladder, and so forth. What does this transformation of a human being into an object, a human's self-transformation into a nonhuman thing, mean?

KB: I started thinking about self-transformation while looking at photographs of insects that camouflaged themselves for survival. What was most notable here were questions such as "how could they become so much like their surroundings?" and "how do they feel when they become like that?" And I thought a lot about this in relation to humans—for instance, as in jobs, in terms of processes and efforts in one's possession of the identity one chooses.

Change in one's value system and internal change seem to be much bigger than changing one's appearance. It also seems that humans change their own unique identities, as much as they can manage, through their appearances and behaviors when necessities, such as survival, arise. Perhaps humans are fundamentally and by definition changeable.

SK: You describe another of your artist books, *Hometown* (1998), as something to be used by those who do not know their hometown or by those who do know it but wish to conceal it. And to receive a copy of this book, you must pick up the postcard placed where the book is exhibited and mail it to you. Could you explain more about this work and the reason why you limited it to those who come to its exhibitions?

KB: The essential use of this book is to "lie" to others about having a beautiful hometown, and this is why it is not meant for many people. *Hometown* contains detailed information about a place that doesn't actually exist. It describes—to the extent that its fictiveness will not be discovered—many aspects of this place, such as its lovely nature, gorgeous landscape, customs, history, and legends, which one could very well be proud of and even yearn for. The theme and format of this work also seem to arise from the questions of fiction, as in deception and camouflage, and of actuality. Moreover, contemporary discourses about imaginary space that were discussed a lot at the time seemed to have influenced the work.

SK: You made a video work about a "bullet taxi" {an illegally operated, over-the-speed-limit taxi} running on the now-demolished Cheonggye Elevated Highway that used to run through downtown Seoul. It shows an image of an endlessly continuing space. After the car passes, the same car appears in the rearview mirror, and after that disappears, the image connects to another space in the side-view mirror. This work was made for an exhibition theme, which was "speed," and it narrates a story about space as well as speed. I'd like to hear your thoughts about space in art through this work.

KB: In the video work you described, *Three Worlds (After Escher, Cheonggye Skyway, 1/19/97 5:00–5:25)* (1997), I intended to capture past, present, and future in one moving-image screen through the landscape and speed of the skyway, which represented the typical temporality of Seoul—in the way M.C. Escher's drawing *Three Worlds* contains in it the underwater view of a pond, the surface of the water, and the landscape reflected on the surface. The screen is bisected by the contour of the rearview mirror; the part that is not obstructed by the mirror shows a landscape approaching in one direction, while the mirror reflects the landscape that the car just passed receding far into space. Through this, I tried to express the temporal characteristics possessed by a particular space, based on the movement and speed of that space.

I have a painter's perspective, and the space in art to which I pay closest attention is still that which is inside a "painted" flat image. A space that is created or reconstructed through perception of a story or a shape seems to produce a completely different world and is for me always attractive. Escher's spaces are also possible because they are two-dimensional. Perhaps I have an idealist attitude toward space. And this tendency often conflicts with the works I wish to make and the problem of the actuality of image, therefore creating difficulties for me.

SK: What kinds of works are you planning for your solo exhibition at Artsonje Center in Seoul in 2009?

KB: I recently completed a video work, which tells an animistic story about the deaths of things. In addition, I'm in the process of making, like always, paintings, drawings, some objects that utilize everyday materials, and more meticulous craft objects. There are other works I'm thinking of as well, but they will likely be very difficult to fabricate, so it's not clear yet how many of these plans will be completed.

Kimsooja (born 1957 in Daegu, Korea; lives and works in New York) once said in an interview with curator Olivia María Rubio that her art is concerned with "old questions that have no answer." Though her subject matter ranges from historical tragedies and the role of women in society to nomadism and the relationship between the self and the other, she always endeavors to bring forth the common thread of humanity within them all. She gathers together minimal elements—such as cloth, light, breath, people, her body—to construct her installation, photographic, performance, and video works. In the late 1990s, Kimsooja started making the series *A Needle Woman*, in which she visited eight of the world's large cosmopolitan cities, and later cities in undeveloped countries. In each video of a different city, she is seen standing immobile with her back to the screen while throngs of urban crowds pass by or react to her. In this multichannel installation, Kimsooja acts as a needle threading in and out of the fabric of humanity in each place until they all become unified by her anonymous, silent presence.

Education BFA, Hongik University, Seoul, Korea, 1980; MFA, Hongik University, Seoul, Korea, 1984 **Selected Solo Exhibitions** *Black Box: Kimsooja,* Hirshhorn Museum and Sculpture Garden, Washington, D.C., 2008; *Kimsooja,* Shiseido Gallery, Tokyo, Japan, 2008; *To Breathe—A Mirror Woman (Respirar—Una mujer espejo),* Palacio de Cristal, Museo Nacional Centro de Arte Reina Sofía, Madrid, Spain, 2006; *Seven Wishes and Secrets,* MIT List Gallery, Cambridge, Massachusetts, 2005; *Conditions of Humanity,* Museum Kunst Palast, Düsseldorf, Germany, 2003, Museum of Contemporary Art, Lyon, France, 2003, Padiglione d'Arte Contemporanea, Milan, Italy, 2004; *Kim Sooja,* Kunsthalle Bern, Bern, Switzerland, 2001; *A Needle Woman,* P.S.1 Contemporary Art Center/Museum of Modern Art, New York, 2001; *A Needle Woman—A Woman Who Weaves the World,* Rodin Gallery, Seoul, Korea, 2000 **Selected Group Exhibitions** *Void in Korean Art,* Leeum, Samsung Museum of Art, Seoul, Korea, 2008; *Street Art, Street Life,* Bronx Museum of Art, New York, 2008; *ArTempo: Where Time Becomes Art,* 52nd Venice Biennale, Palazzo Fortuny, Venice, Italy, 2007; *Always a Little Further,* 51st Venice Biennale, Arsenale, Venice, Italy, 2005; *Ideal City—Solares,* 2nd Valencia Biennale, Valencia, Spain, 2003; *Whitney Biennial,* Central Park, Whitney Museum of American Art, New York, 2002; *Markers,* 49th Venice Biennale, Venice, Italy, 2001; *Human-being and Gender,* 3rd Gwangju Biennale, Gwangju, Korea, 2000; *d'APERTutto,* 48th Venice Biennale, Venice, Italy, 1999; 24th São Paulo Biennial, São Paulo, Brazil, 1998; *Cities on the Move,* Secession, Vienna, Austria, Louisiana Museum of Art, Copenhagen, Denmark, Hayward Gallery, London, UK, CAPC, Bordeaux, France, KIASMA, Helsinki, Finland, and P.S.1, New York, 1997–99; *Traditions/Tensions,* Asia Society, Gray Art Gallery, Queens Museum of Art, New York, 1996–97, Vancouver Art Gallery, Vancouver, Canada, 1997, Art Gallery of Western Australia, Perth, Australia, 1998; *On Life, Beauty, Translations and Other Difficulties,* 5th International Istanbul Biennial, Istanbul, Turkey, 1996

A NEEDLE WOMAN / 1999–2001 / left to right, top to bottom: Tokyo, New York, Delhi, Mexico City / four of an 8-channel video projection / 6:33 min. loop / collection of the artist

A NEEDLE WOMAN / 2005 / left to right, top to bottom: Havana (Cuba), Rio de Janeiro (Brazil), San'a (Yemen), N'Djamena (Chad) / four of a 6-channel video projection / 10:40 min. loop / collection of the artist

Kimsooja

Sunjung Kim: I would like to begin with a question about your video installation *A Needle Woman,* perhaps your best-known work {see page 124}. It was made from 1999 until 2001 and was shot in various locations, such as Tokyo, Shanghai, Delhi, New York, Mexico City, Cairo, Lagos, and London. Could you describe your experiences in those cities and countries, and the background of the work?

Kimsooja: When the CCA (Center for Contemporary Art) Kitakyushu [in Japan] approached me about a new project, I had the idea of making a performance video that would show the relationship between my body and the people on the streets of Tokyo. But it wasn't clear what form it would eventually take. At first, I got on and off crowded subway trains, and walked around for two hours. After this two-hour-long period, when I arrived at a street in Shibuya where hundreds of thousands of people were constantly passing through, like waves of a human ocean ebbing and flowing, I suddenly became aware of the meaning of my walking. It was a breathtaking moment. I had to stop on the spot and stand still—creating a contradictory position against the flow of the pedestrians, like a needle or an axis, observing and contemplating them coming and going, weaving through and against my body as a medium, like a symbolic needle.

I decided to record this experience of standing motionless in a crowd, viewed from behind. I immediately let the cameraman know and documented the performance. As if facing and sustaining a giant surf, my body was completely exposed to everyone in the middle of this street, and in the course of this intense standoff, my body and mind gradually transcended to another state. In other words, as I accelerated the state of my isolation, the presence of my body seemed to be gradually erased by the crowd. Simultaneously, as the sustained immobility of my body was leading me toward a state of peace and balance in my mind, I passed the state of tension between the self and others and reached the point at which I could bring

and breathe others into my own body and mind. My heart began to slowly fill with compassion and affection for all human beings living today. Experiencing the extreme state that the body and mind could reach and embracing sympathies for humankind, paradoxically, liberated my mind and body from the crowd. I saw an aura of a bright white light emerging from an unknown source beyond the horizon, and I cannot help but feel that it was a mysterious, transcendental experience.

After the Tokyo performance, I had a desire to see all of the people in the world, and the series *A Needle Woman,* in which I visited eight metropolises on five different continents, came out of this desire. The relationship between my body and the crowds of each city was different in each instance, and the responses I got were also quite diverse. According to the geographical, cultural, religious, and socioeconomic conditions, people responded completely differently to the body of the performer as an "other"—or an Asian female—and my inner reaction also manifested itself in various ways.

In this work, I established the immobility of my body as a symbolic needle, and further questioned my relationships with others through the act of a social, cultural sewing. At the same time, I see this video series as an extension of my *bottari* work, in which I tried to embrace the humanity within myself.

SK: A new version of *A Needle Woman* was made for the 2005 Venice Biennale, with footage you shot in rather dangerous places riddled with many social and political problems {see page 125}. I'm curious about the reasons why you selected those cities and what kinds of issues you wanted to address in such backgrounds.

K: The first series of *A Needle Woman* consisted of real-time videos that focused on the spatial dimensions created by the body as a symbolic needle, or an axis within various spaces in the midst of densely populated metropolises. The new version I presented at the 2005 Venice Biennale takes more of an interest in the cities that are experiencing poverty, violence, postcolonialism, civil wars, and religious conflicts—Patan, within Kathmandu Valley (Nepal), Havana (Cuba), Rio de Janeiro (Brazil), N'Djamena (Chad), San'a (Yemen), and Jerusalem (Israel). My intention was to present a critical perspective on current conditions of humanity. Created in slow motion, this new series places my body at the zero point on the axis of time and explores temporal dimensions by showing the contrast between my motionless body and the others' slow motion. This work also shows the subtlety of the relationship between bodies, and their emotional transitions and psychologies. This was another opportunity for me to explore the question of time, which has been important to me since my first video, *Sewing into Walking*.

SK: *To Breathe—A Mirror Woman,* which was presented in your solo exhibition in the Palacio de Cristal, commissioned by the Reina Sofía museum in Madrid, was a work that changed the context of a given space and its spatiality. It seems that the work places emphasis on changing a space, and on the experience one may have in that space. If your earlier work had been about the two-dimensional experience of visiting different places via performance translated into video, this work asks viewers to experience the very space in which it is shown. Could you discuss the background and intention of this piece?

K: *To Breathe—A Mirror Woman* is a site-specific project that brings together and amplifies the relationships between *yin* and *yang* and the concepts of the needle and sewing that I have been developing for two decades—sewing into wrapping, sewing into walking, sewing into looking, and sewing into breathing. The idea of this project is based on wrapping the transparent architecture of the Palacio de Cristal building into a *bottari* of light and sound. I incorporated the diffraction-grating film into the entire glass pavilion of the Palacio de Cristal to create a constantly changing spectrum of colors; the sound element consisted of a chorus blended from my own breathing and humming. Both elements were absorbed in and reflected by the mirror that covered the whole floor of the building, expanding a "void" within the skin of the architecture, and even becoming one with viewers' bodies and breaths as a sanctuary.

SK: The body is an important element in your work. If *A Needle Woman* substitutes your own body for the needle, what does *A Mirror Woman* do? What kinds of metaphorical functions are performed by the needle and the mirror?

K: If in *A Needle Woman* my body was featured as a tool that symbolizes the needle, in *A Mirror Woman* the mirror functions in lieu of the body that observes and reflects the "other." One can see the linguistic operations of anthropomorphizing the "needle" and the "mirror," which draw out the meaning of the works.

SK: I didn't have a chance to visit your public project *A Lighthouse Woman,* and only got to see photographs of it. How did you start this project?

K: The piece was commissioned as part of the Spoleto Festival in Charleston, South Carolina, in 2002, under the theme of "Witness of Water, Witness of Land." Charleston was one of the coastal cities used for the importation of African slaves. My work consisted of projecting a lighting sequence onto a lighthouse that had been out of commission for almost forty years on Morris Island, where the devastating Civil War began. The piece was intended to breathe life back into the lighthouse and to commemorate the numerous lives lost in the war. The lighthouse was wrapped with a spectrum of nine colors, which gradually changed over the course of a thirty-minute cycle in rhythm with the waves. *A Lighthouse Woman* structurally symbolized the body of a woman waiting for her husband and lover, children and brothers, who had gone off to war. I installed another work at the Drayton Hall Plantation House: four black carpets embroidered with the names of the slaves who had worked there, which were placed in front of the fireplaces of the house.

SK: Your *Bottari Truck* {see pages 41 and 52} addresses mobile globalism. Does the importance of this work lie in the concept of globalism in mobility? Or is it the notion of identity or "being" in the global era?

K: I wasn't thinking about globalism when I made *Bottari Truck,* as I have never made a work related to a particular "ism" or category. I was always interested in the notion of the body, personal histories and memories, and the questions of human despair and desire. I think this particular piece began to be interpreted from the perspective of globalism because the notions inherent in it came to be considered an important point of departure for globalism—such as location/dislocation and locality—and the work evolved with this social change. While I was performing for eleven days throughout Korea, I was paying attention to the mobility of the *bottari* truck, and the continuity of both the *bottari* truck and the stillness of my body on the move. The truck was a moving sculpture, loaded with histories and memories, and its constant mobility and the immobility of my body coincided on a temporal and spatial grid.

SK: It seems to me that works such as *Bottari Truck* and *A Needle Woman* are located on a "border." They also encompass dualities such as inside and outside, life and death, pleasure and sadness. What would you say constitutes your interest in the border?

K: One might say that a consciousness about the "border" forms a sensitive spiritual axis in my thoughts. The idea connects with Eastern spirituality, which interprets all of existence in terms of yin and yang. Awareness of "border" in my work can refer to the question of the surface in painting, which was one of the starting points in my earlier sewing work. I consider the canvas as a mirror of identity, upon which artists are searching for their whole lives. Perhaps my obsession with "border" also has to do with my childhood, which was spent near the dangerous border of the Demilitarized Zone (DMZ).

SK: In your 1994 solo exhibition *Sewing into Walking,* **you developed the concept of "sewing into walking" by transforming "sewing stitch by stitch" into "walking step by step." Did your engagement with sewing start from a feminist point of view, or would you say that it started from personal experience?**

K: This sewing practice didn't arise from a feminist point of view, or because I was particularly fond of, or good at, sewing. At that time I was exploring the structure of two-dimensionality and the world and its methodologies. One day in 1983, I was sewing a bedcover with my mother and suddenly came to realize possible formal, aesthetic, psychological, and cultural anthropological implications in the act of sewing. It was a question and an answer that came to me like a lightning bolt, or a divine revelation. I have to say that it was like a fated encounter between the universe and the needle, my hands and my body, that became an unforgettable event. This realization was completely unrelated to works that were made as part of the feminist art movements taking place in the United States and other places. As the notions of the "needle" and "wrapping" developed, the notion of sewing also expanded and evolved to relate to other acts of daily life, such as walking, looking, breathing, and mirroring.

SK: Please describe the new works you are planning.

K: In the long term, my wish is to make my artistic desire disappear. In the short term, I'd like to make works that are like water and air—works that, like most of my works, cannot be possessed, but can be shared by everyone. I'd still like to wander around the world and answer questions that come to me at each moment, freely using any medium. I will continue to work without any preconceived plan, and answer questions that come to me through the evolution of my ideas.

SK: What do "Korea" and "Korean" mean for you?

K: My Korean identity and my life in Korea are my main source of inspiration, but this source isn't always a positive one. Korea seems to me to be a land of shamanistic energy. I will continue to live as an anonymous outsider, as an anarchistic cosmopolitan.

Koo Jeong-A

Mothballs, dust, and sugar cubes are the common stuff viewers encounter in the poetic installations of Koo Jeong-A (born 1967 in Seoul, Korea; lives and works "everywhere," according to the artist). The imperceptible nature of her strategic arrangements of exquisite found objects can be understood as a reflection or even an extension of her worldview, shaped by her itinerant and transitory lifestyle. In the early 1990s, Koo studied at the École Nationale Supérieure des Beaux-Arts in Paris, where she has since resided. She currently divides her time between Paris and London. Koo began her career working in her studio and in private flats, where she experimented with making subtle modifications, such as laying out mothballs in a kitchen or placing a phosphorescent tab in a cupboard. Her seemingly haphazard scatterings of random objects belie the intense concentration she devotes to preparing for each installation. Her installations often comprise several vignettes discretely located around the gallery space. Each scene of accumulated objects creates microcosmic fantasy-scapes that the visitor is encouraged to happen upon accidentally.

Education École Nationale Supérieure des Beaux-Arts de Paris, Paris, France, 1996 **Selected Solo Exhibitions** *Koo Jeong-A,* Yvon Lambert, Paris, France, 2008; *OUSSSEUX,* Centre International d'art et du paysage de l'île de Vassivière, Vassivière, France, 2007; *Koo Jeong-A,* Aspen Art Museum, Aspen, Colorado, 2007; *Wednesday,* Portikus im Leinwandhaus, Frankfurt, Germany, 2004; *Koo Jeong–A,* Centre Pompidou, Espace 315, Paris, France, 2004; *Koo Jeong-A,* Artpace, San Antonio, Texas, 2003; *The Land of Ousss,* Douglas Hyde Gallery, Dublin, Ireland, 2002; *121002 very,* CCA Kitakyushu Project Gallery, Kitakyushu, Japan, 2002; *3355,* Secession, Vienna, Austria, 2002 **Selected Group Exhibitions** Torino Triennale, Turin, Italy, 2008; *Eurasia: Geographic cross-overs in art,* Museo di arte moderna e contemporanea di Trento e Rovereto, Rovereto (Trento), Italy, 2008; *GOD & GOODS,* Villa Manin, Codroipo, Italy, 2008; *La Force de l'Art,* Paris, France, 2006; 2nd Guangzhou Triennial, Guandong Museum of Art, Guangdong, China, 2005; *Hermes Missulsang,* Artsonje Center, Seoul, Korea, 2005; 1st Moscow Biennale, Moscow, Russia, 2005; *Singular Forms (Sometimes Repeated),* Guggenheim Museum, New York, 2004; *On Reason and Emotion,* 14th Sydney Biennale, Sydney, Australia, 2004; *Dreams and Conflicts: The Dictatorship of the Viewer,* 50th Venice Biennale, Venice, Italy, 2003; *Happiness: A Survival Guide for Art and Life,* Mori Art Museum, Tokyo, Japan, 2003; *Living Archive,* 4th Gwangju Biennale, Gwangju, Korea, 2002; Hugo Boss Prize, Guggenheim Museum, New York, 2002; *Self/In Material Conscience,* Fondazione Sandretto Re Rebaudengo, Turin, Italy, 2002; *En el Cielo,* 49th Venice Biennale, Venice, Italy, 2001; *MEGA-WAVE,* Yokohama Triennale, Yokohama, Japan, 2001; *From a Distance: Approaching Landscape,* Institute of Contemporary Art, Boston, Massachusetts, 2000; *Le Jardin 2000,* Villa Medici, Rome, 2000; *Unfinished History,* Walker Art Center, Minneapolis, Minnesota, 1998; *Power,* 2nd Gwangju Biennale, Gwangju, Korea, 1997; *Cities on the Move,* Secession, Vienna, Austria, 1997

　　R (details) / 2005 / ink on paper / each 10⅝ × 8¾ inches (27 × 22 cm) / each one of 1,001 drawings

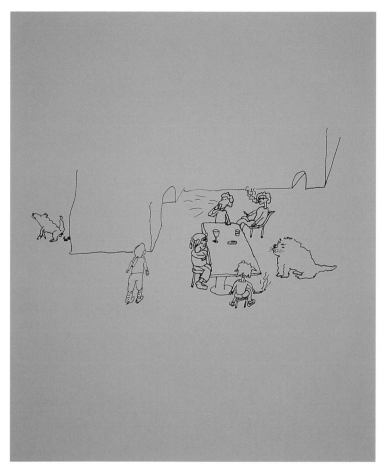

R (details) / 2005 / ink on paper / each 10⅝ × 8¾ inches (27 × 22 cm) / each one of 1,001 drawings

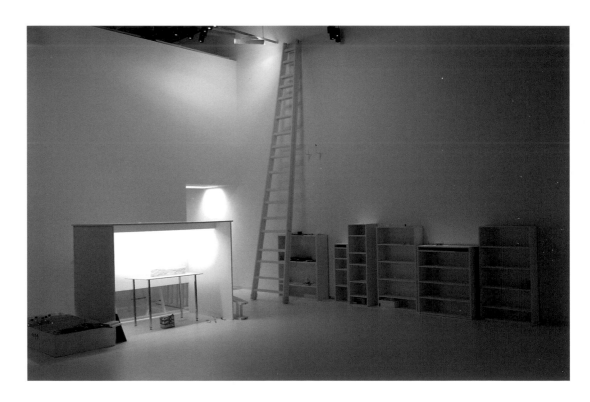

MOUNTAIN FUNDAMENTAL / 1997/2009 / stone powder on wooden panel / dimensions vary

CRAPULE / 2004 / mixed media / installation

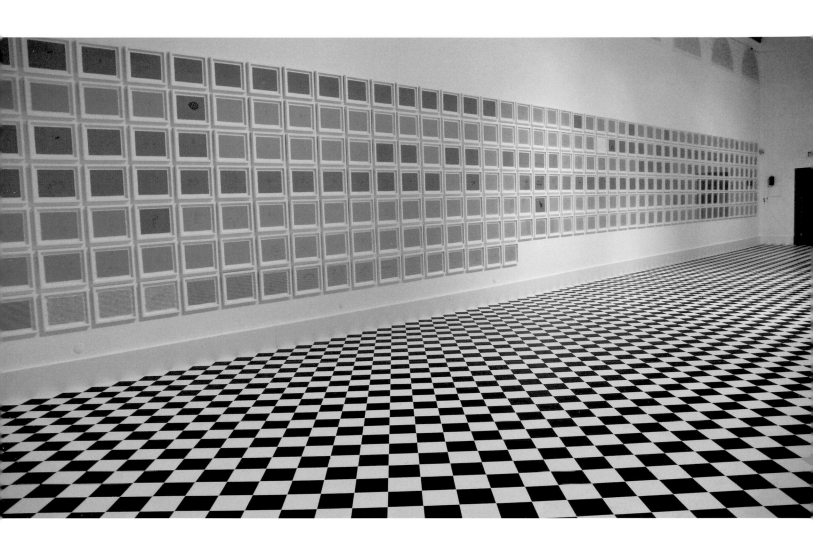

Koo
Jeong-A

Sunjung Kim: Let's begin with your work *The Land of Ousss*. Ousss is a fictional country that started sometime in the 1970s and has its own people, places, and events. Your guide for Ousss mixes Korean and English, and the Korean text appears in English letters. As the Korean becomes English, it turns into an incomprehensible language. It is impossible to read the language of Ousss, and the materials of your installations are invisible. Could you please explain what kind of place it is?

Koo Jeong-A: When I had an exhibition at Douglas Hyde Gallery in Dublin in 2002, I found a title for the show; this is where *The Land of Ousss* was born. . . . There is a text by Edouard Glissant talking about Ousss in relation to *La Cohée du Lamentin,* a specific place. Ousss is between a place and a nonplace.

SK: Is Ousss your utopia? Is this a place where dreams and desires can be realized?

KJ: I had a show in 2007 called *OUSSSEUX* at the Centre International d'art et du paysage de l'île de Vassivière. It was an exhibition to use "ousss" as an adverb. There was a work called *OUSSSGOOD* [see page 137], which I produced in Aspen, comprising the smell from a huge candle structure, heating a room with high temperature, and so forth—*ousss* went so far.

SK: You often use fragile, invisible, and insignificant materials like dust, sheetrock, and tiny objects. What is the reason behind this?

KJ: As an artist, I am invited to lots of different places, museums, and other exhibition venues. These spaces are not used for habitation or as clean offices; they are dedicated only to artwork. . . . Sometimes they bought for me some food or paper paste, and I used it all to make art.

SK: The spaces you create using leftovers invoke memories. What are the memories you think about and that can be shared by viewers?

KJ: I think that how an audience thinks would be similar to how I think. It is like when one talks in the city, you don't know if it is true or not.

SK: In your 1994 work *La Piscine (The Swimming Pool),* you painted the space and enabled viewers to imagine it as different spaces. In your mind, what can a journey to a different space or world bring to us?

KJ: We can discover, learn, play, and enjoy, as in life in general.

SK: In several works, you have made a house. What is the meaning of this house?

KJ: When you are away from a house, you see more houses; it is like when you are not breathing at all for a minute, you think just to breathe; it is something to make it extreme. All the projects about houses that I have participated in, for example Sir John Soane's Museum (London), Barragan House (Mexico City), and Casa Lorca (Granada), have that kind of reason . . .

SK: Although you create houses in works like *Abstract House, La maison de chien,* and the little dollhouses at the 2000 Echigo-Tsumari Triennial, it seems that your houses are closer to temporary shelters. Could you discuss why you chose this method of temporary settlement and also your working method of exposing leftovers or things that are abandoned or hidden?

KJ: The series *Abstract House* was made for the gallery show. When they proposed having a show, I asked to have the total space during the preparation time. Then that was my house while I was there, and the piece came out as an abstract house. *La maison de chien* was another story. I imagined a house that has two open doors of different sizes. You could enter easily through the big door, and you came out through the small door; it was a kind of subtle psychological amazement, but still, I would feel tremendous danger if I could not leave that house. Perhaps the door would become smaller and finally close forever . . .

SK: What is the significance of architectural elements in your work?

KJ: *The Floating House* (1996) is made with wooden panels and sugar cubes; *Dreams & Thoughts* (2007) was subsequently made with chewing gum; it was made with food to diffuse the smell around whatever smells are near: modern paintings, shiny photo frames, and so forth, at the Mori Art Museum's opening show. So the piece starts to make a journey and change its forms and smells by different locations/organizations. One of my favorite museums in the world is the Kimchi Museum in Korea.

SK: The places you create are re-created in fictional, abstract ways, and they demonstrate placelessness. How would you describe this placelessness and its meaning?

KJ: I always try to have an idea and to make it turn, or to go through it instead of giving up what I want.

SK: Through the details and the temporary revelation of emotions in your work, you also show what has been forgotten. In particular, *A Reality Upgrade & End Alone,* which you installed at the Venice Biennale in 2003, is made from glass crystals embedded on a wall and creates a temporary environment. In the installation made out of mothballs that you showed in the 2002 Gwangju Biennale, the visible elements dissipated with the flow of time, leaving only olfactory elements. What is the significance of immaterial elements you use?

KJ: When Carlos Basualdo wanted me to participate in his section in the Venice Biennale, there were two fantastic walls; I played with both. We purchased two huge white lamps and twelve hundred pieces of shiny stones. The exhibition was in a historically designated building, where I was not to touch or to destroy any part of walls, so I promised we would just pose the stones in the interstices.

I like the smell of mothballs; the Gwangju Biennale allowed me to show it. The work with a smell needed no storage to keep it, so it was well-suited to my situation of lack of space in cities like Paris or London, where I have only my thoughts as free space.

SK: You were born in Seoul, lived in France since 1991, and recently have been living in London and Berlin. How are your experiences related to your work?

KJ: It is very stimulating to be one day in German space, another day in British space, and you get different foods and different worlds; you also get the other cities between them. I truly love this experience of not belonging to geography, of being in between.

Minouk **Lim**

Minouk Lim (born 1968 in Daejeon, Korea; lives and works in Seoul, Korea) engages with the very arteries of city life—the streets—to create her poignant commentaries on Korea's rapid urban development. Her single-channel video *Rolling Stock* (2003) derives from photographed images in a brochure the artist was commissioned to create as a cultural guidebook for foreign audiences visiting the 3rd Gwangju Biennale. The images depict motorized vehicles and carriages on the move that are common fixtures of cities all over Korea. Her later video *New Town Ghost* (2005) assumes a more proactive stance, where Lim hired a young woman to stand astride the deck of a KIA motor truck as it cruised through the redevelopment area of Yeongdeungpo in Seoul, all the while rapping through a megaphone, to the beat of a drummer, a personal narrative attacking the neighborhood's quick urban growth and the indifference of its residents toward it. Appointed as one of the "new towns" of the Seoul Metropolitan Government's New Town Project, Yeongdeungpo is where the artist's office and studio are located. Lim is known as an active community organizer who collaborates with different experimental groups through her Pidgin Collective, which she founded in 2003.

Education Ewha Womans University, Seoul, Korea, 1988; École Nationale Supérieure des Beaux-Arts de Paris, Félicitation Diplôme National Supérieur d'Art Plastique, Paris, France, 1994; BFA, Art Plastique (Fine Arts), Université Paris I, Paris, France, 1995 **Selected Solo Exhibitions** *Subjective Neighbours,* Insa Art Space, Arts Council Korea, Seoul, Korea, 2000; *Screen Drugs,* Alternative Space Loop, Seoul, Korea, 1999; *Minouk Lim—General Genius,* Galerie la Ferronerie, Paris, France, 1997, Galerie Véronique Smagghe, Paris, France, 1997 **Selected Group Exhibitions** *An Atlas of Events,* Fundação Calouste Gulbenkian, Lisbon, Portugal, 2007; *Activating Korea: Tides of Collective Action,* Govett-Brewster Art Gallery, New Plymouth, New Zealand, 2007; 10th International Istanbul Biennial, Istanbul, Turkey, 1997; *Peppermint Candy: Contemporary Art from Korea,* Museo de Arte Contemporáneo, Santiago, Chile, 2007; *Hermes Korea Missulsang,* Atelier Hermes, Seoul, Korea, 2007; *The Last Chapter Trace Route: Remapping Global Cities,* 6th Gwangju Biennale, Gwangju, Korea, 2006; *Symptom of Adolescence,* Rodin Gallery, Seoul, Korea, 2006; *Parallel Life,* Frankfurter Kunstverein, Frankfurt, Germany, 2005; *8 Tempo of Seoul,* Montevideo Netherlands Media Art Center, Amsterdam, Netherlands, 2003; *Super Korea Expo,* Tokyo International Exhibition Center (Big Sight), Tokyo, Japan, 2000

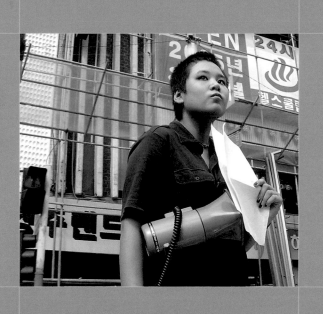

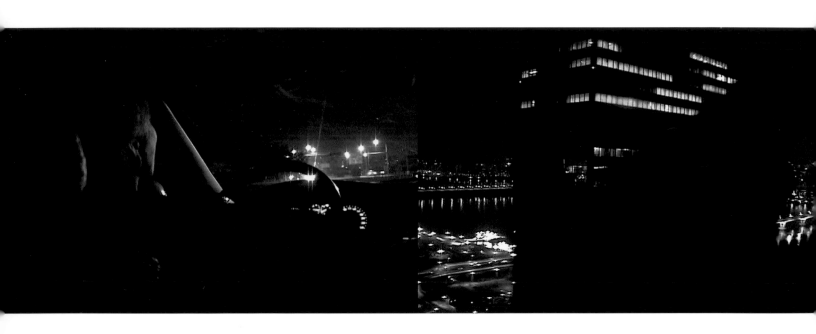

WRONG QUESTION / 2006 / 3-channel video installation / 9:38 min.

WRONG QUESTION / 2006 / 3-channel video installation / 9:38 min.

Minouk Lim

Sunjung Kim: Let's begin with discussing your *New Town Ghost* (2005) {see page 44}.

Minouk Lim: In 2002 the city of Seoul selected twenty-five areas under the program New Town Project Special Areas, and this redevelopment will, in coming years, spread to the rest of the country. The motivation and background for *New Town Ghost* can be found in an awareness of my own reality and circumstances, and accordingly, it reveals all the confusing memories and psychological conflicts. The areas where I grew up, where I lived during my college years, and where I currently live have all been included in the New Town Project.

I realized that not only traces of the past are gone, but also, at the same time, the images of the present are being erased even before they can be recognized. Can we understand such a phenomenon—not a *déjà vu* but a *déjà disparu? New Town Ghost* is a distorted hope, hitchhiking on the fantasy of development, agitating and haunting this development, on the one hand, and, on the other, a kind of energy that I myself draw on subjectively.

SK: Paralleling your own practice, you have also participated in the collaborative Pidgin Collective. What are the differences between your own work and the work of the collective?

ML: It's not clear to me why I would need to define differences. When I collaborated with another group, General Genius, our objective lay not in relinquishing individual practices, but in sharing the idea of activating potentials. This approach is oriented toward art as nonisolationist actions that generate exchanges and frictions with diverse fields, rather than toward me becoming a specialist of a sort. But I came to realize that collaborative work within the institution of art could also operate as a refuge from direct criticisms. To work under the name of Minouk Lim means to become an object of more direct and intense experimentations and criticisms, and in spite of this, to make myself instrumental in my art.

SK: Your *Rolling Stock* (2003) **addresses speed and movement. What are your thoughts on movement and vehicle, exactly?**

ML: *Rolling Stock* quotes a number of arguments from Paul Virilio. Contrary to the quote "To stop is death," movement per se does not generate thinking. Actions such as publishing a book or facing a moving image are equal in value with slowing and pausing. Of all mammals, human beings take the longest to be fully formed in the uterus. Furthermore, women were the first means of transportation in human history.

SK: You are preparing for your one-person exhibition in 2008. What are your plans for it?

ML: As always, the most critical and absolute questions, at this time and place, have been what is important to me. Instead of seeing the framework of a solo exhibition as a collection of monologues and symbols, I ask myself if art could offer a more interesting life. Not exploring the soul, but rather opening up, revealing, and liberating the viscera in a simple gesture . . . ? Seeing that I get close to people more because I am nonprofessional and nonartistic, I imagine a fun solo show, which will make them smile. I wish that a solo exhibition wasn't simply an occasion that determines an artist's life, but could be a failure, which leads to more opportunities for revision, enhancement, and experimentation—that is, for permanent changes: not a political refuge, but a point of articulation between productive tensions and space. In that light, Artsonje Center makes me think of a lot of different things. The Center's site stands on a border that recalls the past and makes one query the fate of the future.[1] I want to make efforts to draw on topics around the border, while also questioning a variety of structural and formal problems in the process of making.

SK: *New Town Ghost* shows the image of a city after redevelopment through a rapper shouting. *Wrong Question* (2006) {see pages 142–43} offers viewers the stories of political ideals that you always get from taxi drivers, and how blue-collar workers could very well represent right-wing politics. These shoutings and stories do not take the form of conventional artistic videos, but borrow those of music videos and documentary films. Why do you often use video, and what roles do these issues play in your work? Where would you say your main interests lie?

ML: *New Town Ghost* offers two edited versions of a video in an installation. My own edited version is projected on the wall, and the other, edited by a television producer, is shown on a monitor placed at a right angle to the wall. When viewers sit down to see the monitor version, they become part of the landscape of the projected image. The viewer's physical being is activated in different ways, depending on the intensity of the sound and light, and I was curious to see if this could create multiple conditions for interpretation, which I thought might be explored through the video installation. In *Wrong Question,* viewers walk along an approximately ten-meter-long narrow and dark slope, led by sound and by dim light seeping from the other end, to arrive at a space in which they look down onto two-channel projections on the walls, divided by a balcony, and a monitor showing English subtitles lying askew on the floor. In the two projections, records of the everyday crisscross at varying speeds, and the details of colors captured in each screen get amplified and diffused. On the other hand, the taxi driver's monologue, which can be heard in the balcony space, is based on manipulated myths, and as a forced nostalgia, it is a codified speech. In that sense, rather than being oppressed by it, viewers are inspired to make efforts to "re-search" history and to independently create specific everyday conversations. I attempted to experiment with a video installation as an apparatus to elicit correct answers in response to what I recognized to be wrong questions. Both works exhibit the ways in which conflicts between what I hope to show in exhibition contexts and the medium of video itself manifest themselves as ways of liberating the weight of the here and now.

SK: Regarding your exhibition *Too Early, or Too Late an Atelier* (2007), Kang Soo-mi, in his review in the April 2007 issue of *Wolgan Misool* (Art Monthly), discussed the problem of temporality in the official social structure of Korea in relation to the country's rapid growth and modernization. In light of this discussion, what does Korea mean to you?

ML: Things like the abstraction of scale, which penetrate the understanding of Korea as a geographically bound, sovereign nation, for me, constitute the modernity that I think of and that we experienced. In my work, I seek to focus on points of history repeating itself and to question the actualities behind concepts, such as the notion of the nation, which keep endlessly returning. This notion of nation, which influenced not only history but also the geographical, linguistic environment I was raised in, sometimes materializes like a ghost as my "way of life." With this relationship as a conceptual background, the exhibition *Too Early, or Too Late an Atelier* revealed the context of the works on display, dramatized the specificities of Surrealism, and superimposed the artist's means of survival. The spiritual alienation created by Korea's economic development and the political confusions experienced in personal history produce a constant balance between tragedies and comedies. The relationship between the meaning of Korea and my work, which is located within the paradox and awareness of a "successful failure," operates as the motor for my continuing work.

SK: In 1999, you covered the slogan of the Ministry of Culture & Tourism, "21st Century, the Culture Century Is Coming," which was on the facade of the Korean Culture and Arts Foundation Gallery (now, Art Center Arko) building, with a banner emblazoned with the phrase "Restraint, Foreknowledge, Controlling Body Odor." What do you think is the role of the artist in society?

ML: I don't think I really understand the idea of "role" itself. I haven't thought much about this question. . . . But aren't artists those who resist society in the name of freedom? Is there such a thing as accepted freedom? I just work constantly toward freedom. My answer for the question above about *Rolling Stock* is in the same vein: the role of the artist in society is to endlessly invent and rearrange, and not repress the impulse to go against the grain; to observe by racing around and by looking sideways at issues, rather than operating rationally and legitimately; to press tender spots; and to propose questions instead of building a consensus. The act of replacing the slogan "21st Century, the Culture Century Is Coming," which seems suspiciously cultish, with "Restraint, Foreknowledge, Controlling Body Odor" was an attempt to demonstrate that there is more to the words and that such an artistic intervention paradoxically reveals what is hidden. This sort of approach was intended to force viewers to witness the deconstruction of "what is coming" through conflict and confrontation and to have them understand it as yet another thing.

SK: How would you define your own identity?

ML: My own identity, I believe, belongs to my private realm. For instance, it is not important to know how Cézanne's art was influenced by not being kind to his wife. I hope that my identity is defined through my work.

SK: You studied in France. How would you describe the influence of your experience and studies in a foreign country?

ML: There, I transitioned from the studio of a politically active painter, where I encountered the discourse initiated by that artist's work, to an art critic's seminar, which was a time of reading about and discussing the process of working. A while ago, I read an American critique of the French education system, which described its deeply rooted anticapitalist consciousness. I don't know if it is an anticapitalist consciousness, but I do think I adopted freedom, tolerance, and solidarity from my observations and experiences during my years in France. Furthermore, it was in France that I became interested in American artists, criticism, and educational methods and gained specific awareness and experience of globalization through Arab immigrants, gays, and Asian friends.

SK: Pidgin Collective, which you formed with Frederic Michon in 2003, calls itself a "cultural artistic hybrid research project." Could you describe your activities in the collective?

ML: At present, there are no collective activities because there is no collective. As for the previous activities, it started with *LOST? Container Project,* in which we researched new paradigms of survival for artists. At Haja Center, a municipal center offering vocational experiences for youths, we remodeled a container, which had been used as storage for old materials, and moved in. There, we asked the so-called teen cultural workers how to invite audiences to interact with artworks and how to live together, instead of teaching them to pursue the mythology of the artist yoked to the circulation of artworks, and we demonstrated how nonartistic methods can catalyze art through activities such as exhibition, design collaboration, and so forth.

SK: Your works such as *Bus Stop* (1998), *Social Meat* (1999), and *An Annex to the Posco Art Museum* (2001), which was shown at the exhibition *Lunchtime of Necktie Force* (2001), were all temporary projects in which aspects of the everyday were replaced with art. What is "participation" here?

ML: Voting is participation, as seen in the recent presidential election in Korea, and Pierre de Coubertin, the founding father of the Olympic Games, said that participation is more important than winning. The system called "exhibition" is, these days, often described as participation, and in interviews, I often wonder what use there is in discussing it theoretically like this. This feeling of confusion is also a point of departure for participation. On the question of the artist's role, as I mentioned above, the will to freedom necessitates the responsibilities associated with such freedom. Let us recall Chantal Mouffe here: "The act of renouncing the fiction of absolute freedom from power and understanding the actuality of power relations and their mutations is specific to the project we name a 'radical pluralist democracy'."[2] Participation in art is perhaps tantamount to severing ties with something like "universalism," which supports the notion of transcendence.

SK: Critic Jang-un Kim wrote in his essay "The Mutation of the Artist," published in the November 2004 issue of *Space* magazine: "{The artist} does not focus on devising finished apparatuses, nor does s/he emphasize concept and practice or suggest alternatives. Rather, s/he seeks to posit the lowest common multiple in the operative principle of that rhetoric and focuses on that act of positing." Do you work with the presumption of what the final product will look like, or is it only the process that is important?

ML: Perhaps the question is itself flawed. . . . Neither the positing of how the final product will look nor the assumption that only the process is important is possible. Kim's essay, I think, is motivated by an intention to identify and clarify things in the midst of the particular situation of the Korean avant-garde and newly emerging project-oriented art. I also believe that it was trying to sound the alarm against the tendency of project-oriented art's resemblance to advertisement campaigns, political instruments, and the tendency to rely on the artist-centered mythology. If art is located in the point of departure that suggests certain possibilities of understanding the world, is it not because art allows us to accept the reality, as is? What this means is that we should not create or offer an objectified subject and product, nor should we remain as an immaterialized ghost. After closing the cover on the book in which ideas such as utopia, dreams, and hope, which promise another world, unfold, the door through which I enter the world still stands as it always has. That's why the point I desperately focus on perhaps takes a detour from the situations and conditions of the reality in which I live now. It's like the difference between my memory of my neighbor's gate and my neighbor's everyday experiences with that gate in reality. The documentary film *Asia Movie Travel* (2005), produced by Indicom Cinema and CJ Media, includes this memorable sentence in its segment on filmmaking in Iran: "The children didn't act. They just . . . lived . . . again in front of the camera." I'm not at all sure about this, but if we are living our lives as if acting out roles, our neighbors could perhaps open the door and just . . . live . . . again.

NOTES

1. According to the Center's Web site: "The Artsonje Center is located in Sokeuk-dong that links the Kyungbok Palace area and the Insadong area, the two main scenes for Seoul culture and art. Sokeuk-dong is a unique area located in the middle of ancient cultural museum and the contemporary art scene, and it has kept the traditional living style and the residence architecture of the old Seoul," http://www .artsonje.org/eng/.

2. Chantal Mouffe, *The Return of the Political* (Brooklyn, New York, and London: Verso Books, 2005).

Jooyeon Park (born 1972, in Seoul, Korea; lives and works in Seoul) creates video and installation art, writings, and photographs that all touch upon the vulnerable psychological space of human existence and people's indeterminate sense of longing. Consequently, her works reflect on movement, whether of people, places, or language, and the prolongation of time. In her artist book *Passer-by* (2008), she presents a fictional script between characters searching aimlessly for "something." The book and related film and photos are derived from travelogues, cursory thoughts, and conversations that she shared with other artists and strangers whom she encountered during her three-month residency in Istanbul, Turkey. She offers the viewer these disjointed glimpses as a temporary oasis from the banal chaos of daily life. Likewise, her series of photographed benches, mats, and *pyeongsang* (wooden tables that Koreans use as seats) documents temporary stations where people often linger between life's comings and goings.

Education BA, Goldsmiths College, University of London, UK, 1996; MFA, St. Martins College, University of the Arts, London, UK, 2001 **Selected Solo Exhibitions** *Summer Light,* Insa Art Space, Arts Council Korea, Seoul, Korea, 2008; *Full Moon Wish,* Gallery Chosun, Seoul, Korea, 2006; *Art Position,* Art Basel Miami, Miami Beach, Florida, 2005; *White on White,* Next Door, Rome, Italy, 2005; *Everything in Its Right Place,* Gallery Chosun, Seoul, Korea, 2004; *New Talent,* Art Cologne Award for Young Artist, Cologne, Germany, 2004; *Rhyme,* Insa Art Space, Arts Council Korea, Seoul, Korea, 2002 **Selected Group Exhibitions** 7th Gwangju Biennale, Gwangju, Korea, 2008; *Slices of Life,* Rodin Gallery, Seoul, Korea, 2007; *Tina B.,* Prague Contemporary Art Festival, Prague, Czech Republic, 2007; 5th Busan Biennale, Busan, Korea, 2006; *Cinéma expérimental coréen, un cinéma différent,* Paris Cinema, Paris, France, 2006; *LYBSY,* Akiyoshidai International Art Village, Yamaguchi, Japan, 2005; Festival Internationale di Rome, Palazzo Fontana di Trevi, Rome, Italy, 2005; *Art Video Lounge,* Art Basel Miami, Miami Beach, Florida, 2005; 5th Gwangju Biennale, Gwangju, Korea, 2004; *Forum A special,* Video Art Centre, Tokyo, Japan, 2004

MONOLOGUE monologue / 2006 / single-channel video / 9:06 min. / collection of the artist

MONOLOGUE monologue (production still) / 2006

UNTITLED / 2004 / inkjet print of digitally modified photograph / 15¾ × 13 inches (40 × 30 cm) /
private collection

UNTITLED / 2002–4 / inkjet print of digitally modified photograph / 51¼ × 39⅜ inches (130 × 100 cm) / private collection

Jooyeon Park

Sunjung Kim: Your 2000 work *Forget Me Not* is a documentary video that deals with an article about someone named Anne Smith that was published in the British newspaper *The Guardian*. The video addresses the problem of an individual who cannot find her place in society, and the life depicted in this work is that of one person who thrives outside the conventional social structure. Did you make this work because you are generally interested in those who cannot belong to social institutions and who exist outside the social structure? I'd like to hear about the interests you wished to convey with this work.

Jooyeon Park: When this work was first shown, a lot of people discussed it in relation with the problem of social minorities. However, *Forget Me Not* arose from a pure interest in Anne Smith, the person. Rather than a documentary about a specific person, it was closer to a video diary. The story of Anne Smith, who lived in her car from the age of thirty until sixty, separated from everyone else, was being passed around as if it were an old fairy tale. I don't know how this once-promising musician ended up living in a car, but the Anne Smith I got to know was very self-respectful. Because her car wasn't recognized as a legal residence, after a long legal battle, it was impounded. The question of freedom that one could have within the social system does not pertain only to a minority but to the majority.

SK: *Everything in Its Right Place* (2004) deals with temporary stations and passing spaces taken from real landscapes and shown inside the institutional frame of the gallery. It shows a transitional space between movement and settlement. Does this speak to your interest in transitional space? Or is it about traces?

JP: Because the work came out of an interest in the state in which not settlement but constant movement is possible, the open state, I should say that it was an interest in transitional space. Within the institutional frame, densely populated by highrises, the Han Riverside Park is a kind of void, where one could stay for a little while; it's not so stable, but nonetheless it is a clear space where individual will is permitted to a certain extent. If Anne Smith's car overstepped the boundary of creativity accepted by society, *Everything in Its Right Place* shows arbitrary creations made by individuals within the boundaries allowed by society.

SK: *White on White* (2005) depicts an exhibition gallery during construction. What did you mean to show through this particular space?

JP: It signifies invisible labor in spite of the act of painting white on white, just as the title indicates. I began planning the work when I discovered the process of renovation at the gallery that invited me for an exhibition. I felt that, at the point that it was captured, the exhibition space and the everyday could be either separated from or extended to each other. I captured in video the labor of the workers who were making a perfect white wall inside the gallery, projected the image on the wall that was worked on, and included what is normally invisible in an exhibition, thus making visible "white on white."

SK: In *Flickering Landscape* (2003), memory—especially the memory of a place you deal with in your work—enables an experience of a hypothetical landscape inside a real landscape. It seems to me that memory here is that of an individual, located within society, rather than a collective memory.

JP: In *Flickering Landscape,* I pursued historical, social, and personal meanings of a particular place in Seoul—the former campus of Seoul National University, which became the Marronnier Park in the mid-1980s, and which was then relocated inside the park. Although it is a well-known site for frequent student protests and demonstrations, there were few events supposedly worthy of historical record, so it was difficult to find related materials about it. There are, thus, a lot of unverifiable rumors included in the collected materials. The narration that was installed in the park gathered and mixed the history of the Marronnier Park and diverse contemporary movements within, and, through fragmentation and reconnection, created yet another story. It took the form of a record of travels to and observations of different times and spaces. Several episodes and histories are intermingled and present a nonlinear concept of time. While ambiguously trekking back and forth between reality and imagination, it portrays a fictional landscape existing among fragmented memories.

SK: In your 2006 one-person show, *Full Moon Wish* {see page 38}, you showed artworks, theatrical elements, texts, and videos together. Could you explain the relationship between Samuel Beckett's *Waiting for Godot* and your incorporation of theatrical elements and other works in the exhibition?

JP: I was less interested in theater per se than in paying attention to the locutionary method in the medium of theater. The works I presented in the one-person show exhibited direct or indirect connections to *Waiting for Godot,* while composing a story. *Full Moon Wish* names the moon that appears in *Waiting for Godot* "Full Moon," and symbolizes Estragon and Vladimir's passive waiting and blind hope in a soap-bubble drawing. During the exhibition's run, I invited BH Productions into the work, and they performed the play twice. In this way, multiple layers overlapped with and also got separated from one another, creating a range of interpretations.

SK: Language is one main axis of your work. Your works that reference *Waiting for Godot, MONOLOGUE monologue* (2006) {see pages 150–51}, in your solo show *Full Moon Wish,* and *Third-Person Dialogue* (2006), show the limits of language that become apparent when subtle points get lost in the process of translation, as well as the inability to communicate in a foreign country where a different language is spoken. Is there a particular reason why you became interested in and chose to address contradictions of language and communication?

JP: When I'm asked this kind of question, though I have a persuasive answer in my heart, I have to answer carefully because it might legitimate my work too facilely. I've been living between Seoul and London since I was fifteen, though I have made Seoul my main base in the last six years or so, and the problem of language that confronts me not in my own country but in another country reminds me of the reality of it. I cannot help but live every day being especially sensitive to how I am connected to the world and how I might be understood or misunderstood by others. This is perhaps because language is the expression of consciousness as well as of existence. Of course, my foreign-language skills improved with time, and now I can do simple translations and interpretations. At the same time, with the experience of mediation, I have become more convinced that a language cannot be translated into another language. In my *Third-Person Dialogue,* I tried to contain this complicated and subtle situation within the temporal frame of ten minutes. The "third-person" here signifies the state of a subject not being a subject, or the state of a subject becoming a third person.

I tried to express the limits of language by positing the controlled situation of a telephone call, in which one can rely only on language. Although there were quite a lot of Korean lines, I attempted to create a sketch that more closely resembles reality by denying the possibility of linguistic translation, except by the assistance of an English interpreter in the latter part of the work. In *MONOLOGUE monologue,* I first recorded monologues by Irish lecturers teaching English at a Korean university, and then had Korean students taking their beginners' class lip-synch the recordings, thus leaving only the facade of language and emptying its meanings. My Irish collaborators were also those who performed *Waiting for Godot* in English during my one-person show. As they couldn't smoothly communicate with Korean audiences, this created another self-contradictory situation. This was also a result of inversely representing the experience I had as a foreigner.

SK: It seems that language functions as the key element in your work. Could you explain a little bit more about it?

JP: Perhaps it is because I make my work while recognizing that language is a powerful medium that connects me to the world. Therein, I always have a sense of lack and inappropriateness, and perhaps that's why I have gotten considerably interested in the linguistic potential of silence.

SK: As you thought much about utopia, asking "is it possible?" in *Third-Person Dialogue,* **you expressed that your fictional Huyan Forest is utopic. What is utopia for you?**

JP: A little while ago, I met up with someone with whom I became friends by chance, and we talked about our divergent thoughts about death. This friend, who gets scared whenever he is a little sick and runs to the hospital, compared his fear of death to that of Glen Gould's and David Lynch's and justified the relationship between fear of death and the work of art. When you hear people's thoughts on death, you get a sense of their ideal life. I think this is the utopia they dream of. I'm interested in artists' late works, because I'm curious about how the undeniable silence that death brings influences their practices. For instance, Beckett's later works became increasingly minimal, even to the extent of *Breath,* which has no spoken lines and which I interpret as perhaps coming from the silent influence of death. For Beckett, death meant liberation from language and consciousness. Then it seems that he accepted death as a kind of rest. In a similar way, the Huyan Forest that appears in the lines of *Third-Person Dialogue* is a fictional utopia that also signifies a space of freedom bound to nothing.

SK: In another topic related to freedom, you seem to view motion and movement through "stopping," "moving," and "distance" in your work. Can you share your thoughts on the will to move, movement, and motion?

JP: It seems that my approach is seen as "distance" by others, because I try to make work by simply choosing and placing a perspective without trying to possess the object. The meaning of movement in my work is the minimal motion needed to reveal invisible realms. The minimal motion is mostly not a physical movement but rather a motion that takes place internally; it encompasses invisible motions and imperceptible motions. I think my work seems to be moving yet also stopping because I want to visualize complicated and subtle emotions and stories hidden beneath the tranquil and peaceful surface without unfurling them explicitly in front of the eyes.

SK: What I like about your work is the way you deal with existence and its immaterial aspect, as seen in the soap-bubble drawing of *Bubble Blow* **and in** *Third-Person Dialogue.* **In a way, you address art itself. How do you feel about artistic methods that are not visible to the eye?**

JP: In the drawing *Bubble Blow,* I tried to suggest my reflections on existence, in which I have consistently been interested, through soap bubbles that appear for a short time then disappear. I often have such reflections while working in video and film. Both are immaterial mediums that become visible through light but disappear like a ghost when the electricity is shut off. Nevertheless, I felt that something that wasn't satisfied in video found satisfaction in film. I'm not advocating one working method over another. But after some serious thought, I came to a realization. Video records digital information on magnetic tape; it is thus a convenient and perfect means of imaging, but it made me insensitive to surrounding light situations and specific times. On the contrary, filmmaking obliged me to perceive my surrounding situations much more directly and made me realize that I was communicating with particular beings and within particular times. Each brings a different sense of understanding through different working conditions, but ultimately their differences made me return to the question of the visible and the invisible.

SK: How do you feel about the role of art in society?

JP: I think that the role of art in society is not different from the role played by other fields. An artist is called *jakga* in Korean, which literally means a "person who makes." All human beings live their lives making something—they make houses, thoughts, lives, nations, languages . . .

SK: Then how do you feel when you are making a work?

JP: Except when it's necessary to resolve a work on the level of content, I rarely think of other things but making it. Perhaps it's because I feel that what I do isn't important enough to be called a "role"; because if one calls it a role, it feels rather constricting; or because I'm making a small resistance to overly socialized contemporary art. The majority of my works begin not from a socially critical message or a megadiscourse, but as a stance from which to create small fissures in the established system through meticulous observations of individual and everyday histories. I'm not sure exactly what kind of role I'm playing, but as one of the artists born and active in this particular time, I'm probably playing some minuscule role regardless of my own intentions.

SK: How do you discover the elements and contents for your art?

JP: I discover them at unexpected moments in life. When I'm drawn to a certain subject or topic without knowing why, most of the time it is because of empathy coming out of my identification with it. This feeling resembles compassion and commiseration. Fragments that are found when I read, travel, watch a film, have a conversation, sleep, and so on, gather to become a sentence, then a paragraph, then an essay.

SK: In an interview with Ly Yunju, you stated that you are increasingly interested in theater and cinema. You also said that if your previous works tended to be documentary, your future direction might be toward fiction. Could you share what you are planning for the future?

JP: After that interview, I made *Third-Person Dialogue,* and last summer, I stayed in Istanbul for three months and worked on a film. Currently, I'm working on a script for an artist's book project. I don't know exactly how documentaries and fiction films are different—or if there is indeed any difference between them. My video works to date simply recorded already existing situations; more recently I write a script before shooting or make plans for how to work with actors. I'm no longer resistant to setting up certain specific situations. I have a sense of freedom that I never felt before from this new approach, and it is perhaps because of the immense freedom that directing and fiction can allow.

SK Your comment on your work—it's not a fiction based on reality but reality itself—seems to reflect your interests in not the totality of a story but in the little things that are invisible to the eye.

JP Yes. Ironically, what ultimately interests me is not fiction but reality. More recently, I have come to think that fiction and reality aren't two separate worlds, but that fiction is located within reality. If this idea is right, fiction never existed from the beginning.

SK Are you going to continue to make theater and film projects?

JP I don't know what will come of the works I'm doing right now. To figure out what to do with which work will be my work.

Since his New York debut in 1997, Do Ho Suh (born 1962 in Seoul, Korea; lives and works in New York) has become renowned for his use of unconventional materials, such as military dog tags and silk, and intricately designed sculptures that surpass regular notions of scale and site-specificity. Suh's resulting large, fantastic re-creations of personally meaningful architectural structures or armies of miniature figures that form architecturelike structures create new contexts in which to view timeless truths. Nothing exists outside of the context, whether it is spatial, social, psychological, or cultural. In his series *Seoul Home, Paratrooper, Speculation,* and *Cause & Effect,* Suh leads the viewer through the many contexts he has personally experienced. The artist even allows the viewer to walk on and interact with some of his pieces, such as *Some/One* (2001), where the viewer is invited to walk on a sea of polished military dog tags covering the floor, which rises in the center to form a hollow suit of armor. A small mirror inside transforms the viewer into yet another chain link in the collective armor. Most of his works show Suh fascinated by the idea of *inyeon,* or karmic fate. Inyeon describes all relationships in the world, from very brief encounters to best friends, as forged by the inherent reason or rhythm of the universe.

Education BFA and MFA in Oriental Painting, Seoul National University, Seoul, Korea, 1985 and 1987, respectively; Skowhegan School of Painting and Sculpture, Skowhegan, Maine, 1993; BFA in Painting, Rhode Island School of Design, Providence, Rhode Island, 1994; MFA in Sculpture, Yale University School of Art, New Haven, Connecticut, 1997 **Selected Solo Exhibitions** *Do Ho Suh: Psycho Buildings: Artists and Architecture,* Hayward Gallery, London, UK, 2008; *Cause & Effect,* Lehmann Maupin Gallery, New York, 2007; *Do Ho Suh,* The Fabric Workshop and Museum, Philadelphia, Pennsylvania, 2005; *Do Ho Suh,* Maison Hermes, Tokyo, Japan, 2005; Arthur M. Sackler Gallery, Washington, D.C., 2005; *The Perfect Home,* Kemper Museum of Contemporary Art, Kansas City, Missouri, 2002; Seattle Art Museum, Seattle, Washington, 2002; Serpentine Gallery, London, UK, 2002; *Some/One,* Whitney Museum of American Art at Philip Morris, New York, 2001 **Selected Group Exhibitions** *Psycho Buildings: Artists and Architecture,* Hayward Gallery, London, UK, 2008; *On the Margins,* Mildred Lane Kempner Art Museum, St. Louis, Missouri, 2008; *Peppermint Candy: Contemporary Korean Art,* Museo de Arte Contemporáneo, Santiago, Chile, 2007; *System Error,* Palazzo delle Papesse, Siena, Italy, 2007; *All the More Real,* Parrish Art Museum, Southampton, New York, 2007; *New Works: 06.2,* Artpace, San Antonio, Texas, 2006; *Facing East: Portraits from Asia,* Freer + Sackler Galleries, Washington, D.C., 2006; *To the Human Future: Flight from the Dark Side,* Contemporary Art Gallery, Art Tower Mito, Mito, Japan, 2006; *Siting: Installation Art 1969–2002,* Museum of Contemporary Art, Los Angeles, California, 2004; 8th International Istanbul Biennial, Istanbul, Turkey, 2003; *On the Wall: Wallpaper and Tableau,* The Fabric Workshop and Museum, Philadelphia, Pennsylvania, 2003; *Lunapark: Contemporary Art from Korea,* Württembergischer Kunstverein Stuttgart, Stuttgart, Germany, 2001; *Plateau of Humankind,* 49th Venice Biennale, Venice, Italy, 2001; *Uniform, Order and Disorder,* P.S.1, Long Island City, New York, 2001; *About Face,* Museum of Modern Art, New York, 2001; *Greater New York,* P.S.1, Long Island City, New York, 2000; *Open Ends,* Museum of Modern Art, New York, 2000

FALLEN STAR 1/5 / 2008–9 / ABS, basswood, beech, ceramic, enamel paint, glass, honeycomb board, lacquer paint, latex paint, LED lights, pinewood, plywood, resin, spruce, styrene, polycarbonate sheets, and PVC sheets / two pieces, each 131 × 145 × 120 inches (332.7 × 368.3 × 304.8 cm)

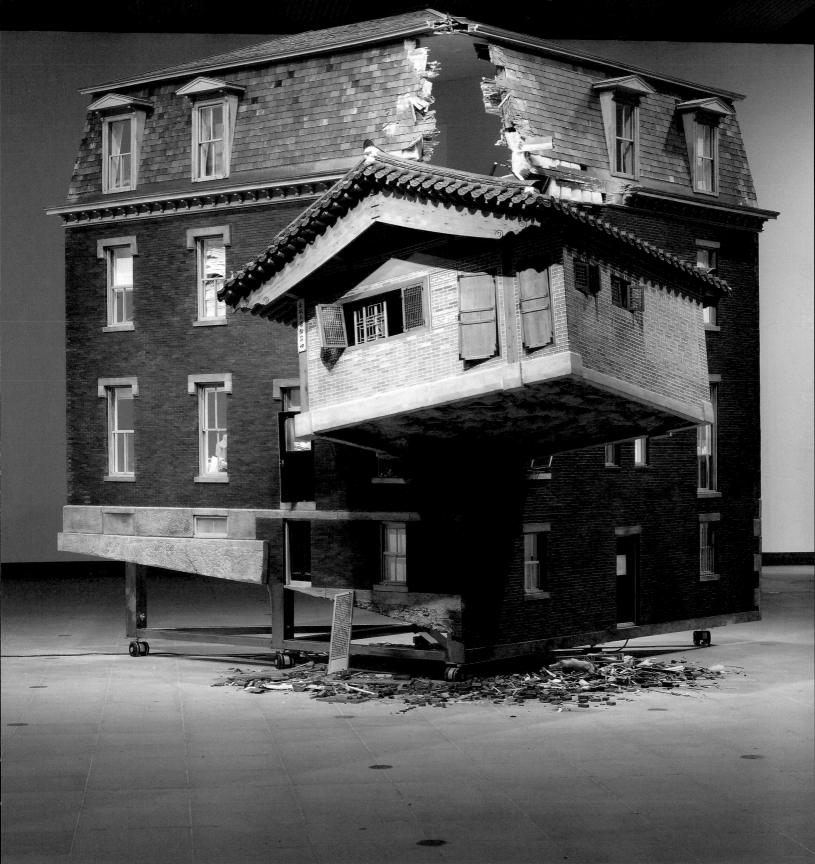

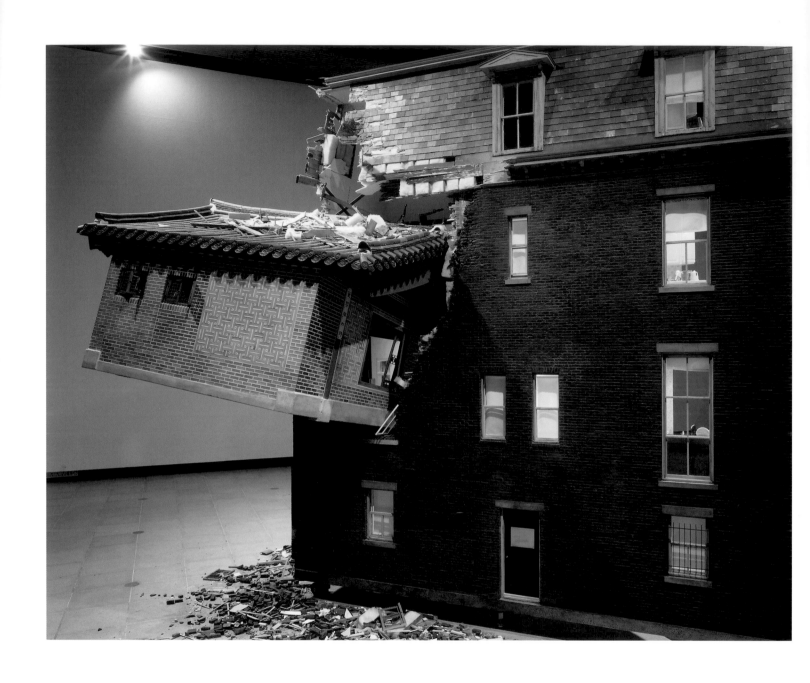

FALLEN STAR 1/5 (detail) / 2008–9

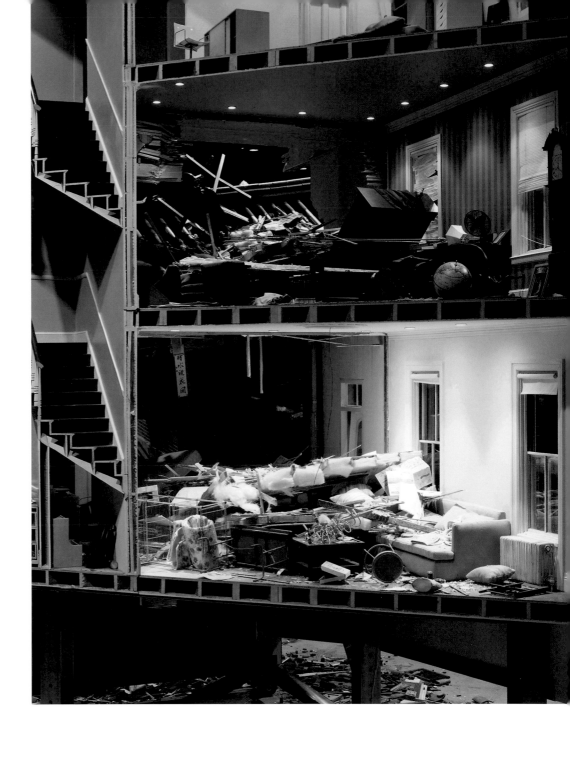

FALLEN STAR 1/5 (detail) / 2008–9

Do Ho
Suh

Sunjung Kim: You first majored in traditional-style painting and then studied sculpture in the United States. As a young traditional-style artist, you were actually having a successful career; you were invited to participate in the São Paulo Biennial, for instance. Did your decision to study sculpture arise from an intention to study in order to transcend two-dimensionality?

Do Ho Suh: My graduate thesis exhibition at Seoul National [University] in 1986 involved an installation as a vehicle for the presentation of my Eastern-style paintings. I then continued my studies in painting at RISD [Rhode Island School of Design] in the United States, and graduated as a painter. I took one sculpture class at RISD accidentally in my sophomore year, and it must have resonated within me. I ended up studying both painting and sculpture at RISD. When it came time to continue on to my graduate studies, I decided to pursue sculpture. That decision didn't result from any kind of linear process, where I felt the need to develop my ideas in painting to ideas of space—they were separate explorations to me.

SK: You are leading a migrant, nomadic life. Critics have discussed your life and art in terms of Michael Hardt and Antonio Negri's concept of "non-place." What are your thoughts on "non-place"?

DHS: The "non-place" that I speak of is more about the notion of transience and the ambiguity of the "in-between." One can make the connection, but it's a more personal take on displacement, whereas Hardt and Negri focus on a larger concept of blurred boundaries. Experiences specific to my displacement, and my removal from one place to another, generate my work.

SK: In the past, you have stated,

The function of the common every-day language is to convey meaning. Paradoxically, in the very act of conveying meaning, language disappears. Once the meaning is understood or extracted, one no longer sees the visual shapes of the written letters nor does one hear the sounds of the spoken words. The material qualities of the language are used up and become transparent. When the language resists disappearing into its own meaning, however, its materiality is set forth. When we hear a foreign language, unable to understand the meaning, we become sensitive to its shapes and sounds. We do not understand it, but we see and hear it. How many of you can tell how the English language looks or sounds? I am incapable of telling how Korean looks or sounds, but I can tell how Greek or Japanese look or sound precisely because I do not understand them. They become opaque and I am directly faced with their materiality.[1]

In your work, you utilize material transparency and formal repetition to expand meaning. Is your methodology related to the statement quoted above?

DHS: The material transparency in the different works is not a common denominator. My fabric works speak of a physical space, and the collective of individual pieces in my other works speaks of a phenomenal space. However, they are not so much bound by the characteristics of their materials, but rather are tied together by various notions of personal space.

SK: Your work banishes ambiguity, a quality often cited as "Eastern," and also tends to eliminate the effect of chance that is one of the characteristics of "Eastern-style painting." What are the reasons for this?

DHS: Simply because I am not making Eastern-style painting. I also believe that the notions of ambiguity and chance in Asian art are very controlled and intentional. To relate my work to Eastern or Asian art is a misunderstanding, and to simplify Oriental art down to those two elements is unjust.

SK: *Seoul Home/L.A. Home/New York Home/Baltimore Home/London Home/Seattle Home* **(1999) and** *348 West 22nd St., Apt. A, New York, NY 10011 at Rodin Gallery, Seoul/Tokyo Opera City Art Gallery/Serpentine Gallery, London/Biennale of Sydney/Seattle Art Museum* **(2000) are architectural, sculptural installations, which re-create your Seoul and New York residences using fabric. And the venues of their exhibitions are added to their titles. In these works, premised on movement, what changes of meaning happen to the concept of "mobility"? And what are your thoughts on "site-specificity"?**

DHS: I explore site-specificity on many levels. Replicating my Seoul home, and having produced it inside the very same building, makes the site-specificity engrained in the work. Once I transport that piece to another space and change the name, it interacts with a new site as it encounters a new space and becomes a new home—yet with the origin ever so present. This kind of repetition within site-specificity is interesting to me. The fact that it doesn't necessarily have to be a physical condition is also very special in this series of works.

SK: You have made several works that take the shape of clothing, such as *High School Uni-form* **and** *Metal Jacket* **and** *Some/One.* **I'd like to hear your thoughts on the boundary where the personal space of "clothes" meets the public space. Could you also describe the spaces of your personal experience? And all these works show an anonymous collectivity, in which singular individualities have disappeared. What does this anonymous collectivity mean for you?**

DHS: Both works do deal with the idea of personal space, while simultaneously creating a boundary—a buffer—to public space. However they represent contrasting personal experiences. The *Uni-form* is a catalogue of myself, whereas *Some/One* is surely reflective of a personal experience, yet represents a larger body of people, not necessarily anonymous, who share that specific experience with me. The works may be read as a portrayal of the anonymous mass—but as I mentioned above, I exist within these pieces, and in the case of *Some/One,* an entire nation is identified and given a place within the piece. I believe it's quite the contrary, where I am making it a point to identify individuals, whether myself or a larger self, in the structural and figurative elements and configurations of the pieces.

SK: Your *Karma* and *Paratrooper* series demonstrate a certain Buddhist way of thinking. How would you describe the influence of Buddhism and other Eastern philosophies?

DHS: I spent the first thirty years of my life in Korea, which is influenced by not only Buddhism, but a juxtaposition of many Eastern philosophies and religious beliefs. These influences are heavily engrained in Korean society and culture, so the observation that certain Buddhist notions exist in my works—*Karma* and *Paratrooper*—is correct. However, my work does not explicitly speak of Eastern thinking and Buddhist thinking.

SK: *Paratrooper-I* (2003) {see page 59} consists of a sculpture of a paratrooper on a pedestal who is pulling a parachute. Although this image embodies the idea that the artist's individuality is completed through personal experiences and with the support from and relationships with others, it also seems that viewers may not comprehend the thoughts and intentions behind this work. Can you share your thoughts on the interpretation of artwork and what is left after interpretation?

DHS: Understanding a work of art is perhaps to misunderstand it first. The viewers' interpretation of a certain piece of art, or their attraction to something, most likely comes from their own reading of the work, which is very interesting to me. As soon as the work is revealed to an audience, it limits the artist's control over others' perceptions and interpretations. The work may never be understood and interpreted fully as the artist intended. My work is a personal record, so I don't expect everyone to relate or understand or accept it 100 percent.

SK: Your personal experiences, memories, and imaginings coexist in your *Speculation Project*. Furthermore, in it, you are transferring a narrative structure into a work. Please describe how this work will unfold.

DHS: The *Speculation Project* is a series of small projects that allows me to explore ideas, fantasies, and the impossible. I get to represent and realize ideas that I would never be able to execute in real life—[to produce them at full scale would be] physically impossible and technically impossible. It is an evolving project, and I may not be satisfied with one solution to a problem. The complexity of this body of work makes it difficult to put into words; I, too, need to continue to explore and watch it unfold.

SK: It is my understanding that *Fallen Star* consists of five separate pieces {see pages 60 and 161–63}. The first chapter, *Wind of Destiny*, portrays an image of a house flying into the sky in a tornado. The fourth chapter, *A New Beginning*, shows an image of a traditional Korean-style house, which is your residence in Seoul, crashing into your American apartment, and the fifth chapter, *Epilogue*, conjures a scene in which the traditional house has been inserted into the other building, and for its survival is sprouting new columns, walls, and floors to find a balance. How would you describe the last two scenes that are yet to be made?

DHS: As of now, I have added two more chapters to *Fallen Star*. As part of the *Speculation Project*, the entire narrative is tough to put down all at once from the very beginning. All of the chapters exist; however, they are not necessarily in a sequence. I may explore and execute one chapter of *Fallen Star*, and as I do this, question various possibilities inherent in the previous chapters and chapters to come. It's a constant back-and-forth, a replaying of the narrative at different moments, in various orders. All I can reveal now is that the next chapter is in the works. I have to feel it out and play it out.

SK: Your narrative for *Fallen Star* reads as follows:

> One day, the wind started blowing all of a sudden and quickly turned into a tornado, taking the house I was living in up into the sky. In the house, he encountered another house flying (Dorothy's house) and eleven swans wearing a crown. During the flight, he also saw a bridge crossing the Pacific Ocean. After passing by all of these, in preparation for the house's final landing, he started making parachutes leaving only a few things such as a tool kit, clothing, and a metal jacket. He first made a parachute for the house, then another for himself. When the tornado started dissipating and the house began a free fall, he put on the parachute and safely landed. At this time, his Seoul house crash-landed in the (19th-century) apartment building in Rhode Island, where he settled when he first moved to the United States.

For me, something that resembles what Marcel Proust termed "involuntary memory" seems to operate in this narrative. In other words, memory continues to consistently operate as an element in your work. What are your thoughts on this?

DHS: The narrative of *Fallen Star* is indeed generated by my memory. Memory is the catalyst, soon after combined with my imagination and speculative thinking. Memory is filtered through the creative process, and, so again, may not be a rigid narrative. This makes it possible for me to meander to and from certain parts of my memory, which is fascinating.

SK: You have consistently addressed transitional spaces like bridges, corridors, and stairways. In what ways are such spaces without final destinations, or spaces of constant movement, important for you?

DHS: I have referred to my interest in transitional spaces many times. It can be a physical movement, or a nonphysical displacement. As I am constantly in transit, from one place to another, from one culture to another, each movement has an impact, and I have become more aware of the in-between spaces that I so frequently occupy. I do not fear not knowing my destination. I accept this aspect of my life and how it even plays out in the way I produce my work—the process is far more important than the result. An appreciation of a strong process will hopefully yield good results—that's what I believe.

NOTE

1. From a conversation with writer Lee Geon-su in 2000.

Haegue Yang (born 1971 in Seoul, Korea; lives and works in Berlin, Germany, and Seoul) has lived in Europe since the mid-1990s and has shown extensively in Germany as well as in Korea ever since. Yang's deceptively casual installations, videos, artist books, and drawings act as furtive interruptions into the viewer's habitual perceptual practices. In Yang's *Grid Block* (2000), sixteen sheets of paper are ruled like scientific graph paper, but their accuracy is undermined upon closer inspection because the squares are of varying colors and widths. Similarly, her installations of random everyday or utilitarian objects, such as Venetian blinds, lightbulbs, and electric heaters in her *Series of Vulnerable Arrangements* (2006), are carefully and precisely arranged to create a stimulating and harmonious grouping. Her works not only embrace the melancholy associated with dislocation, or being out of context, but also celebrate the beauty of relocation, or finding new connections and meanings in new places.

Education BFA, Seoul National University, Fine Arts College in Seoul, Korea, 1994; Exchange Program Grant, Cooper Union in New York, 1997; Meisterschüler in Städelschule Frankfurt am Main, Germany, 1999 **Selected Solo Exhibitions** *Lethal Love,* Cubitt Gallery, London, UK, 2008; *Siblings and Twins,* Portikus im Leinwandhaus, Frankfurt am Main, Germany, 2008; *Haegue Yang: Asymmetric Equality,* Gallery at REDCAT, Los Angeles, California, 2008; Sala Recalde, Bilbao, Spain, 2008; *Remote Room,* Gallery Barbara Wien, Berlin, Germany, 2007; *Unpacking Storage Piece,* Haubrokshows, Berlin, Germany, 2007; *Sadong 30,* Incheon, Korea, 2006; *Haegue Yang: Unevenly,* Basis voor Actuele Kunst, Utrecht, Netherlands, 2006; *Unrealistic to Generalize,* Galerie Public, Paris, France, 2003 **Selected Group Exhibitions** *Life on Mars,* 55th Carnegie International, Pittsburgh, Pennsylvania, 2008; *Eurasia: Geographic cross-overs in art,* Museo di arte moderna e contemporanea di Trento e Rovereto, Rovereto (Trento), Italy, 2008; *Brave New Worlds,* Walker Art Center, Minneapolis, Minnesota, 2007; *Feminist Legacies and Potentials in Contemporary Art Practice,* Museum van Hedendaagse Kunst Antwerpen, Antwerp, Belgium, 2007; *Glocal and Outsiders,* 3rd Prague Biennale, Prague, Czech Republic, 2007; *Como Viver Junto (How to Live Together),* 27th São Paulo Biennial, São Paulo, Brazil, 2006; *Chasm,* 4th Busan Biennale, Busan, Korea, 2004; *D-Free Zone,* 5th Gwangju Biennale, Gwangju, Korea, 2004; *Hermes Korea Missulsang,* Artsonje Center, Seoul, Korea, 2003; *Manifesta 4,* Frankfurt am Main, Germany, 2002

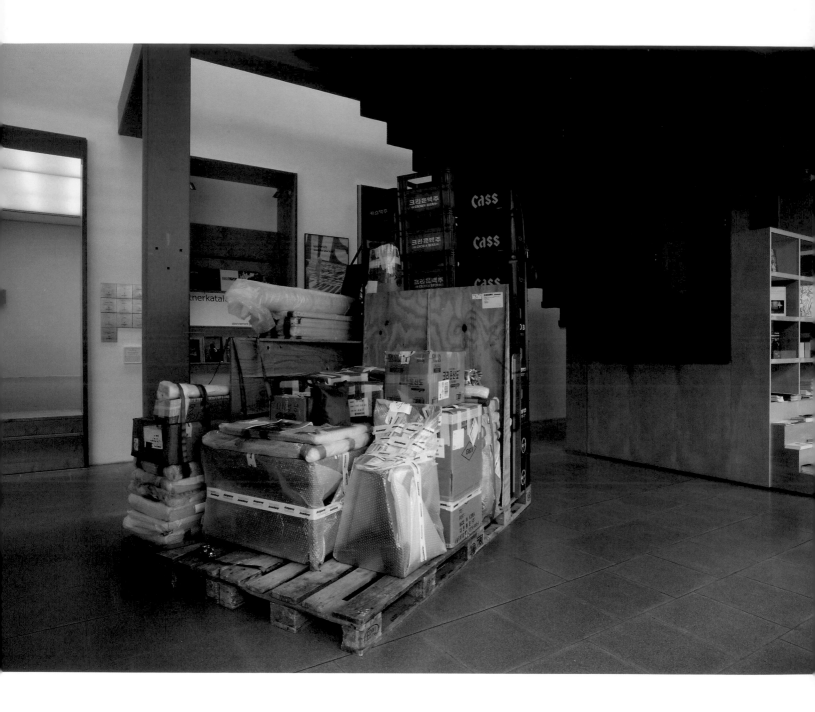

STORAGE PIECE / 2003/2009 / mixed-media installation with performances / dimensions vary /
The Haubrok Collection, Berlin

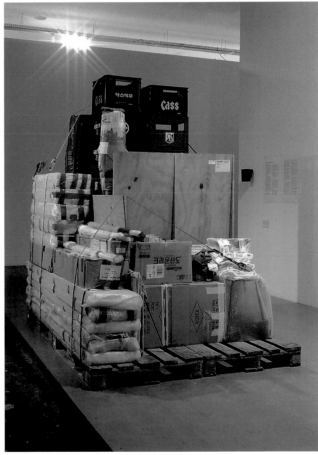

STORAGE PIECE / performance at *Como Viver Junto (How to Live Together)*, 27th São Paulo Biennial /
São Paulo / Brazil / 2006

YEARNING MELANCHOLY RED / 2008 / customized Venetian blinds, moving lights, steel structure, infrared heaters, fans, cables, and drum set / and HIPPIE DIPPIE OXNARD / 2008 / steel, lightbulbs, cables, yarn, thread, shells, postcard rack, ladle, and paint grill / installation in *Asymmetric Equality* / the Gallery at REDCAT / Los Angeles / California / 2008

SADONG 30 / 2006 / site-specific project in an abandoned house in Incheon, Korea / light sources (hanging lights, strobes, light chain), mirror, origami objects, drying rack wrapped in fabric, fan, wall clock, glow-in-the-dark paint, wood piles, spray paint, ventilator, viewing terrace with icebox filled with mineral-water bottles, wood bench, and plants / no longer extant

Haegue
Yang

Sunjung Kim: Your work appears to have taken a turn with *Storage Piece* {see pages 170–71}. Whereas your previous work tended to practice rational distancing, afterward it grew more individualistic and subjective. Could you discuss this particular piece and its background?

Haegue Yang: I agree with your observation that *Storage Piece* was a kind of internal turning point in my work and that it represents a perspective that reflects the crises and urgent desires of singularities that are key to my more recent work. At the same time, the piece also articulates the expression of subjective emotions, which had previously tended to be rather passive, and more proactively acknowledges such emotional states as a distinctive condition rather than as a peripheral element in my work.

I created *Storage Piece* at a time when a desire for storage space, which I desperately needed, and the offer of exhibition space coexisted and collided. An exhibition opportunity is not only an important venue of expression for a young artist but also a space of social duties and responsibilities, and thus becomes a kind of ideal space that must be addressed while personal circumstances are placed on hold. I mulled over whether I, as a social, biological being, could embrace my own individual needs and pains while addressing an ideal space with my work for exhibition. I believe that, rather than merely situating works in isolated spaces, the act of creating moments in which language expresses collisions and contradictions between opposing desires and needs, responsibilities and conditions, as well as the process of physicalizing the everyday, constitutes the work of our time. That is, in my art, I translate the performative aspects of my work into museums.

SK: *Storage Piece* was acquired by collector Axel Haubrok in 2004, and in 2007, for the first time, *Unpacking Storage Piece* was presented unpacked at Haubrok's instigation in his exhibition space in Berlin. This work brings up a number of issues. First, the question of the author: after individual works had been created, they were packed for storage, and then they were shown together in the state of being packed. Once they were unpacked, who was the true author, Haegue Yang or Axel Haubrok? Second, when the piece is unpacked and displayed, does the work continue to be *Storage Piece?* Third, what state will the work assume after the exhibition?

HY: As I discussed earlier, there were various aspects I considered in the conception of *Storage Piece* —such as the collision of desires and needs, the coexistence of opposing existential conditions, and even the artist's own contradictory states of social existence. At the same time, there was an attempt to resist my own frustration, internal dramas, personal unhappiness, and deprivation, combined with my utterly simple and direct emotional attachment to my own works. Instead of identifying the author as a single person or name, I settled on the role of a conceptual author. In other words, in this piece, the author is the person who exhibits desires, abilities, curiosities, needs, and so on, whether that be the collector or viewer. On the contrary, reflecting the state and environment of the original author is what brought this piece into existence. The owner's own desires are reflected in the changes to *Storage Piece* and its new form. One could say that, because it understands its formal transformations according to the changes in its environments, *Storage Piece* presupposes its own changes. Perhaps the accumulated and packed state of *Storage Piece,* presented as a totality, is no more than a trap set by the piece itself. Whether the piece's diverse forms should be seen as aspects of the same work, as different, transformed works, or as different modes of existence for a single piece is a question that I personally (absolutely not as the author) want to address as something that should be determined together by the author, the collector, and subsequent viewers.

One thing I'd like to caution against is the mistake of understanding this potential for change merely as freedom. *Storage Piece* is a conceptual piece. Just because it possesses possibilities for change doesn't mean that it is completely free and open, and that anything is possible. Conversely, the more the form changes, the more stringently we need to remember the consistent strictness of its own conceptual characteristics.

Since its first showing in London in 2003, *Storage Piece* has been exhibited in Berlin (2004), Darmstadt (2005), São Paulo (2006), Hanover (2007), and

elsewhere. But it wasn't until the 2007 exhibition *Unpacking Storage Piece* that the piece was transferred back to its original form for the first time and presented as such. The possibilities for this piece can only be discussed within the parameters permitted by its performative potential. To give a simple example, if the desire that the collector confers upon the piece is not true to the piece's historicity or to the purity of its birth, the piece will not undergo formal changes—changes that would be a reflection of a new desire, need, or urgency, which build the contingency of this piece.

SK: I witnessed your *Sadong 30* project in the summer of 2006. It was a site-specific project at your maternal grandparents' house, which had been left abandoned after the death of your grandmother. Simultaneously, the project seemed to bring together many things, such as personal memories, nostalgia, and melancholy.
HY: The abandoned house that was the venue for *Sadong 30* had already been mentioned in one of the chapters in *Squandering Negative Spaces,* completed in April 2006, and in the last essay in my video trilogy. The script for the video, which had been written before there were any plans to create a project at the house, speaks about the existential condition of the house; it later became the motivation for the project:

Perhaps this house lived against time and development. No, perhaps it has been alone, squandering time and development because it wants to live in a different time zone, or to store time.

Time is neither lacking nor abundant. But time surrounding this house has established its own time zone inside this place. That is really spooky but at the same time, lovely, and very dirty and freaky, but, at the same time, sympathetic.

There is much that is lacking here. Everyday life, social integration, common sense, etc. The deficiency makes this house very finicky. In the black hole of such deprivation, the location of the house has no meaning in terms of urban demarcation and geography. The remoteness of this house cannot be measured in spatial distance. Temporal standards for measurement are also ambiguous. It's an old house, but it is in such a ruin that to say it is of such and such period, or to make any such judgment, interpretation, or analysis would be futile.

The only applicable standard of measurement is deficiency. The house seems to suck everything into its vast chasm; it consumes and squanders everything. That is why much is lacking.

It seems that here perhaps it's possible to add an arbitrary composition to a non-visible place. It is a place where my antagonism toward what is known as "cultural thinking" or "intercultural thinking" is perhaps not a problem. In other words, it is a place where a time for the estimation of the cultural-social-political chasm is allowed. This is usually not the case in reality . . .[1]

The project was self-organized in collaboration with curator Hyunjin Kim as my first solo show in Korea, my home country. That is, it was an environment in which my own desire and need in various ways constituted the subjective impulse for the action.

In addition to the various kinds of personal emotions that coexisted when I found out about the house during my preparations for this piece, my critical attitude vis-à-vis the cultural-political tendencies that I had slowly observed and studied while living and working at length in Europe as a foreigner ultimately brought about existential—rather than sociological—interests. Working with the needs and possibilities encompassed by the European continent—a "developed fossil"—with which I got to be extremely familiar, perhaps I honed myself as an artist through my own pessimistic optimism. Rather than settling in the suffocating constrictions of society, in the form of rational common sense (*Vernunft* in German) and bureaucracy, I have wanted to draw out a more evolved and meaningful critical universalism.

The emotions and attitudes that have materialized out of the everyday problems I experienced and struggled with in Europe as a foreign artist didn't make it easy for me to establish artistic standing in my own country. Often I felt double alienation. In such a situation, the Sa-dong house convinced me that only there could I be generally and existentially coherent. Of course, it was no more than a very intuitive impression. Yet this desire to experiment with creating an immaterial yet existentially intense site at Sa-dong, instead of resisting an existing situation or environment, gained a critical force when I found a collaborator in Hyunjin Kim. Then the project was no longer the hope of a sole being, but a project of a very small

community. The Sa-dong house embodied for me a highly performative and extremely human existence within a very ideal social alienation. And the act of representing the place-ness of the Sa-dong house was my own escape plan. I was also trying to escape the idea that *Sadong 30* was an attempt to expand the narrowing space for art through fragmentation, a cure for personal traumas in my own family history, nostalgia for the past, or a critique of public projects in local contexts.

Of course, there is no reason to dismiss completely the possible socio-cultural readings of the public dimensions of Incheon, the city where this house/place is located—the historical port city for Seoul and currently Seoul's satellite city, where the capital's international airport is located. Furthermore, it was clear that the project provided unique emotional experiences through a journey to the periphery. That is, the act of intentionally leaving the center suggests an awareness of a positional move, and the unique emotions that a peripheral space can evoke naturally become part of the journey's experience. The space that viewers arrived at was extremely fragile, but nonetheless maintained itself physically as well as metaphorically, thus bringing about an existential reflection—not a powerful one but a fragile, vulnerable one.

SK: Could you describe your solo exhibition *Unevenly* at the BAK (Basis voor Actuele Kunst), Utrecht, in April 2006?

HY: The work *Series of Vulnerable Arrangements— Version Utrecht* in *Unevenly* consisted of various kinds of purchased electrical appliances, infrared heaters, a humidifier, light lamps, fans, and scent machines that exhibited their own unique roles and functions. And titles were given to each of them according to their functions. *Relational Irrelevance* consists of a floor lamp and a spotlight of the same height set on a tripod. The floor lamp and the spotlight are lit alternately for three-second and three-minute intervals. They seem mutually dependent, but are actually autonomous elements. The humidifier titled *Handful of Obscurity* humidified the space and reduced visibility with its temporary operations. The scent machine that sent out puffs of "burning wood" smell was called *Almost Exhausted,* and another, which had a "fresh linen" smell, was called *Becoming into Time Machine.* The buzzing fan was titled *Anonymous Movement,* and the two infrared heaters were called *Possible Synonym of Squandering.*

This exhibition title was something that I had thought of as a kind of motto while I was planning the project in order to emphasize the potential of the state of unevenness. Even without citing various thinkers, such as the philosopher Jacques Rancière and his *La haine de la démocratie,*[2] we often feel that many activities carried out in the name of democracy are no more than highly distorted rules, resulting in less equality and more domination of power. Such distortions, brought up by democracy as an institution and accelerated by liberal democracy and late capitalism, alienate our desperate desires for true apolitical life.

In actuality, *Unevenly* referred to the localized sensory experiences scattered through the exhibition space and, at the same time, metaphorically and directly, it explained the forms of an uneven or seemingly highly antidemocratic politics produced by these localized effects. The uncontrollable and unpredictable sensory experiences are also connected to individuals' own definitions of democracy and equality.

SK: In the invitation for the exhibition *Unevenly* are pictures of Kim San, the Korean anarchist/Communist revolutionary who was active in China and Japan, and of Nym Wales, the author who cowrote Kim's biography. Why did you choose these two figures?

HY: Not only was Kim San and Nym Wales's book *Song of Ariran* personally important to me, but also the significance of the book gradually extended into an interest in the political significance of the meaningful encounter between individuals. Instead of the monolithic definitions of their identities in the real world (the Korean revolutionary Kim San and the American journalist who shed light on him), my subjective focus was on the intense moment of their encounter in history. I see the space produced by their encounter as the result of those marginalized figures' unique force in building their own communal space, and it also often creates an opportunity to observe the mistakes of viewing politics or history as a correctional tool, used in order to pursue a kind of justice. History may be seen as a kind of flow, but it is also a rupture in the flow. The conventional historical, social energy makes heroes out of people without considering the contingencies of such ruptures . . . If we were to take interest in humanist history-writing that retraces times and places rather than that which is merely satisfied with heroes and adventures, dramatic historical stories would serve as clues that could be found again in our own surroundings. Kim and Wales's encounter was a sort of exceptional case that rarely happens. And my current artistic interest lies in rehighlighting the community of will they created as a political act and also translating these personages—or this narrative—into a language of abstraction.

Their relationship constituted the narrative for a recent work titled *Mountains of Encounter,* which was presented at the Kunstverein, Hamburg. As the plural of the title suggests, their encounter, for me, was not so much a single encounter as an encounter of one specifically concerned crowd. Moreover, there is the art-specific problem as to how such an observation can be represented in an artistic language. Just like many other contemporary artists who feel skeptical about the political topicalism focused on and satisfied with established readings of history or society, I also struggle to create a new artistic political language.

I have pursued abstraction grounded in narrative through a series of installations in 2008, including *Mountains of Encounter, Three Kinds, Lethal Love,* and *Siblings and Twins.* In a departure from the traditional art-historical understanding of abstraction as the opposite of representation, the power of abstraction can be compared to that of literary language. My installations that consist of lights and blinds, on the one hand, do not appropriate existing narratives. Perhaps it is because of the belief that political encounters should not be processes of decision by the "haves," but rather should be encounters between the "have-nots." Second, even though the form of democracy realized in our contemporary society seems to constitute the appearance of what is political, within it exists the human desire for an essential, specific politicality. In a similar way, I believe that behind narratives there are intimations that cannot be materially conveyed. Just as I explore political philosophy rather than artistic politics, through my series of installations I strive to take up the presentness of art possessed by abstract language.

Of course, abstraction, in a certain sense, has fallen to the level of bourgeois art objects that currently dominate the art market. This situation is comparable to how social-political projects have been reduced to become mere tools for political propaganda in a civil society instead of bringing about true artistic activism. There may very well be questions about how explorations of abstraction can truly claim presentness and movement. Nonetheless, that may be the only unmaterializable action that art can take, in the current state in which the orientation of social development is dotted by bureaucracy and economics.

NOTES

1. Nym Wales and Kim San, *Song of Ariran: A Korean Communist in the Chinese Revolution* (San Francisco: Ramparts Press, 1973).

2. Jacques Rancière, *La haine de la démocratie* (Paris: La Fabrique éditions, 2005).

Young-hae Chang Heavy Industries (YHCHI) (established 1998) creates Web art, which is published on its Web site (http://www.yhchang .com), as well as exhibited in actual gallery spaces. YHCHI is a collaboration of C.E.O. Young-hae Chang (born in Korea, lives and works in Seoul, Korea), and C.I.O. Marc Voge (born in the United States, lives and works in Seoul, Korea). Based in Seoul, they founded YHCHI after acquiring some basic digital media skills, and soon became famous for their quickly moving and edgy digital poetry that flashes to the beat of music. However dynamic their work may appear, they have created certain parameters for their design and have eschewed using the many extravagant graphics and interactive features available today. To date, their pieces still appear just in black Monaco font on a white background, with only a few works appearing white on black. Although they assumed a serious business name to parody powerful, large conglomerates and international companies, their art is readily accessible to anyone online. One of YHCHI's key objectives for these works is simply to entertain. The customary numerical countdown and title screen "YOUNG-HAE CHANG HEAVY INDUSTRIES PRESENTS" in every work resemble early popular film conventions to create viewer anticipation. The texts written by Chang and Voge are provocative and often politically pointed, tongue-in-cheek stories covering everything from sex and violence to alienation and the mundane.

Selected Solo Exhibitions National Museum of Contemporary Art, Athens, Greece, 2008; *BLACK ON WHITE, GRAY ASCENDING,* New Museum of Contemporary Art, New York, 2007; *End Credits,* the Moderna Museet, Stockholm, Sweden, 2007; *BUST DOWN THE DOOR!,* Rodin Gallery, Seoul, Korea, 2004 **Selected Group Exhibitions/ Showings** *Playback,* Musée d'art moderne de la ville de Paris, Paris, France, 2007; *Vidéo Story: 30ème anniversaire du Centre Pompidou,* Centre Pompidou, Paris, France, 2007; 10th International Istanbul Biennial, Istanbul, Turkey, 2007; São Paulo Biennial, São Paulo, Brazil, 2006; *The Art of Sleep,* Tate Online commission, London, UK, 2006; *Video and Media Art by Contemporary Artists,* Getty Center, Los Angeles, California, 2004; *The American Effect,* Whitney Museum of American Art, New York, 2003; *Zone of Urgency,* 50th Venice Biennale, Venice, Italy, 2003; *Universes in Universe,* 50th Venice Biennale, Venice, Italy, 2003; *Webby Prize for Excellence in Online Art,* San Francisco Museum of Modern Art, San Francisco, California, 2000

Young-hae Chang Heavy Industries

ECTICAL

ND GENDER

=

PEOPLE

BULLET IN HEAD. YUP.

BLACK ON WHITE, GRAY ASCENDING (detail) / 2007

BLACK ON WHITE, GRAY ASCENDING / 2007 / 7-channel video with original soundtrack / 11:42 min.

DIALECTICAL SEX AND GENDER = HAPPY PEØPLE.

CUNNILINGUS IN NORTH KOREA (detail) / 2003 / on- and offline Flash animation / 6:15 min.

다. 늘 그랬던 건 아니지만 첨단기술 덕

I'M BORN INTO A HOUSE WITH NO COMPUTER.

YOU STEP OFF THE SUBWAY TRAIN,

TRAVELING TO UTOPIA: WITH A BRIEF HISTORY OF THE TECHNOLOGY (detail) / 2006 / on- and offline Flash animation with original soundtrack / 3:50 min. / Collection Nouveaux Médias Centre Georges Pompidou / Paris

Young-hae Chang Heavy Industries

Sunjung Kim: Is there a difference between the work you did in Paris and the work you're doing now in Seoul? I'd be interested in hearing about some of your first artworks as a painter, sculptor, and installation artist before forming YHCHI.

Young-hae Chang Heavy Industries: In Paris, Young-hae was particularly interested in Marcel Duchamp. Her work back then may have reflected that. Marc was writing poetry. Now we work together. Duchamp still drops by (*LES AMANTS DE BEAUBOURG*), and poetry is eking out a living.

SK: I believe that *THE SAMSUNG PROJECT* was your first video and Internet work. The common thread in all ten of the videos that comprise this project seems to be social commentary. Is this so?

YHCHI: Looking back, we were probably trying to see what makes Korea and Koreans tick. We came up with Samsung. What's interesting for us is that now more than ever the premises of *THE SAMSUNG PROJECT* are valid.

SK: When and why did you start to make art on the computer?

YHCHI: When we moved to Seoul we had no studio or desire to have one. We wanted to make art and write poetry, yet didn't want to repeat the past. It was the beginning of the digital, Internet age . . .

SK: I heard that you do commissioned work. How exactly does that work? Do art institutions approach you and propose a theme? Do you do noncommissioned work? If so, is there a difference between commissioned and noncommissioned work?

YHCHI: Yes to all of the above. Art institutions propose a space or theme or both to us, then we do a site inspection—this can also be a Web site—and a collaboration begins. Two interesting recent collaborations are our work at Tate, London, and at the Centre Pompidou, Paris. If you go to our Web site, http://www.yhchang.com, you can link to the resulting works on the Tate and Pompidou Web sites, *THE ART OF SLEEP* and *LES AMANTS DE BEAUBOURG*.

Our most important project to date is *BLACK ON WHITE, GRAY ASCENDING* [see pages 180–81], commissioned by the New Museum of Contemporary Art, in New York. Unlike the Tate and Pompidou projects, this project is only in real space. It is, in fact, the only piece that cannot, without a total reformatting, be presented online.

We do a lot of commissioned work these days, but in the beginning we did everything just for our Web site. In fact, some of our most popular pieces—*DAKOTA, CUNNILINGUS IN NORTH KOREA* [see page 182], and *SAMSUNG MEANS TO COME*—were just pieces we thought up.

Although the majority of our work these days is the result of proposals from art institutions, no, we don't think there's too much of a difference between how we go about making commissioned and noncommissioned work. In the end, we have to sit down and figure out what to do with outside input, whether it comes from an art institution or a seemingly random stimulus in our daily doings.

SK: Your Web site gets over forty-three thousand visitors a day on average. That's incredible. Your site is like that of a large company in terms of not only the number of visitors but also the domain name ending with ".com." Is there a difference for you between showing work on http://www.yhchang.com and in a real exhibition space? What does it mean for you to show your work in an exhibition space?

YHCHI: Yes, there's a big difference. The YouTube phenomenon illustrates the attraction of numbers for media-minded people, including people in the art world. That's why a recent show we were in, *Playback,* at the Musée d'art moderne de la ville de Paris, also presented some of the show's music videos on http://www.myspace.com. It wanted to get some of those big numbers.

Our work reverses the process. Relatively speaking, we're like the Rolling Stones tuning up for Wembley by giving a one-night only, first-come, first-served free show to 250 club-goers in New Jersey.

Unlike the Stones, though, we can make more money in the small, underground club. :-)

SK: I know you compose the music for your pieces. In the beginning you used music made by others. What made you start to make your own music?

YHCHI: The digital zeitgeist.

SK: How do you create the relationship between text and music in your work?

YHCHI: We don't. It creates itself.

SK: *TRAVELING TO UTOPIA* {see page 183}, which you presented at the Centre Pompidou, in Paris, is based on your personal experience. Could you explain a little about what happens in the piece?

YHCHI: The piece says it all, and in several languages. To resume: a naive young thing living in a foreign country winds up being an unknowing agent for technological change (she discovers a GPS chip embedded in her abdomen) and political change in her native country.

By the way, the piece we presented at the Centre Pompidou was *LES AMANTS DE BEAUBOURG. TRAVELING TO UTOPIA: WITH A BRIEF HISTORY OF THE TECHNOLOGY* was bought by the Centre Pompidou for its new media art collection.

SK: I noticed that when you do two versions of the same piece, one, say, in English, the other, say, in Korean, they can be very different from one another. What makes you do that?

YHCHI: A little gnome inside us.

SK: What do you think about living and working in Korea?

YHCHI: It's a blast.

Seungmin Yoo
with Iris Moon and Joan Kee

CHRONOLOGY

1945

Korea gains independence on August 15 through the intervention of U.S. and Soviet troops, ending thirty-five years of harsh colonial rule by Japan. The forced modernization of the occupation period had changed the face of the agrarian country. Korea becomes embroiled in power struggles between the United States and the Soviet Union and is temporarily divided at the 38th parallel. Provisional governments are established in the north under the trusteeship of the Soviet Union and in the south under the United States.

Developments in Art: Seoul National University establishes departments of painting and sculpture, the first in the country.

1946

Developments in Art: As harsh repression of leftist activities intensifies in the U.S.-controlled south, an increasing number of left-wing artists go underground or defect to the Soviet-controlled north; among them are leading artists Kim Yong-jun and Yi Kwae-dae.

1948

The peninsula is officially divided into North and South Korea following the election of U.S.-backed candidate Rhee Syngman as first president of the Republic of Korea in the south, and the election of Soviet-backed Kim Il Sung as first prime minister of the Democratic People's Republic of Korea in the north.

1949

Developments in Art: The South Korean government initiates the Gukjeon, the Republic of Korea National Art Exhibition, replacing the Seonjeon, the academic, salon-style exhibitions established under Japanese occupation. The state-sponsored Gukjeon goes on to serve as the primary venue for artists to show their work and become "legitimate" artists; the majority of works follow Western styles popularized by artists trained in Japan during the occupation.

1950

The Korean War begins on June 25, when the North Korean government moves its military past the 38th parallel in an attempt to reunify the country, declaring President Rhee a traitor. Despite military support from United Nations forces, U.S. forces aiding the South initially suffer heavy defeats and are pushed back to the southernmost port city of Busan. Civilians are forced to leave the capital, with some fleeing north and others south. UN troops recapture Seoul

in September, following General MacArthur's famed landing at Incheon and the amphibious counterattack by U.S. Marines, which signals a turning point in the war. MacArthur's landing would be stamped in the minds of many South Koreans, making him one of the most memorable figures in the postwar period.

Developments in Art: Hongik University, a key institution responsible for producing many of Korea's leading artists, opens its art school. With different pedagogical traditions, Hongik University and Seoul National University create major rivalries within the Korean art scene. Artists from the north defect to the south, including oil painter Lee Jung-seop and Kim Heung-sou, while painter Mun Hak-su and Kil Jin-seop remain in the north. Study of North Korean artists would be prohibited for decades in South Korea, following harsh anticommunist laws.

1952

The Immigration and Nationality Act (McCarran-Walter Act), primarily governing immigration and citizenship in the United States, is passed by the U.S. Congress. Although direct racial restrictions are lifted, the act still maintains national-origin quotas; one hundred Koreans are permitted entry per year. Nevertheless, the second wave of Korean immigration to the United States begins when U.S. servicemen return home with Korean war brides. (The first wave came to Hawaii beginning in 1903 to find work on sugar plantations. Many eventually made their way to the U.S. mainland.) Increasing numbers of professional workers and students begin entering the country due to the conflict. In South Korea, artists are mobilized by the government to produce memorial paintings documenting the Korean War.

1953

Following three years of peace negotiations, armed conflict ends in a stalemate, with the country still divided. The United Nations, North Korea, and China sign the Korean Armistice Agreement at Panmunjeom; South Korean President Rhee Syngman refuses to sign. A demilitarized zone (DMZ) is established along the 38th parallel. Civilians return to a decimated Seoul, thousands lose their homes, and families are separated between the North and South.

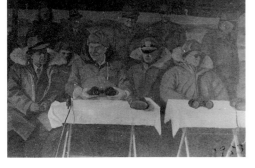

War memorial painting, 1953, Lee Se-duk Collection, Archives of Korean Art, Leeum.

1954–58

Developments in Art: A number of Korean artists study in Paris, including Kim Whanki and Lee Ungno.

1955

The U.S. Congress passes a special act allowing Bertha and Harry Holt, founders of Holt International Adoption Agency, to adopt eight Korean war orphans. Thousands more are soon brought to the United States.

1956

Developments in Art: A new generation of Korean-educated artists begins to lay the foundations of a domestic artistic scene through the establishment of professional art criticism and journalism; the first Korean art journal, *Sin Misul* (New Art), and the Korean Art Critics' Association is founded.

Nam June Paik leaves Korea to study first in Japan and then in Germany. Living in the United States and Germany, Paik becomes internationally known as a pioneer of video art.

新美術　NEW ART 1956 NO.2

Cover of *Sin Misul* (New Art), 1956, no. 2.

Suh Se-ok, *Noon,* 1957, ink on rice paper, 72 × 27 inches (183 × 68.6 cm), exhibited on the occasion of the first Mungnimhoe show, collection of the artist.

1957

Developments in Art: Abstract art becomes popular as experimental groups stage counter-exhibitions with the creation of art groups such as the Modern Art Association. Despite the continuing importance of academicism in state-sponsored national exhibitions, artists become interested in trends abroad. *Informel,* the European counterpart to American Abstract Expressionism, gains currency among young Korean artists aiming to create a critical avant-garde art movement.

1960

President Rhee Syngman is ousted from office following the April 19 movement, a student-led protest demanding his resignation amid charges of electoral corruption. Despite the brief establishment of the Second Republic with the election of President Yun Bo-seon and Prime Minister Chang Myeon, April 19 creates social unrest.

Developments in Art: Led by Suh Se-ok (the father of Do Ho Suh), the Ink Forest Group {*Mungnimhoe*}, the first ink-brush painters' group in Korea to consciously explore the notion of modernity in traditional ink painting, holds its first exhibition in Seoul. The *Wall* exhibition, the first open-air show in Korea, opens and is considered a watershed event at the time for bringing *Informel* works to a wider public.

1961

General Park Chung-hee stages a coup d'état on May 16, overthrowing the unpopular Second Republic, and places the country under martial law. Park establishes the Korean Central Intelligence Agency (KCIA), which would become notorious for its arbitrary detention and torture of people viewed as enemies of the state under the National Security Law, which gave the state wide powers to ban any Communist, pro-North Korean, or "antistate" activities in the South.

1963

Park Chung-hee is officially elected president. Park initiates South Korea's first large-scale economic reform program, combining nationalism and strong economic development in an effort to reconstruct a country still affected by the disasters of war. North Korea at this time has greater military and economic strength, supported by the Soviet Union and China. Under Park, ministries of finance, trade, and industry are created. The age of big industry begins in Korea, with a construction boom contributing to the meteoric rise of conglomerates, or *jaebeol,* such as Samsung, Lucky Goldstar, and Hyundai. Large numbers of rural inhabitants move to the capital in search of better opportunities.

1964

South Korea sends its first troops to South Vietnam to support the United States in the Vietnam War; the country provides the second largest contingent of soldiers next to the United States. The last South Korean troops are not withdrawn until 1973.

Suh Se-ok, *Line Variation,* 1959, ink on mulberry paper, 29⅛ × 37 inches (74 × 95 cm), collection of the artist.

Suh Se-ok, *Point Variation,* c. 1960, ink on mulberry paper, 37 × 29⅛ inches (95 × 74 cm), collection of the artist.

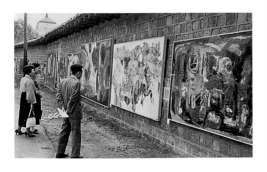

The 1960 *Wall* exhibition, held on the stone walls surrounding Deoksu Palace, Seoul, Archives of Korean Art, Leeum.

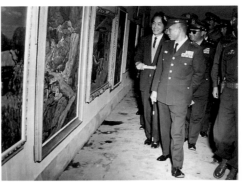

Park Chung-hee inspecting works from the 1961 Gukjeon, Lee Se-duk Collection, Archives of Korean Art, Leeum.

Developments in Art: The state establishes a committee for constructing monumental statues of historical figures. Created by Kim Se-jung (the father of Kim Beom) the statue of legendary naval hero Yi Sun-sin is situated at Sejongno, a new thoroughfare cutting through downtown Seoul. Influenced by Asian and Western philosophy, Japanese artists such as Nobuo Sekine and Tokyo-based Korean artist Lee Ufan create experimental works that would later become known as Mono-ha, or "school of objects," designating works that explore the relationships between object, materials, and space. The first large-scale exhibition of contemporary Korean art in Japan, *Contemporary Korean Painting,* takes place at the National Museum of Modern Art in Tokyo.

1965

Partly in response to U.S. pressure, relations between South Korea and Japan are normalized despite protests in both countries. The third and largest wave of Korean immigrants enters the United States following the Immigration Act of 1965. Although many immigrants are highly educated in skilled professions in Korea, they are forced to open small businesses such as groceries, restaurants, and dry-cleaning shops due to language and cultural barriers. Many settle in metropolitan areas such as Chicago, Los Angeles, and New York.

Developments in Art: Korean ink painter Lee Ungno participates in the São Paulo Biennial, the world's second-oldest art biennial, as more Korean artists begin to exhibit abroad.

1966

Developments in Art: The multidisciplinary journal *Space* is founded by architect Kim Swoo Geun. It is the only cultural journal to be consistently distributed during authoritarian rule, serving as a leading promoter of Korean contemporary art and architecture as well as a source of information on overseas artistic developments for Korean artists.

1968

On January 31, an armed North Korean unit of thirty-one commandos carries out an assassination attempt on President Park, creating widespread paranoia throughout the country. Disguised as South Korean soldiers, the unit infiltrates the grounds of the Blue House, the president's residence. After a gunfight, the North Korean unit disbands, sending national police and American soldiers across the country in search of remaining members.

Jung Kang-Ja and other artists, *Happening—The Transparent Balloons and Nude,* one and a half hours from 6 PM on May 30, 1968, at C'est Si Bon music hall, Seoul. Background music by John Cage. Visitor participation is encouraged.

1969

Pressured by the KCIA, the National Assembly amends the 1963 constitution, allowing President Park to hold a third term in office.

Developments in Art: The artistic scene is divided into several different factions; Space and Time (ST) is founded, a collaborative experimenting with conceptual art and organizing seminars and reading groups to examine foreign art theory; another group, Avant Garde (A.G.), stages performance pieces and creates works in film, showing the strong modernist vein that continues to affect Korean art. The National Museum of Contemporary Art is founded at Gyeongbok Palace, a former Joseon-dynasty residence in Seoul. Poet Kim Ji-ha drafts the manifesto for the Reality Group (*Hyeonsil dongin*), an artists' group comprising four Seoul National University students, including Oh Yoon. The manifesto would sow the seeds of Minjung art, or people's art, a leftist popular art movement emphasizing a socially engaged political realism over modernist abstract art, which Minjung adherents viewed as a mark of U.S. cultural hegemony.

1970

The Gyeongbu Expressway, the first major highway to run through the country, is completed as the Saemaeul Movement, a nationwide project aimed at modernizing the rural Korean countryside, begins. Developments do not always take a smooth course as the Wau apartment complex in Seoul, part of the first wave of modern concrete residential buildings to be constructed, collapses only four months after being built. The Seoul mayor resigns, revealing larger corruption and malpractice in such "overnight" rush development projects. However, real-estate development and speculation continues in Gangnam, the emerging southern part of Seoul, which would come to be defined by concrete apartment complexes and an upwardly mobile population.

Developments in Art: The first commercial art galleries, Hyundai Gallery and Myongdong Gallery, open in the Anguk-dong area of Seoul, despite initial difficulties. The galleries sell, alongside traditional calligraphy or ink paintings, oil paintings by established Korean artists, increasingly popular among collectors and newly wealthy clients. The Myongdong Gallery becomes known for its support of avant-garde, often unsaleable paintings and sculptures.

Ha Chong Hyun, *Conjunction 74-24*, 1974, oil on hemp, 78¾ × 39⅜ inches (200 × 100 cm), collection of the artist.

Suh Seung-won, *Simultaneity* (detail), 1970, fourteen panels of paper, each 39⅜ × 39⅜ inches (1 × 1 m), collection of the artist, originally shown in the 1971 A.G. exhibition *Réaliser et la Réalité*, National Museum of Contemporary Art, Seoul.

Ha Chong Hyun, *Conjunction 74-26*, 1974, oil on hemp, 42⅞ × 87⅜ inches (109 × 222 cm), collection of the artist.

Facade of Hyundai Gallery, Seoul, 1975.

1971

Park Chung-hee is elected to a third term in office, narrowly defeating opposition candidate Kim Dae-jung.

Developments in Art: Within an artistic scene dominated by men, Expression Group, the first all-women artists' group, is established.

1972

Park declares a state of emergency and imposes martial law. He dissolves parliament, abolishes the previous constitution, and creates a new one, known as the Yusin constitution, giving the president an unlimited term of office and the right to appoint a majority of seats in parliament. Many Koreans come to associate the Yusin constitution with a period of harsh oppression, and a strongly policed society.

Developments in Art: The Korean Artists' Association holds the first of a series of exhibitions aimed at expanding the scope of contemporary art, known as the Indépendants exhibitions.

1973

A vocal proponent of democracy, Park's long-standing political opponent, Kim Dae-jung, is kidnapped by the KCIA while he is in exile in Tokyo because his calls for democracy were seen as a threat to the South Korean government.

1974

On August 15, a national holiday commemorating Korea's liberation from Japanese colonial rule, a failed second assassination attempt is made on President Park by North Korean agent Mun Se-gwang; First Lady Yuk Young-soo is shot and killed.

1975

Developments in Art: The Tokyo Gallery hosts *Five Korean Artists, Five Kinds of White,* an exhibition that launches the influential art movement known as Korean monochrome painting. The journal *Space* establishes an annual cash award for fine artists.

1978

Park is elected to office for a fourth term. A growing number of political opponents, dissident students, and laborers are detained, tortured, and jailed under increasingly harsh authoritarian rule. Students demonstrate and gain increasing support from major public figures. Among the most vocal critics is prodemocracy dissident politician Kim Dae-jung, who is placed under house arrest.

Developments in Art: While conceptual art and photorealist painting gain popularity among artist groups in Seoul, monochrome painting dominates the artistic scene through the group exhibition series *École de Seoul,* held from 1976 to 1989. At the National Museum of Contemporary Art in Seoul, the *Tendencies in 20 Years of Korean Contemporary Art* exhibition is one of the first state-sponsored survey shows to present works by younger artists interested in different styles and art movements.

Kim Soun-Gui, *Today,* 1975, drawings on paper, each 10 × 16⅛ inches (25.5 × 40.8 cm), concept for performance. During the exhibition, the public inscribed "yesterday, today, and tomorrow" on the calendar on the date of their visit, bringing about the realization that "yesterday, today, and tomorrow" are the same day and thus encouraging an awareness of the paradox of language.

Park Seobo, *Ecriture No. 37-75-76,* 1976, pencil and oil on canvas, 76⅝ × 118⅛ inches (194.5 × 300 cm), collection of Seobo Foundation.

thousands take to the streets in Gwangju, taking over the city. Demonstrators are brutally suppressed by the army, which had been ordered to quell the "rebellion" by Chun; hundreds are killed. The May 18 Uprising would become a rallying cry for the prodemocracy movement.

Developments in Art: Younger art groups with an emphasis on social and political concerns emerge, seeing realism rather than abstract art as a means of critiquing society. The first exhibition of the group Reality and Utterance, originally scheduled to open at the state-sponsored Korean Culture and Arts Foundation, is abruptly cancelled due to the volatile political subject matter; the show opens instead at the private Dongsanbang Gallery in Seoul. Participating artists, including Kim Jeong-heon, Oh Yoon, Min Jeongki, Sung Wan-kyung, Lim Ok-sang, Joo Jae-hwan, Kang Yobae, and Son Jang Seop, form the backbone of the politically active Minjung art movement.

1981

Chun Doo-hwan is inaugurated as president amid discontent and increasing student-organized protests. Like Park, Chun focuses on economic reforms, proposing a five-year development plan upon taking office. Seoul is chosen to host the 1988 Summer Olympics, putting the developing country in the international spotlight and bringing attention to its volatile political situation.

Developments in Art: The Gukjeon, the annual state-sponsored national exhibition, is discontinued after thirty years. Modernist works by monochrome and *Informel* artists such as Kim Tschang-Yeul and Suh Seung-won are shown at the exhibition *Korean Drawing Now* at the Brooklyn Museum of Art. The early 1980s see a resurgence of interest in modern ink painting, beginning with the debut of the loose affiliation of artists known as the Sumukhwa group in 1981.

1979

KCIA Director Kim Jae-gyu and coconspirators assassinate President Park, citing his undemocratic rule as their prime motive. Park's death throws the country into national mourning and political uncertainty; a state of emergency is declared and a national curfew imposed. On December 12, Park's favored protégé, General Chun Doo-hwan, stages a coup d'état, placing control of the country with the military elite.

Developments in Art: The multivolume series *Selected Works of 100 Modern Korean Painters and Sculptors*, one of the first attempts to establish a canon of modern and contemporary art in Korea, is launched by the Kumsung publishing company.

1980

Called "Seoul Spring," widespread demonstrations against military control take place in the hopes of bringing change; 100,000 unionized student protesters and civilians surround Seoul Station, demanding democratization. The well-organized students, who came of age during the prodemocracy protests, would subsequently be called the "4-6-8 generation" (now in their 40s, born in the '60s and at university in the '80s). Martial law is imposed, with universities closed and protests and gatherings banned. On May 18,

Song Soo-Nam, *Mountain and Autumn,* 1980, Indian ink on Korean paper, 47¼ × 63 inches (120 × 160 cm), collection of the artist.

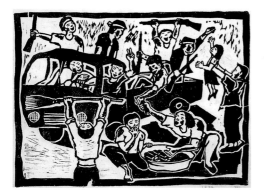

Sung-Dam Hong, *Solidarity 1,* 1984, woodprint, 16½ × 21¾ inches (42 × 54 cm), collection of the artist.

1982

Developments in Art: The Samsung conglomerate opens the Ho-Am Art Museum in downtown Seoul. Artist Bahc Yiso leaves Seoul to study at Pratt Institute in Brooklyn, New York, where he remains for the next thirteen years.

1984

Developments in Art: Nam June Paik's new media work *Good Morning Mr. Orwell* is simultaneously shown on television sets in the United States, France, Germany, and Korea, broadcast via satellite on New Year's Day, signaling an optimistic vision of technology in forging global interconnections. Korean galleries take part in the Foreign Investment Advisory Council (FIAC) for the first time, indicating the extent of contemporary Korean art's viability in an expanding international art market.

1985

Developments in Art: Minjung art gains increasing support from artists and is placed under greater scrutiny by the Chun government. The government confiscates thirty-six publicly

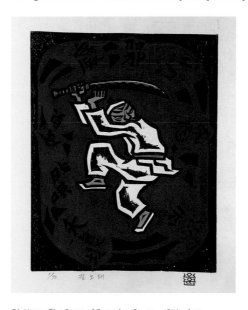

Oh Yoon, *The Song of Sword,* 1985, 12 × 9¾ inches (30.3 × 25 cm), collection of the artist.

Minor Injury exterior, 1985, Brooklyn, New York.

displayed works under the National Security Law. Five participating artists are jailed. Minjung art, as Korea's first visibly leftist art movement, becomes the subject of intense social debate as artists mobilize into groups that create works with clear prodemocracy or proreunification messages on nontraditional forms such as banners, leaflets, and posters. Amidst a U.S. art-market boom in New York, Korean artist Bahc Yiso and a group of artists based in Greenpoint, Brooklyn, found the nonprofit art space Minor Injury in Brooklyn. With the aim of providing an exhibition space for minority artists and others in the community with difficult access to mainstream galleries and art institutions, Minor Injury brings political activism and community-building into the white cube.

1986

Seoul hosts the Asian Games for the first time.

Developments in Art: Nam June Paik's *Bye, Bye Kipling* is shown in the United States, Japan, and Korea on the closing day of the Asian Games. The Minjung art mural *Joy of Unification,* painted by Hongik University students on a three-story building in Seoul, is demolished. Yeomiyeon, the women's art group affiliated with the Minjung movement, holds the show *From the Half to the Whole.* Attempting to engage directly with its target audience of middle-class women, the exhibition is the first feminist art event to take place in Korea.

1987

Chun Doo-hwan chooses fellow military alumnus Roh Tae-woo as his successor for the presidency, sparking protests. Prodemocracy demonstrations gain increasing support from civilians and major political and public figures. More than five million people throughout the country take to the streets for twenty days to protest in what would come to be known as the June Opposition. Following the protests, a direct electoral system is established, with Roh Tae-woo winning the vote by a narrow margin in the first democratic elections held in the country. The deadliest North Korean terrorist attack directed at the South occurs when two North Korean agents plant a bomb aboard Korean Air flight 858, killing all 115 passengers.

Developments in Art: Artists take part in the June Opposition, painting flags, murals, banners, and leaflets used during the protests. Minjung artists Lee Sang-ho and Jeon Jeong-ho are imprisoned for their pro-unification work, *A New Day for Unification Is Dawning at the Foot of Baekdusan Mountain.* An alternative culture

of underground clubs, bars, and informal art spaces begins to spring up around the area of Hongik University. Younger artists disillusioned with national politics become interested in the mixture of American, Japanese, and Korean popular culture, commercialism, and kitsch created by rapid economic development; the group "Museum," including Hongik graduates Lee Bul, Choi Jeong-Hwa, Kho Nakbeom, Lee Sang-yoon, Hong Sung-min, and Lee Yong-baek, holds its first exhibition.

1988

The 24th Summer Olympic Games opens in Seoul, as former general Roh Tae-woo is inaugurated president. Despite his close ties to the Chun regime, Roh promises democratic reform. Through a *Nordpolitik* foreign policy, the Roh administration announces the intention to form ties with the Soviet Union, China, and the Eastern bloc in an effort to isolate North Korea. The 1988 Olympics is seen as a milestone in South Korea's economic development, proving that its embrace of capitalism has taken it beyond the economic and military strength of North Korea. North Korea boycotts the Olympic Games. Thanks to Korea's new consumer culture, an increasing number of people achieve middle-class status. The first McDonald's opens in Korea. Koreans begin studying abroad in large numbers, many of them heading to the United States and Europe.

Developments in Art: The government lifts the ban on pre-1948 artistic, literary, and musical works seen as pro–North Korean. Minjung art receives greater attention when the New York alternative venue Artists Space opens the exhibition *Minjung Art: A New Cultural Movement from Korea*. As multiculturalism and identity politics become increasing concerns, American art critics Lucy Lippard, Hal Foster, and Kim Levin and Korean Minjung artist Sung Wan-kyung participate in a panel to discuss the clashes between "first-world" and "third-world" politics and cultures. Bahc Yiso participates in *Immigrant Show* at New York's Alpine Gallery; he creates *Project DMZ* at the Storefront for Art and Architecture, also in New York. The Seoul Museum of Art is founded.

1989

Developments in Art: The Samsung conglomerate publishes the first issue of *Wolgan Misool,* a specialized art magazine. Under the National Security Law, three artists are arrested and charged with sending a slide of a large banner portraying messages of unification to the North Korean Pyeongyang Festival. Shin Hak-chol's *Planting Rice,* which features pro–North Korean and anti-American imagery, stirs controversy; Shin is arrested for violating the National Security Law.

1990

On a U.S. visit, President Roh meets Soviet leader Mikhail Gorbachev; both cautiously pledge to normalize diplomatic relations between South Korea and the Soviet Union.

1991

Developments in Art: Organized by the Seoul Arts Center, *Ten Contemporary Korean Women Artists* is shown at the National Museum of Women in the Arts in Washington, D.C. Including the works of Kimsooja, Baik Soonsil, Jin Ok-sun, Kim Won-suk, and others, the show attests to the strong work by women artists emerging from Korea, grappling with issues of modernization and tradition, gender and identity. The Sonje Museum of Contemporary Art {now Artsonje Center} is established by the Daewoo conglomerate.

1992

Kim Young-sam wins the presidential election, defeating rival candidate Kim Dae-jung to become South Korea's first democratically elected civilian president. Seotaiji and Boys release their first album to enormous success. Incorporating a variety of sounds, from death metal to gangsta rap, Seotaiji provides an outlet for angst-ridden teenagers.

The Los Angeles riots begin April 29, following the beating of black motorist Rodney King by police officers caught on tape. The riots continue for six days, with violence, looting, and arson taking place in a Korean American neighborhood; many residents' businesses are damaged or destroyed. The event, known as "sa-i-gu" among Koreans, brings to light ongoing racial, ethnic, and class tensions among different communities in the United States.

1993

Kim Young-sam is sworn into office. Former presidents Chun Doo-hwan and Roh Tae-woo are arrested on charges of corruption and treason, as Kim pardons thousands of political prisoners jailed under previous administrations. Kim attempts to enact reform through an anticorruption campaign, forcing government officials and corporations to make financial accounts public. However, *jaebeol* continue to control the economic life of the country.

Developments in Art: Nam June Paik is awarded the Golden Lion for Best Pavilion at the Venice Biennale as a participant in the German Pavilion (with Hans Haacke). Paik's award raises criticism in South Korea over its lack of representation at the world's most prestigious biennial. Accordingly, plans for a Korean Pavilion begin, with support from Paik. Paik helps to spur an interest in new-media art, alongside the increasing role of technology in Korea's economic development. A new wave of postmodern art is introduced into the country when the controversial 1993 Whitney Biennial travels to the National Museum of Contemporary Art in Gwacheon, near Seoul. Issues such as institutional critique, multiculturalism, and marginal discourses reflecting the negative side of America are seen for the first time in the country. Meanwhile, in part as a response to the large Korean immigrant population in the New York metropolitan area, the Queens Museum of Art hosts *Across the Pacific: Contemporary Korean and Korean American Art*. It is one of the first exhibits to show a variety of artistic currents among Korean and Korean American artists. The show includes works by Choi Jeong-Hwa, Lee Sookyung, Min Yong Soon, Kim Hongjoo, Christine Chang, and many others. The controversial show later travels to the Kumho Museum of Art in Seoul.

1994

North Korean leader Kim Il Sung dies. The United States and North Korea sign the Agreed Framework in an effort to curb North Korea's nuclear ambitions and normalize the hermetic country's relations with the international community. Seongsu Bridge collapses in Seoul, killing thirty-two and injuring seventeen. Hasty building procedures and lack of safety measures are blamed for the collapse.

Developments in Art: Minjung art receives a major state-sponsored exhibition with *15 Years of Minjung Art* at the National Museum of Contemporary Art. Drawing over seventy thousand visitors, the controversial exhibition is a demonstration of Minjung art's entry into mainstream artistic discourse; some critics deem it the movement's "official funeral."

1995

South Korea's largest peacetime disaster occurs when the Sampung department store collapses, killing 502. The disaster raises issues of government corruption, corporate greed, and low safety standards in the still-booming Korean construction industry. The former Japanese Government-General Building, a neoclassical building and symbol of Japanese imperial oppression, is demolished to commemorate the fiftieth anniversary of national independence. South Korea joins the UN Security Council.

Developments in Art: The year is a watershed moment in Korean contemporary art. The Korean Pavilion is built in the Giardini at the Venice Biennale; pavilion artist Jeon Soo-cheon receives a special prize. East Asia gets its first taste of the biennial boom when the southern city of Gwangju, site of the 1980 uprising, hosts the first Kwangju Biennale (subsequently changed to Gwangju), *Beyond the Borders*. With a staggering $23 million budget and a reported 1.6 million visitors, the biennial commemorates the fifteen-year anniversary of the uprising while bringing international art to the "third world." In Seoul, Artsonje Center opens *Ssak*, an exhibition showing artists emerging after the dominance of Minjung art, including Lee Bul, Choi Jeong-Hwa, Bahc Yiso, and others. Bahc Yiso returns to Korea after thirteen years in New York.

Ssamzie Space exterior, Seoul, 1998.

1997

The East Asian financial crisis hits Korea. The country struggles with heavy losses stemming from overstretched debts by the nation's *jaebeol*. The International Monetary Fund (IMF) is forced to bail out South Korea and other Asian countries hit by the financial disaster. Kim Jong Il, son of deceased North Korean leader Kim Il Sung, formally becomes general secretary of the Workers' Party of Korea and, as chairman of the National Defense Commission, becomes the highest-ranking official in North Korea.

Developments in Art: In the second Gwangju Biennale, *Unmapping the Earth*, globalism, nomadism, and hybridity emerge as key themes. Kang Ik-joong and Lee Hyung-woo, artists based respectively in New York and Paris, are chosen for the Korean Pavilion at the Venice Biennale. Lee Bul becomes the first female Korean artist to have a solo exhibition at the Museum of Modern Art, New York. However, tensions arise between the artist and museum following her refusal to remove rotting fish from her installation *Majestic Splendor*. Korean artists Kimsooja, Choi Jeong-Hwa, Lee Bul, Kim Jinai, Koo Jeong-A, Kim Yun-tae, Minn Sohn-joo, and architect Seung H-sang join in the discourses of globalization and mobility, participating in the traveling exhibition *Cities on the Move*, curated by Hans Ulrich Obrist and Hou Hanru at the Vienna Secession. The globetrotting exhibition becomes influential for a younger generation of curators. Domestically, fewer artists join in the collective art movements and groups of the past and begin to work more individually.

1998

Former jailed dissident and activist Kim Dae-jung is inaugurated president. As the country continues to feel the effects of the Asian financial crisis, corporate responsibility and economic reform become key aims of his administration, as well as opening a dialogue with North Korea. Many Koreans living abroad are forced to return home when the South Korean won declines to almost half of its previous value. Mobile-phone usage jumps to ten million as the wireless service-provider market is opened up to competition.

Developments in Art: Art galleries and private museums opened by wealthy individuals and corporations close as a result of ongoing financial difficulties. Busan holds its first international biennial art festival (PICAF). Several Korean artists who studied abroad return to participate in *Seoul in Media: Food, Clothing, Shelter*, sponsored by the Seoul Metropolitan Government at the Seoul Metropolitan Museum of Art and curated by Lee Young Chul. An intergenerational show that includes installations, video art, photography, and other forms, *Seoul in Media* offers a new, low-budget exhibition paradigm. The show includes Sora Kim, Gimhongsok, Bahc Yiso, Kim Sang-il, Chung Suejin, Ham Kyungah, and Hong Seunghye. The accessories company Ssamzie opens the first artists' residency program at Ssamzie Space, in the lively Hongik University area of Seoul. Ssamzie Space artist-in-residence Young-hae Chang cofounds Young-hae Chang Heavy Industries with Marc Voge in Seoul, producing Web-based art.

Rodin Gallery exterior, Seoul, 1999.

1999

High-speed Internet service is introduced to the country. The box-office hit *Shiri* begins the domestic cinema boom.

Developments in Art: In Seoul, the Samsung Culture Foundation opens Rodin Gallery, which becomes the premier location for solo exhibitions in Korea. Low-budget, alternative spaces Loop and Sarubia open, highlighting work by younger artists. Artists Noh Sang-kyun and Lee Bul represent South Korea at the Venice Biennale; Lee Bul, the first female artist to represent the country at the Biennale, wins a special prize.

2000

South Korean President Kim Dae-jung and North Korean Chairman Kim Jong Il meet for the first time at the first Inter-Korean Summit Talks in Pyeongyang, capital of the North. Kim Dae-jung is awarded the Nobel Peace Prize as a result of the talks. As the Asia-Europe Meeting (ASEM) between leaders of Europe and Asian countries takes place in Seoul, antiglobalization protesters take to the streets.

Developments in Art: An increasing number of alternative art spaces develop alongside Web sites dedicated to art. Gwangju hosts its third biennial, *Man and Space*, as Seoul's *City and Media* biennial changes its focus to new-media art in *Between 0 and 1*. As part of PICAF, Busan expands its fledgling biennial with *Leaving the Island*, a show including 110 works organized by Lee Young-chul, Rosa Martinez, and Hou Hanru. Traveling exhibitions such as *My Home Is Yours: Your Home Is Mine* at the Rodin Gallery focus on the artist as cosmopolitan global nomad. This is a shift from the early 1990s image of the displaced immigrant. Korean artists include Do Ho Suh, Gimhongsok, and Sora Kim. For the second year in a row, the San Francisco Museum of Modern Art recognizes Young-hae Chang Heavy Industries for its pioneering work in Web art.

2001

Newly elected Japanese Prime Minister Junichiro Koizumi visits Yasukuni Shrine, a controversial memorial that holds the remains of convicted war criminals, sparking outrage in Korea and China.

Developments in Art: Modeled after the Whitney Biennial, the Samsung Culture Foundation sponsors the *ArtSpectrum 2001* at Ho-Am Art Museum to offer support to emerging Korean artists. Kimsooja holds her first solo exhibition in New York at P.S.1. Do Ho Suh has a solo show at the Whitney Museum at Philip Morris. Suh and Korean American artist Michael Joo represent South Korea at the Venice Biennale, drawing criticism from the South Korean media that neither artist is based in Korea.

2002

Korea and Japan host the 2002 World Cup. Millions take to the streets in Korea's first non-protest public gathering in celebration of South Korea reaching the quarter finals. In a surprise victory, political outsider and human-rights lawyer Roh Moo-hyun is elected president, with large numbers of young "netizens," or Internet citizens, rapidly mobilizing votes through the Web and mobile technology. In his state of the union address, U.S. President George W. Bush declares North Korea part of an "axis of evil," causing diplomatic tensions between Washington, D.C., and Seoul.

Developments in Art: The 4th Gwangju Biennale opens under the theme *P_A_U_S_E*, with conflict between local Gwangju administrators and exhibition organizers because of the lack of local representation in the show. Busan opens its international art festival under the new name Busan Biennale.

2003

Roh Moo-hyun is inaugurated as president of South Korea as North Korea withdraws from the Nuclear Non-Proliferation Treaty, causing concern that it will continue to develop its nuclear weapons program.

Developments in Art: Bahc Yiso, Chung Seo-young, and Whang Inkie participate in *Landscape of Differences* in the Korean Pavilion at the 50th Venice Biennale.

Choi Sung-Hun and Park Sun-Min, *The Paradise Is Burning,* 2005, ephemeral installation in *Anyang Public Art Project,* no longer extant.

Are My Sunshine: Korean Contemporary Art 1960–2004 opens at the Total Museum of Contemporary Art in Seoul in an attempt to create a timeline of contemporary Korean art. Following the opening, the art community is shocked at the unexpected death of forty-seven-year-old artist Bahc Yiso, who dies of a heart attack in Seoul.

2005

Proposals begin for developing an area of Incheon into New Songdo City, a $25 billion project for building a self-contained city where public and private information services are connected in a high-tech infrastructure. The project is called the "largest private real estate development in the world."

The Korean Pavilion *Secret Beyond the Door* exterior, 2005, the 51st Venice Biennale, Italy.

Developments in Art: Seoul becomes the center of focus at the Venice Biennale Korean Pavilion, as fifteen artists based in the city are invited to exhibit in the cramped pavilion under the theme *Secret Beyond the Door.* Recently established Arario Gallery becomes the first commercial gallery to sign young artists on a contractual basis. Auctions and art investments become increasingly popular, at the same time that public and environmental artworks are brought to the forefront in exhibitions such as *Anyang Public Art Project.*

2006

North Korea announces that it has successfully undertaken its first nuclear test, causing international alarm. Korean minister of foreign affairs Ban Ki-moon is elected eighth Secretary-General of the United Nations. South Korea and the United States negotiate a free-trade agreement, despite demonstrations by farmers, students, and other anti-free-trade protesters. The government attempts to place skyrocketing real-estate speculation under greater scrutiny.

2004

The opposition-party-led National Assembly votes to impeach President Roh for incompetence and for using illegal election processes. Citizens hold candlelight demonstrations to support the president. The case goes to the constitutional court, where it is ultimately overturned. The popular-culture phenomenon known as Hanryu, or the Korean wave, hits Japan and other East Asian countries, as fans become obsessed with Korean soap-opera stars. Korea deploys military troops to Iraq.

Developments in Art: Leeum, Samsung Museum of Art opens in a huge complex designed by world-renowned architects Mario Botta, Jean Nouvel, and Rem Koolhaas. Cultural capital gains increasing importance as the domestic art market begins to take off. The Gwangju Biennale, Seoul City Media Biennale, and Busan Biennale are held despite dwindling interest in the biennial system and increasing interest in art fairs. *You*

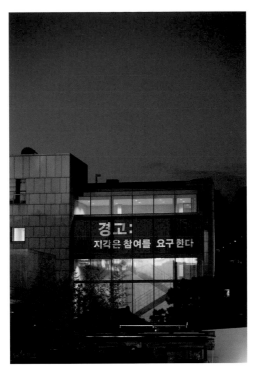

Antoni Mutadas, *Artsonje Center Print—Seoul,* 2007, from the series *On Translation: Warning* (1999–), vinyl cutting sheet, dimensions vary, installation view at the exhibition *Tomorrow,* Artsonje Center, Seoul, 2007.

Developments in Art: Art investments become popular among wealthy Koreans. Pioneering video artist Nam June Paik dies in New York and is buried in Seoul with funeral ceremonies commemorating his death. Artist Bahc Yiso is remembered with *Divine Comedy: A Retrospective of Bahc Yiso,* a exhibition at the Samsung Art Foundation's Rodin Gallery, Seoul

2007

Former Seoul mayor Lee Myung-bak is elected president, riding on a platform of economic development and solidifying ties with the United States. Korea and the United States sign a free-trade agreement. During elections, Lee is involved with the investment firm BBK in allegations of price-fixing and embezzlement.

Developments in Art: Artist Lee Hyungkoo is selected for the Korean Pavilion at the Venice Biennale. Art investments continue to be popular, despite increasing scrutiny following the investigation into Samsung group family members' improper use of company funds to buy works of art. Controversy erupts over the appointment of Shin Jeong-ah, former curator of Sungkok Art Museum, as commissioner of the 7th Gwangju Biennale. Ongoing investigations reveal that Shin forged her educational credentials and is linked to an embezzlement scandal involving a senior presidential aide of the Roh administration. Internationally known Nigerian curator Okwui Enwezor takes over as commissioner.

2009

Developments in Art: *Your Bright Future: 12 Contemporary Artists from Korea* opens at the Los Angeles County Museum of Art, June 28–September 20, and at the Museum of Fine Arts, Houston, November 22, 2009–February 14, 2010.

Bae Bien-U, *Pine Tree,* 2006, C-print, 49¼ × 98⅜ inches (125 × 250 cm), collection of the artist.

Checklist of the Exhibition

In Korea, family names precede given names; however, some individuals reverse the name order in international contexts. In the following list, family names are set in all uppercase letters and are arranged according to the artist's preference.

1.
BAHC Yiso
Weeds Grow, Too, 1986
Acrylic on canvas
74 × 72¹⁄₁₆ inches (188 × 183 cm)
Private collection

2.
BAHC Yiso
Untitled, 1986
Acrylic on canvas
70¹⁄₁₆ × 72¹⁄₁₆ inches (178 × 183 cm)
Private collection

3.
BAHC Yiso
Moon-Night-Picture, 1989
Acrylic and pencil on paper
29¹⁵⁄₁₆ × 22¹⁄₁₆ inches (76 × 56 cm)
Private collection

4.
BAHC Yiso
Homo Identropus, 1994
Acrylic and collage on paper
29¹⁵⁄₁₆ × 22¹⁄₁₆ inches (76 × 56 cm)
Leeum, Samsung Museum of Art, Seoul

5.
BAHC Yiso
Untitled (The Sky of Los Angeles / Houston),
2000/2009–10
(Based on *Untitled [The Sky of San Antonio],* 2000)
4 video cameras, 4 video projectors, wood, plaster
wallboard
Dimensions vary
Courtesy of the estate of the artist

6.
BAHC Yiso
Your Bright Future, 2002/2009
Electric lamps, wood, and wires
Dimensions vary
Courtesy of the estate of the artist

7.
BAHC Yiso
We Are Happy, 2004
Billboard
Dimensions vary
Courtesy of the estate of the artist

8.
CHOI Jeong-Hwa
HappyHappy, 2006–7/2009
Two site-specific outdoor installations: one an
educational project made of chain-link fence and
recycled plastic containers; the other a "chandelier"
made of commercial plastic containers
Dimensions of each vary

9.
CHOI Jeong-Hwa
Welcome, 2009
Site-specific outdoor installation using colored fabric
Dimensions vary

10.
GIMhongsok
Human Abstract, 2004
Ink on paper, framed
10¾ × 7⅞ inches (26 × 20 cm) each
Collection of the artist

11.
GIMhongsok
Mao Met Nixon, 2004
Glass, wood, and brass
Glass box: 39⅜ × 39⅜ × 39⅜ inches (100 × 100 × 100 cm)
Collection of the artist

12.
GIMhongsok
The Talk, 2004
Single-channel video on flat-screen television
26:09 min. loop
Collection of the Museum of Fine Arts, Houston,
museum purchase with funds provided by the
Caroline Wiess Law Accessions Endowment Fund,
2007.1299

13.
GIMhongsok
Jeju Island, 2004
Single-channel video
HDD, 14:50 min.
Collection of the artist

14.
GIMhongsok
Record—A4 p3, 2005
C-print, framed
44½ × 52⅜ inches (113 × 133 cm)
Collection of the artist

15.
GIMhongsok
The Wild Korea, 2005
Single-channel video DVD from HD original
16:20 min. loop
Collection of the Museum of Fine Arts, Houston,
museum purchase with funds provided by the
Caroline Wiess Law Accessions Endowment Fund,
2007.1279

16.
GIMhongsok
Literal Reality 4 TAN, 2006
Text on wall
Dimensions vary
Collection of the artist

17.
GIMhongsok
Journey to the World, 2006
Single-channel video on flat-screen television
11:48 min.
Collection of the artist

18.
GIMhongsok
Public Blank, 2006–8
16 framed drawings, ink on plywood board, each
with framed text
Each framed element: 23⅝ × 32 inches (60 × 81 cm)
Collection of the artist

19.
GIMhongsok
The Bremen Town Musicians, 2006–7
Foam rubber, fabric, wood, and paint
102⅜ × 182¾ × 98⅜ inches (260 × 464 × 250 cm)
Plinth: 87 × 57½ × 21¾ inches (221 × 146 × 55 cm)
Collection of Art Pension Trust, Beijing

20.
GIMhongsok
Bunny's Sofa, 2008
Foam rubber, fabric, wood, and paint
77⅝ × 32¼ × 25⅝ inches (197 × 82 × 65 cm)
Private collection

21.
JEON Joonho
The White House, 2005–6
Digital animation
32:16 min.
Collection of the National Museum of Fine Arts,
Taiwan
Courtesy of the artist and Arario Gallery, Seoul

22.
KIM Beom
Pregnant Hammer, 1995
Wood and iron
10½ × 2 × 2¾ inches (27 × 5 × 7 cm)
Artsonje Center, Seoul

23.
KIM Beom
*An Iron in the Form of a Radio, a Kettle in the Form of
an Iron, and a Radio in the Form of a Kettle,* 2002
Mixed media
Dimensions vary
National Museum of Contemporary Art, Gwacheon,
Korea

24.
KIM Beom
Untitled (A Plant from the Places #1), planted 2007
Newspaper photographs, glue, flowerpot, and
wood table
Dimensions vary
Collection of the artist

25.
KIM Beom
Untitled (A Plant from the Places #2), planted 2007
Newspaper photographs, glue, flowerpot, and
wood shelf
Dimensions vary
Collection of the artist

26.
KIM Beom
Untitled (Inanimate Objects), 2008
Single-channel video
5:55 min.
Collection of the artist

27.
KIM Beom
Noonchi, 2009
Artist's book
Courtesy of the artist

28.
KIMsooja
*A Needle Woman, Patan (Nepal), Havana (Cuba),
Rio de Janeiro (Brasil), N'Djamena (Chad), San'a
(Yemen), Jerusalem (Israel),* 2005
6-channel video projection
10:40 min. loop, silent
Courtesy of Kimsooja Studio

29.
KOO Jeong-A
Mountain Fundamental, 1997–2009
Stone powder on wood table
Dimensions vary
Courtesy of the artist

30.
KOO Jeong-A
R, 2005
1,001 drawings on paper, photographed
and projected
Dimensions vary
Courtesy of the artist

31.
Minouk LIM
Wrong Question, 2006
3-channel video installation
9:38 minutes
Courtesy of the artist

32.
Jooyeon PARK
MONOLOGUE monologue, 2006
Single-channel video
9:06 min.
Collection of the artist

33.
Jooyeon PARK
Eclectic Rhetoric, 2008
Installation, including a 16mm film, 13:14 min. loop,
and ten silkscreen prints
Overall dimensions vary; each framed print
15¾ × 19½ inches (40 × 49.5 cm)
Courtesy of the artist

34.
Do Ho SUH
Fallen Star 1/5, 2008–9
ABS, basswood, beech, ceramic, enamel paint, glass,
honeycomb board, laquer paint, latex paint, LED
lights, pinewood, plywood, resin, spruce, styrene,
polycarbonate sheets, and PVC sheets
Approximately 131 × 145 × 300 inches (332.7 ×
368.3 × 762 cm)
Courtesy of the artist and Lehmann Maupin Gallery,
New York

35.
Haegue YANG
Storage Piece, 2003
Mixed-media installation and performances
Dimensions vary
The Haubrok Collection, Berlin

36.
YOUNG-HAE CHANG HEAVY INDUSTRIES
SAMPLES OF ME, 2009
Video installation
Courtesy Young-hae Chang Heavy Industries

37.
YOUNG-HAE CHANG HEAVY INDUSTRIES
SUCKERDOM, 2009
Web program
Courtesy Young-hae Chang Heavy Industries

Copyright and Photography Credits

Photography Credits

Bahc Yiso
Page 33 (bottom)

Courtesy of the Archives of Korean Art, Leeum
Pages 187 (right and left), 189 (left and middle), 191

Courtesy of Chungwoo Lee
Page 27

Courtesy of Kim Tai Soo Partners
Page 22

Courtesy of the Samsung Museum of Art, Leeum
Pages 193 (bottom), 196 (bottom)

Courtesy of Ssamzie Space
Page 196 (top)

Daenam Kim
Page 173

Gallery Chosun
Pages 37 (bottom), 150

Haegue Yang
Page 37 (middle)

John D. Schiff
Page 21 (top)

Jooyeon Park
Pages 149, 151–3

Juan Guerra/Arquivo Histórico Wanda Svevo
Page 171

Kim Soun-Gui
Page 191 (middle and bottom)

Kim Yong-Il
Page 188

Kim Youngkwan
Page 196 (bottom)

Kyungsub Shin
Page 95 (top)

Lee Man-Hong
Page 192 (top)

Luca Campigotto
Page 52 (right)

Ludger Paffrath, Berlin
Page 36

Myungrae Park
Pages 38 (bottom), 199 (top)

Peter Moore
Pages 46–47

Sangtae Kim
Page 94

Scott Groller
Page 172

Seale Studios
Page 64

Suh Yong-Don
Page 38 (top)

Todd Johnson
Page 60 (left and middle)

Werner Maschmann
Page 170